The Family of Children

A Ridge Press Book Grosset & Dunlap, New York

Editor and Publisher: JERRY MASON

Art Director: ALBERT SQUILLACE

Project Editor: KEN HEYMAN

Quotations Edited by: SYLVIA COLE

Editor: ADOLPH SUEHSDORF
Associate Editor: RONNE PELTZMAN
Associate Editor: JOAN FISHER
Art Associate: DAVID NAMIAS
Art Associate: NANCY LOUIE
Art Production: DORIS MULLANE

Assistant Project Editor: MARK BUSSELL
Assistant Project Editor: FRED RITCHIN

The Family of Children

Acknowledgements

W. H. Auden, "In Memory of W. B. Yeats," *The Collected Poetry of W. H. Auden.*
Copyright 1945 by W. H. Auden. Reprinted by permission of Random House, Inc.

Basho, *The Four Seasons,* translated by Peter Beilenson. Reprinted by permission of Peter Pauper Press.

Karin Boye, "On the Road," translated from Swedish by May Swenson in *Half Sun Half Sleep,* published by Charles Scribner's
Sons. Copyright 1967 by May Swenson. Reprinted by permission of May Swenson.

Robert Bridges, "Ode to Music," *The Poetical Works of Robert Bridges,*
published by Oxford University Press. Reprinted by permission of the publisher.

Confucius, "The Book of Songs," *The Wisdom of Confucius,* ed. Lin Yutang.
Copyright 1938, renewed 1966 by Random House, Inc. Reprinted by permission of the publisher.

James Dickey, "Them, Crying." Copyright 1964 by James Dickey. Reprinted from *Poems 1957–1967*
by permission of Wesleyan University Press and Rapp & Whiting, Ltd. "Them, Crying"
first appeared in *The New Yorker.*

Emily Dickinson, "A Narrow Fellow in the Grass," *The Poems of Emily Dickinson,* ed. Thomas H. Johnson,
Cambridge, Mass.: The Belknap Press of Harvard University Press, copyright 1951, 1955 by the President and Fellows
of Harvard College. Reprinted by courtesy of Little, Brown and Company and Harvard University Press.

Richard Eberhart, "On a squirrel crossing the road in autumn," *Collected Poems 1930–1976,* published by
Oxford University Press, Inc. Copyright 1960 by Richard Eberhart. Reprinted by permission of the publisher.

Euripides, *Ten Plays by Euripides,* trans. Moses Hadas and John McLean. Copyright 1960 by Bantam Books, Inc.
Reprinted by permission of the publisher.

Robert Frost, "The Bonfire," *The Poetry of Robert Frost,* ed. Edward Connery Lathem. Copyright 1916, copyright 1969
by Holt, Rinehart and Winston; copyright 1944 by Robert Frost. Reprinted by permission of Holt, Rinehart and Winston, Publishers.

Robert Henri, *The Art Spirit.* Copyright 1923, by J. B. Lippincott Company. Copyright renwed 1951 by Violet Organ.
Reprinted by permission of J.B. Lippincott Company.

Flora Hood, "Rivers Flow" and "In the house of long life," reprinted by permission of G. P. Putnam's Sons
and Curtis Brown Ltd. from *The Turquoise Horse.* Copyright 1972 by Flora Hood.

Gerard Manley Hopkins, "The Windhover," *Poems of Gerard Manley Hopkins,* ed. Robert Bridges and W. H. Gardner.
Copyright 1948 by Oxford University Press. Reprinted by permission of Oxford University Press.

Arnold Lobel, *Frog and Toad Are Friends,* copyright 1970 by Arnold Lobel.
Reprinted by permission of Harper & Row, Publishers, Inc., and World's Work, Ltd.

Wilfred Owen, "Arms and the Boy," *The Collected Poems of Wilfred Owen,* ed. C. Day Lewis.
Copyright by Chatto and Windus, Ltd., 1946, 1963. Reprinted by permission of New Directions Publishing Corp.,
Chatto and Windus, Ltd., and the Owen Estate.

John Crowe Ransom, *Selected Poems,* 3rd ed., revised and enlarged. "Blue Girls" copyright 1927
by Alfred A. Knopf, Inc., renewed 1955 by John Crowe Ransom. "Bells for John Whiteside's Daughter" copyright 1924
by Alfred A. Knopf, renewed 1952 by John Crowe Ransom. Reprinted by permission of Random House, Inc.

Jean Rhys, *Wide Sargasso Sea.* Copyright 1966 by Jean Rhys. Reprinted by permission of
W. W. Norton, Inc., and Andre Deutsch, Ltd.

Rainer Maria Rilke, "Lovesong," *Translations from the Poetry of Rainer Maria Rilke,* trans.
M. D. Herter Norton. Copyright renewed 1966 by M. D. Herter Norton. Reprinted by permission
of W. W. Norton, Inc., and The Hogarth Press, Ltd.

Theodore Roethke, "Open House," copyright 1914 by Theodore Roethke from the book *Collected Poems
of Theodore Roethke.* Reprinted by permission of Doubleday & Company, Inc., and Faber and Faber.

Carl Sandburg, "Phizzog," *Good Morning, America,* copyright 1928, 1956 by Carl Sandburg.
Reprinted by permission of Harcourt Brace Jovanovich, Inc.

Paul Simon, "The 59th Street Bridge Song." Copyright 1966 by Paul Simon. Used by permission.

Gertrude Stein, *Useful Knowledge.* Reprinted by permission of Harcourt Brace Jovanovich, Inc.

Wallace Stevens, "Sunday Morning," *The Collected Poems of Wallace Stevens.* Copyright
1923, renewed 1951 by Wallace Stevens. Reprinted by permission of Alfred A. Knopf, Inc.

Joe Tex, "Papa Was Too." Copyright 1966 by Tree Publishing Co. Used by permission.

Dylan Thomas, *A Child's Christmas in Wales.* Copyright 1954 by New Directions Publishing Corp.
Reprinted by permission of New Directions Publishing Corp., J M Dent & Sons Ltd, Trustees
for the Copyrights of the late Dylan Thomas, and David Higham Associates.

Chidiok Tichborne, "The Spring is Past," *Tom Tiddler's Ground,* ed. Walter de la Mare, published
by The Bodley Head (1961), and Alfred A. Knopf, Inc. (1962). Copyright 1961 by The Bodley
Head, London. Reprinted by permission of Alfred A. Knopf, Inc., and The Bodley Head, London.

Alan W. Watts, *The Way of Zen,* published by the New American Library.
Copyright 1957 by Pantheon Books, Inc. Reprinted by permission of Pantheon Books, a division of Random House, Inc.

Richard Wilbur, "Grace," *The Beautiful Changes and Other Poems,* copyright 1947; renewed 1975 by Richard Wilbur.
Reprinted by permission of Harcourt Brace Jovanovich, Inc.

William Butler Yeats, "The Stolen Child." Reprinted with permission of M. B. Yeats, Miss Anne Yeats,
the Macmillan Co. of London and Basingstoke, and Macmillan Publishing Co., Inc., from *Collected Poems.*
Copyright 1906 by Macmillan Publishing Co., Inc., renewed 1934 by William Butler Yeats.

Two quotations from *The New Book of Unusual Quotations,* ed. Rudolph Flesch, reprinted
by permission of Harper & Row, Publishers, Inc.

Quotation from "Corn-Grinding Song," *Sung Under the Silver Umbrella,* trans. by Natalie Curtis,
published by Macmillan Publishing Co., Inc. Copyright 1968 by Paul Burlin. Reprinted by permission of Barbara Wedell.

For Edward Steichen

The Family of Children

This unique anticipation : then this birth
This infant grasps my finger
This infant has voice and shape and size and color
This infant has unfathomed style
This infant hungers — I nourish ; wails — I console.

This baby speaks my name and walks in my direction
This baby falls asleep on my shoulder and I have never
 kept myself so still
This baby laughs and cries and I follow a maze of secrets.

This child holds my hand for safety and assurance
I become the absolute of protection
This child amazes me with unpredicted embraces —
 impulsive, joyous and total
This child puts on my big hat, my big shoes —
 amused and serious — innocently trying to be me.

This young one absorbs my big and little thoughts
This young one scorns and questions
This young one is ready to challenge the past or repeat it,
 to take risks, to know danger
This young one pushes to evade defeat and horror
This young one, casual, volatile, content, bewildered,
 confident, fearful
Ferocious with hope —
This young one needs me, wants me, leaves me, loves me.
Who am I to be so cherished and so confounding ?
How will I re-supply such love ?

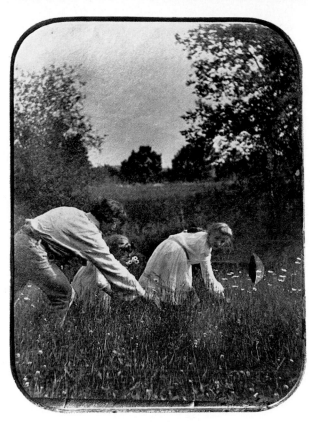

Edward Steichen, 1905, by Alfred Stieglitz

What kind of world do I give this child? What will
this child do with it? Love? Fight? Suffer? Rejoice?

The Family of Children. The circle. The natural circle
of universality from birth to birth. The circle that encloses
all the meaningful moments of life. The emotions born
in those moments. And the lightnings that play against them.

Look at, feel the morning time of life. This is the
child who grasps tight your hand. This is the child who was you.

Two decades ago I had the honor to edit and publish
THE FAMILY OF MAN, the exhibition created by Edward Steichen.
He said: "The art of photography is a dynamic process of giving
form to ideas and of explaining man to man."

The question here, as then: "Who Am I?" The answer: "I
Am." All in the images from hundreds of thousands of photographs
from 70 countries. As the United Nations and UNICEF prepare
to celebrate "The Year of the Child," this is the universal
circle of childhood.

It is Carl Sandburg saying
There is only one child in the world
and the child's name is All Children

This child speaks our name.

— Jerry Mason

O, wonder:

How many goodly creatures are there here:

How beauteous mankind is: O brave new world

That has such people in 't! William Shakespeare

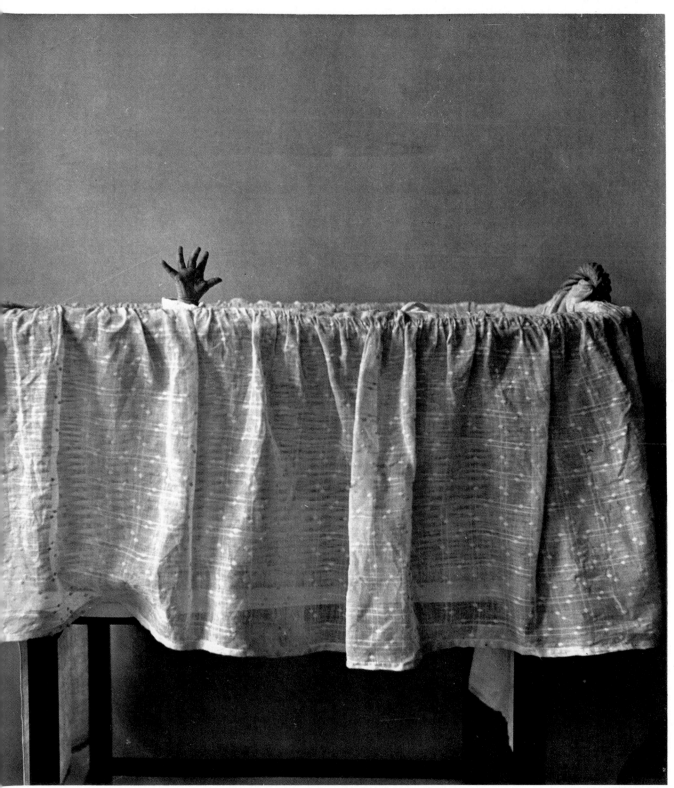

CZECHOSLOVAKIA Jan Lukas

7

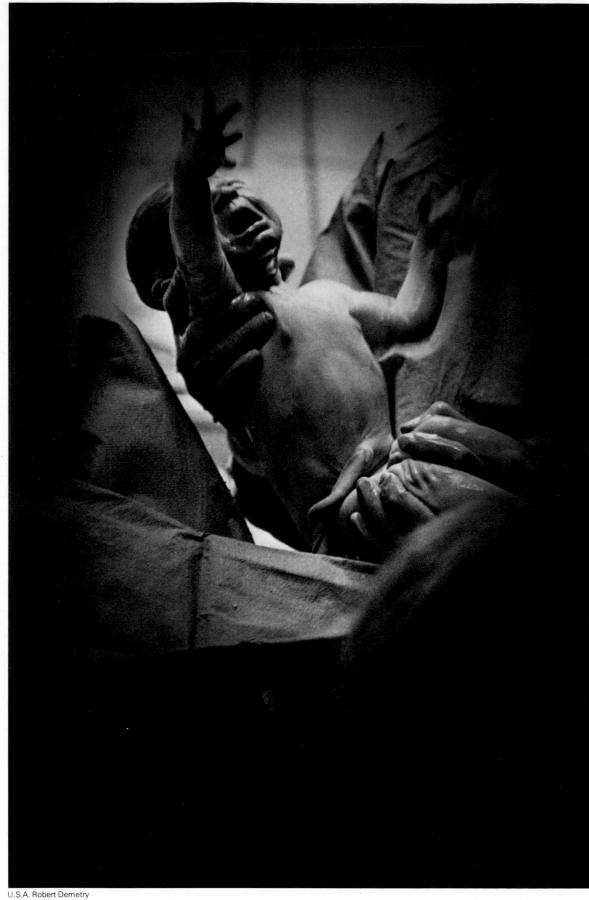

U.S.A. Robert Demetry

8

Such a knot of little purposeful nature! Richard Eberhart

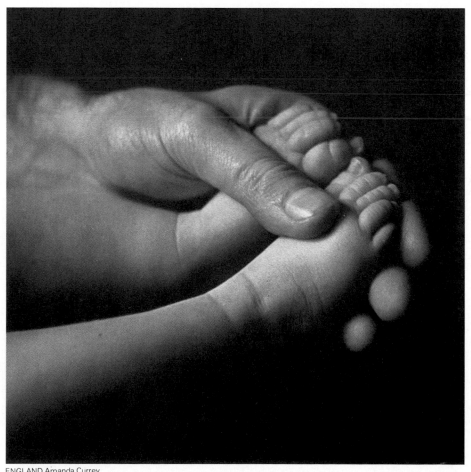

ENGLAND Amanda Currey

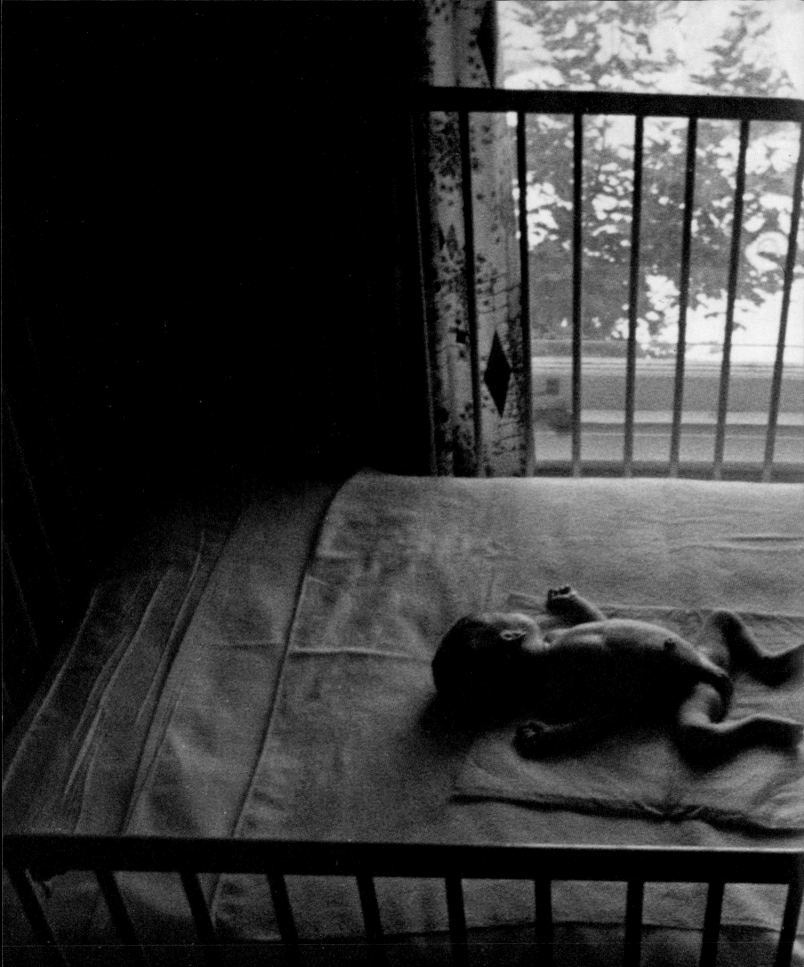

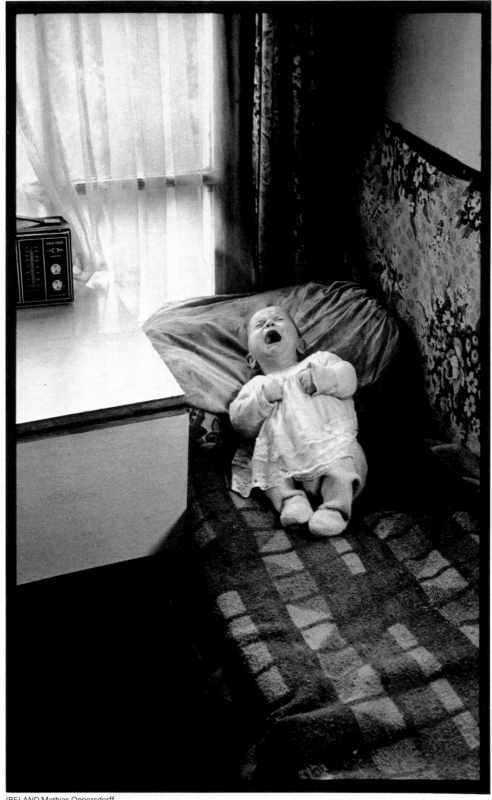

IRELAND Mathias Oppersdorff

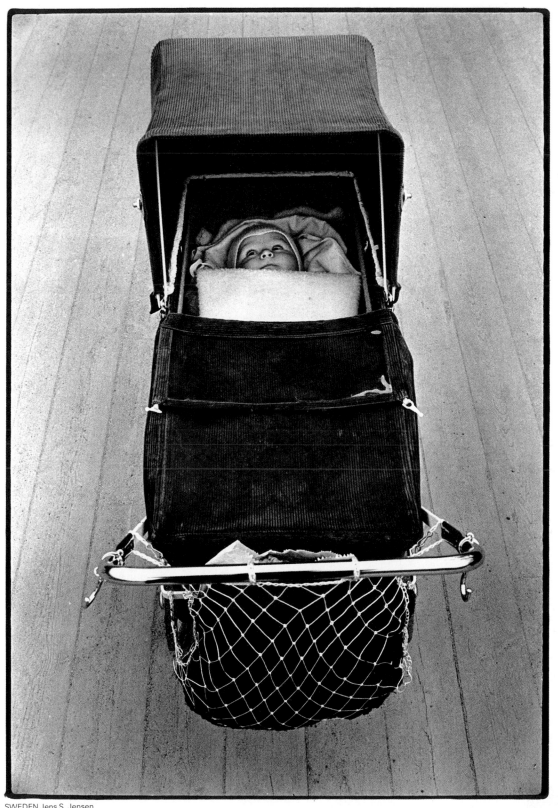

SWEDEN Jens S. Jensen

O young thing, your mother's lovely armful!

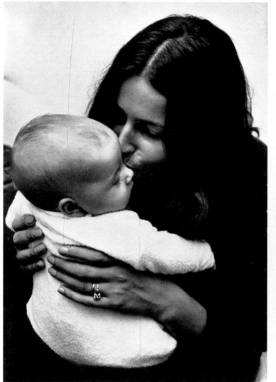

GUATEMALA Ken Heyman

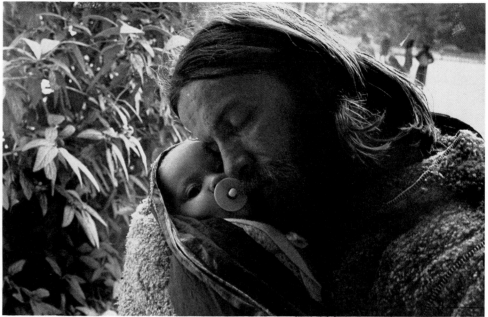

WEST GERMANY Patrick Scharat

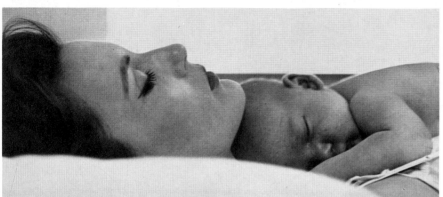

U.S.A. Edward T. Russell

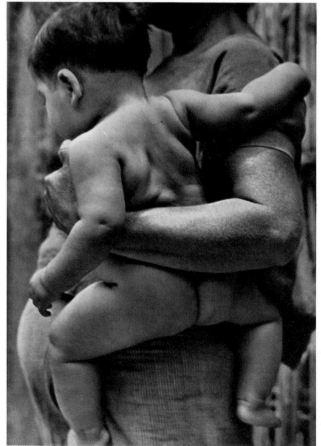

MEXICO Tina Modotti

14

/How sweet the fragrance of your body! Euripides

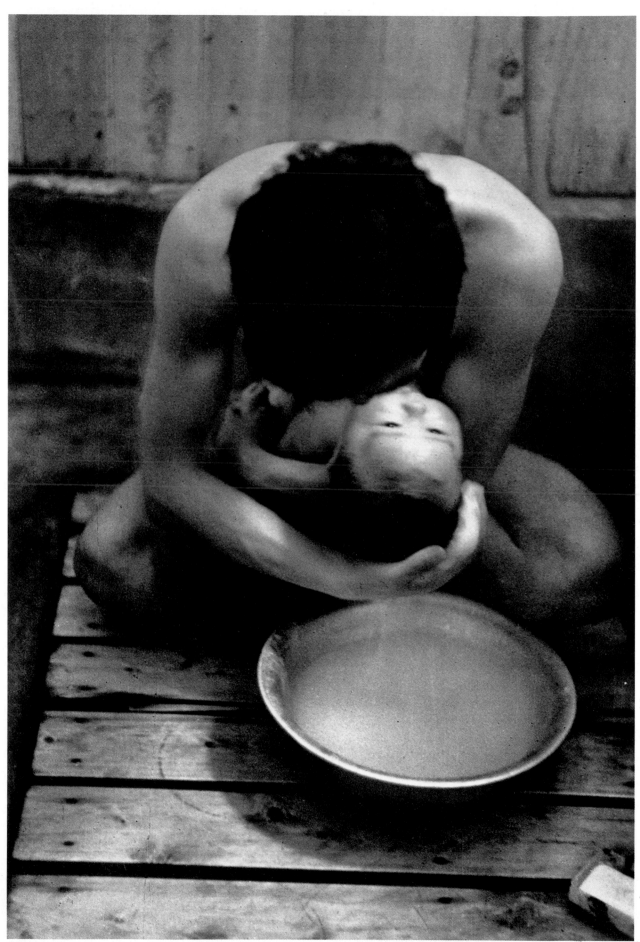

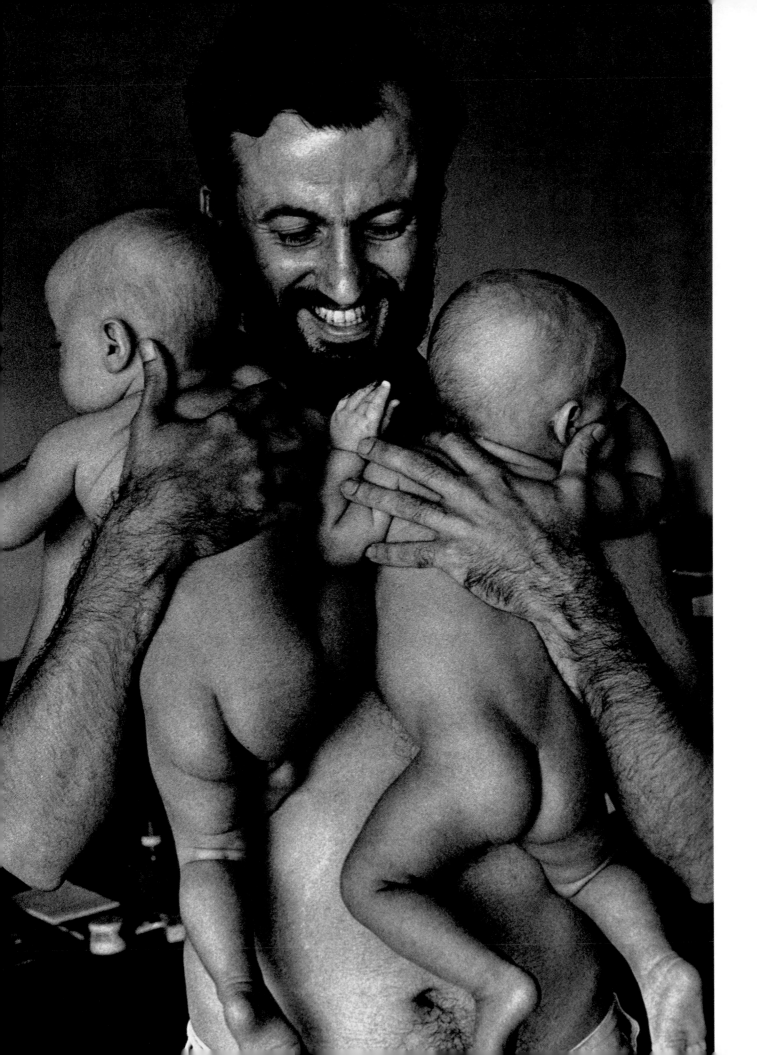

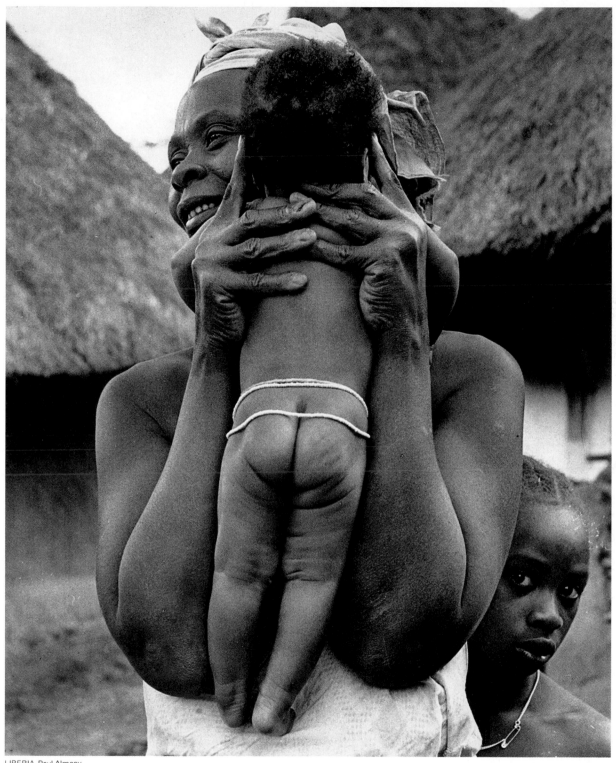

LIBERIA Paul Almasy

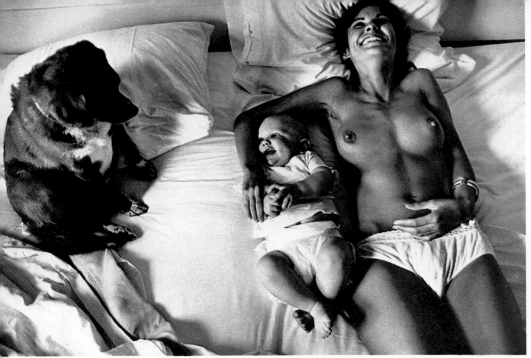

U.S.A. Mary Ellen Mark/Magnum

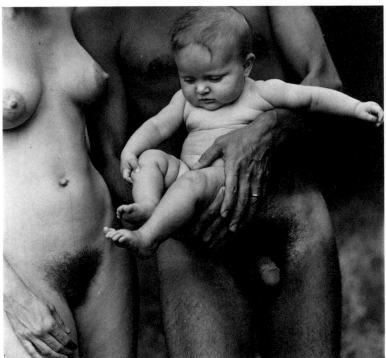

U.S.A. Joan Dufault

LONDON Robina Rose

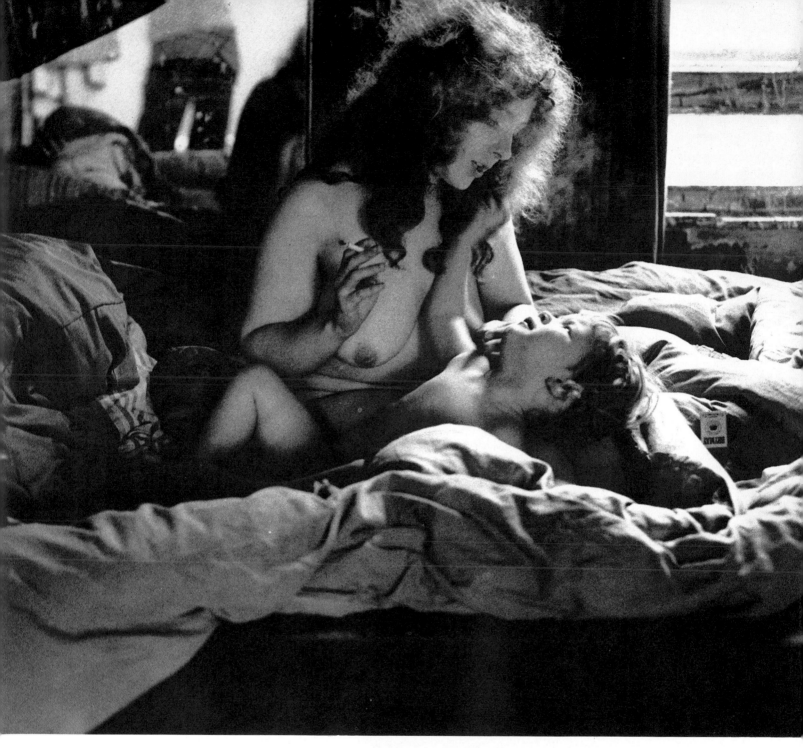

BANGLADESH Margaret Murray/Christian Aid

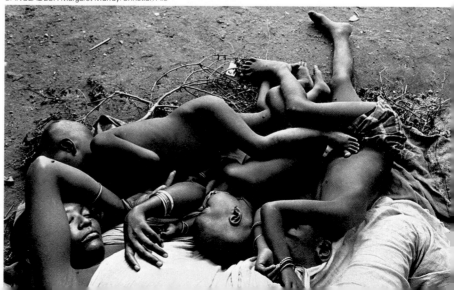

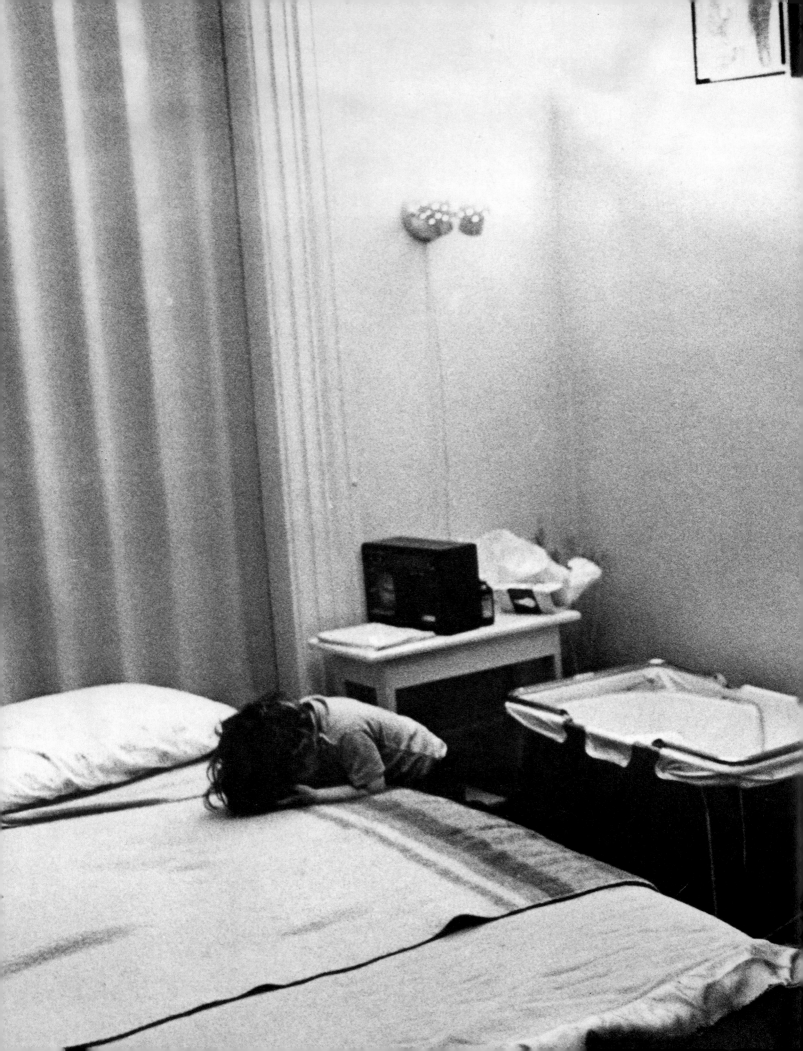

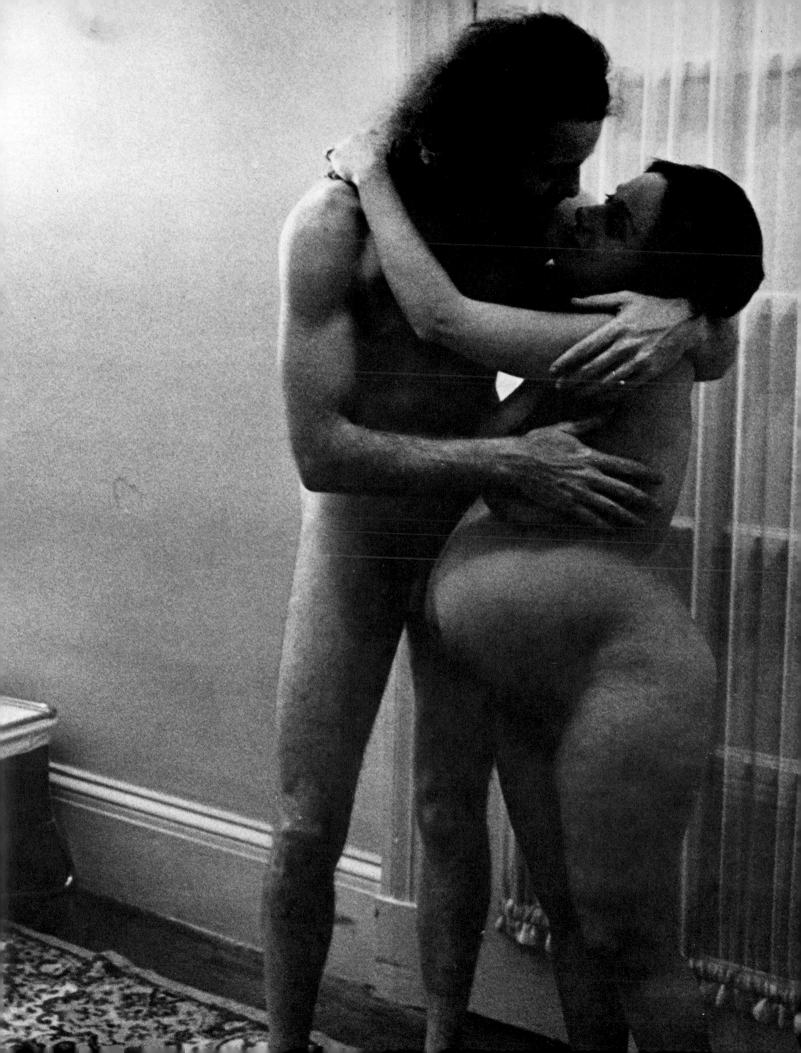

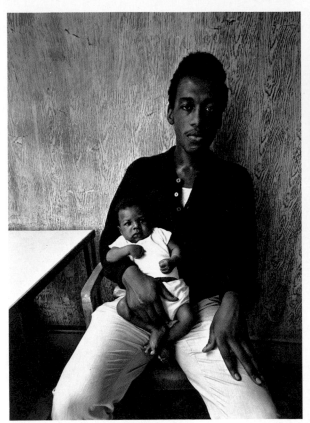

EAST HARLEM Bruce Davidson/Magnum

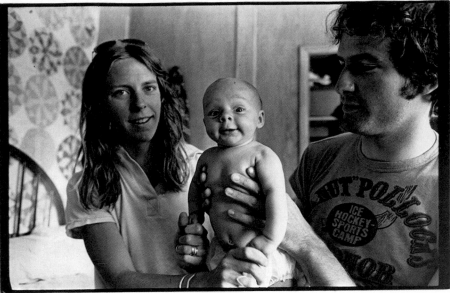

U.S.A., Lynn Adler/Optic Nerve

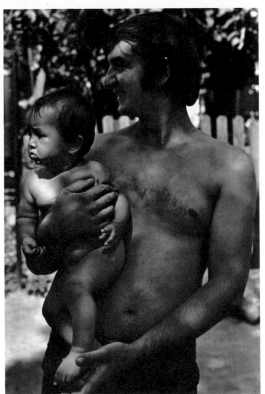

U.S.S.R. Louis Stettner

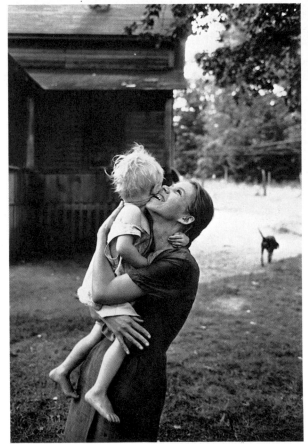

U.S.A. Ken Heyman

lo, such faces! Walt Whitman

Preceding pages: U.S.A. Suzanne Opton

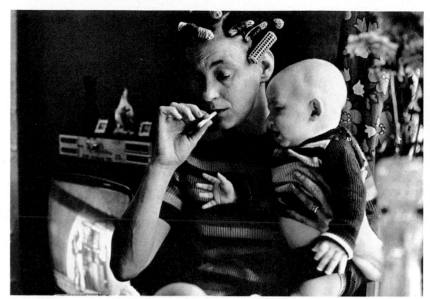
ENGLAND Robina Rose/Co-Optic

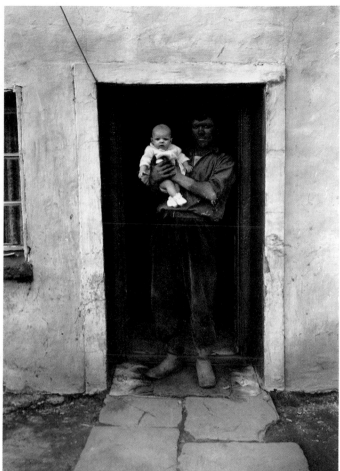
WALES Bruce Davidson/Magnum

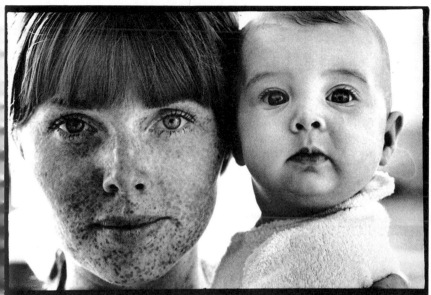
U.S.A. Jerome Ducrot

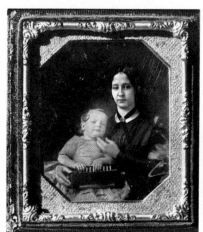
U.S.A. Daguerreotype ca. 1850

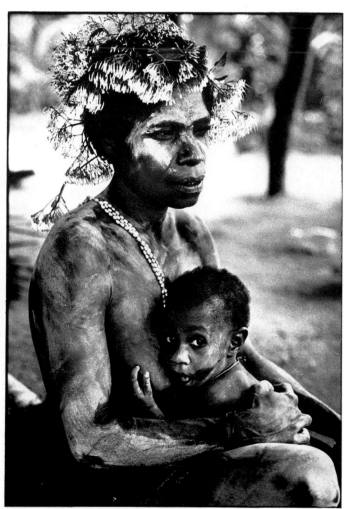
NEW GUINEA David Bailey/Co-Optic

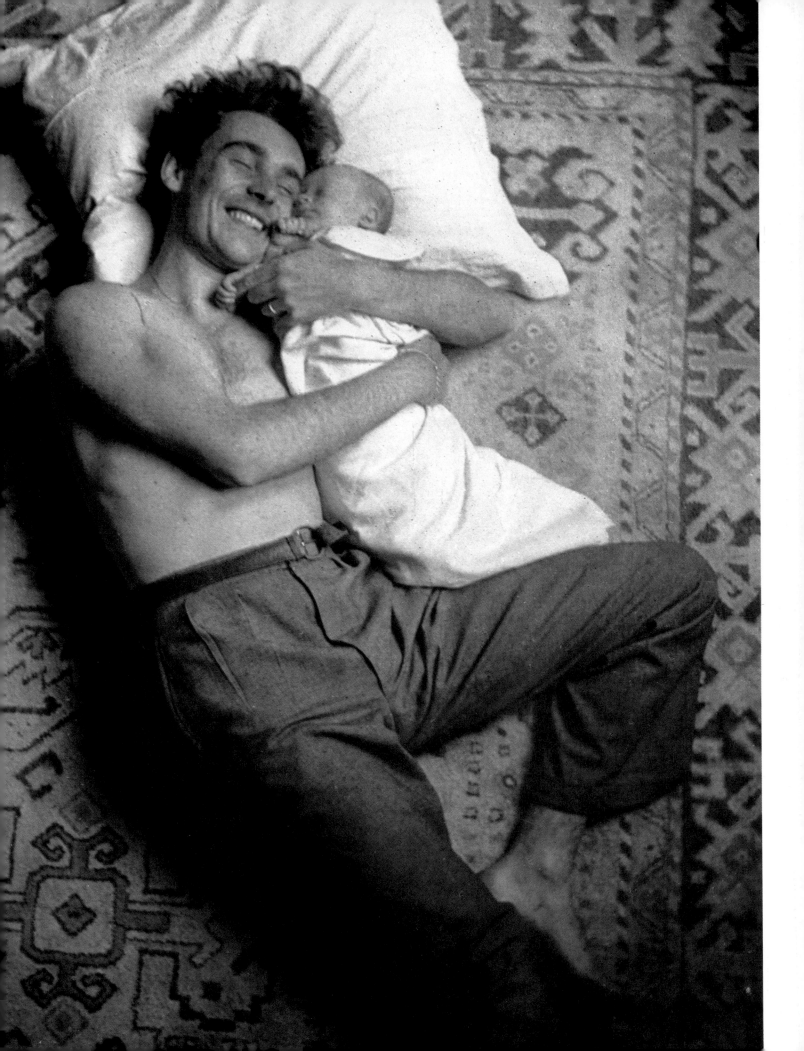

FRANCE J. H. Lartigue (1944)

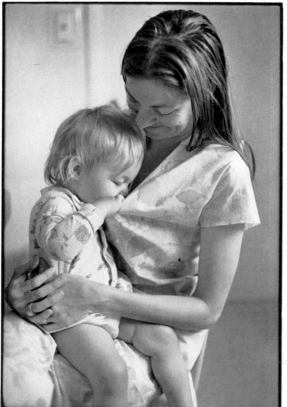

U.S.A. Robert Burroughs

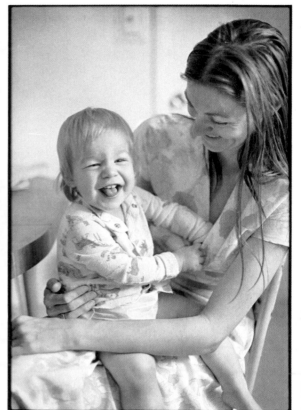

U.S.A. Robert Burroughs

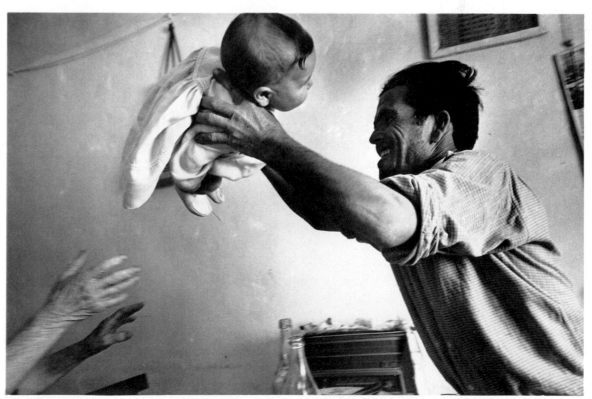

SICILY Ken Heyman

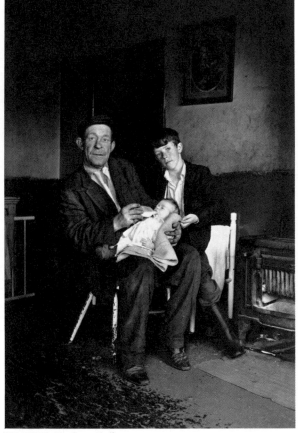

IRELAND Mathias Oppersdorff

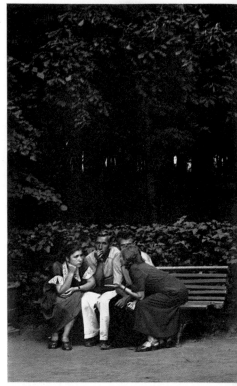

U.S.S.R. Georg Oddner

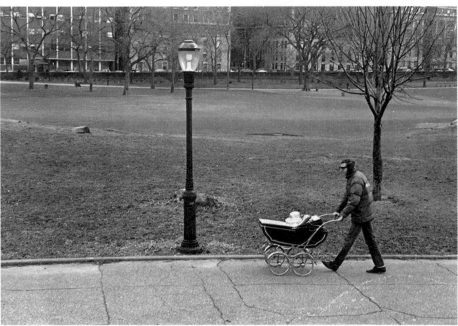

U.S.A. Robert Burroughs

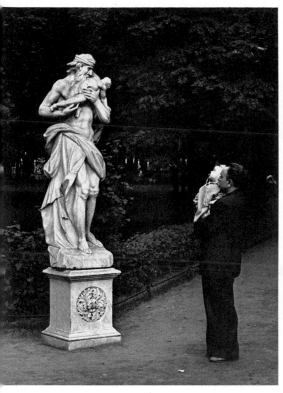

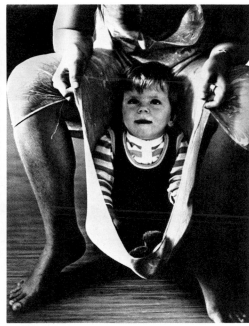

FINLAND Aulis Nyqvist

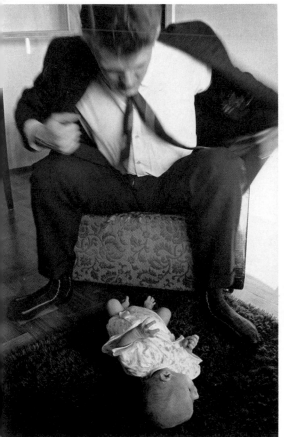

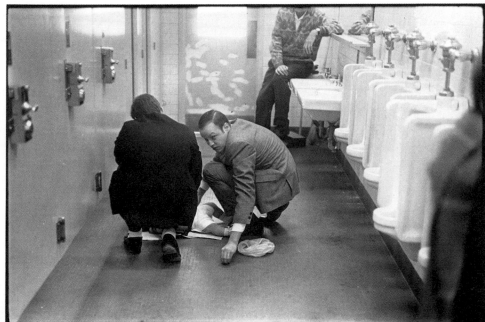

U.S.A. Charles Biasiny Rivera

SWEDEN Hans Malmberg/Tio

The folded leaf is woo'd from out the bud
With winds upon the branch, and there
Grows green and broad Alfred Lord Tennyson

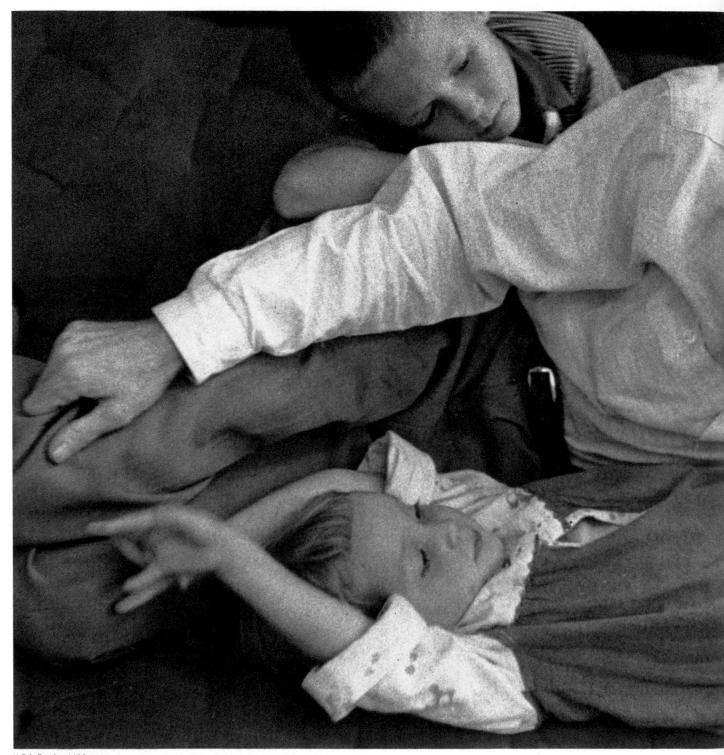

U.S.A. Eve Arnold/Magnum

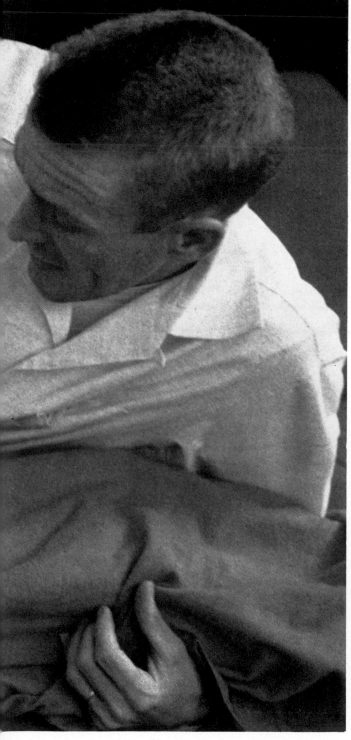

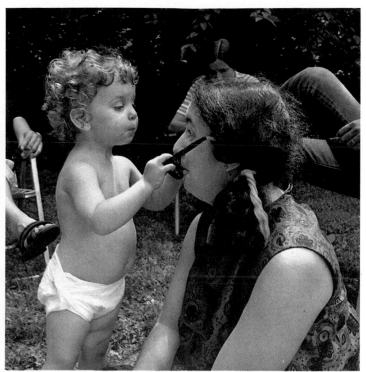

U.S.A. Frederic Underhill

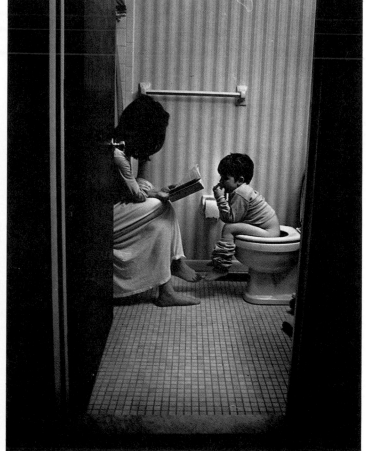

U.S.A. Pat Crowe

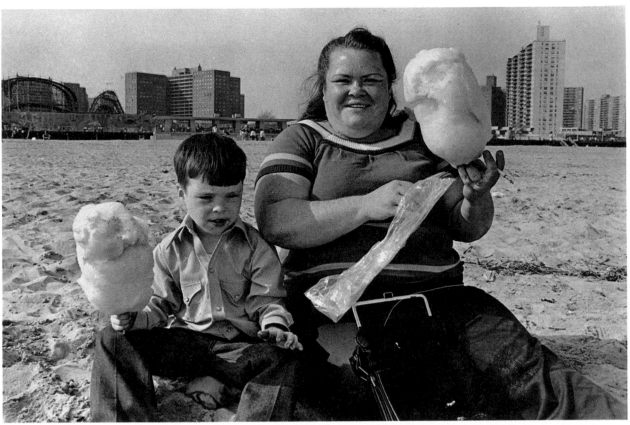

U.S.A. Catherine Noren

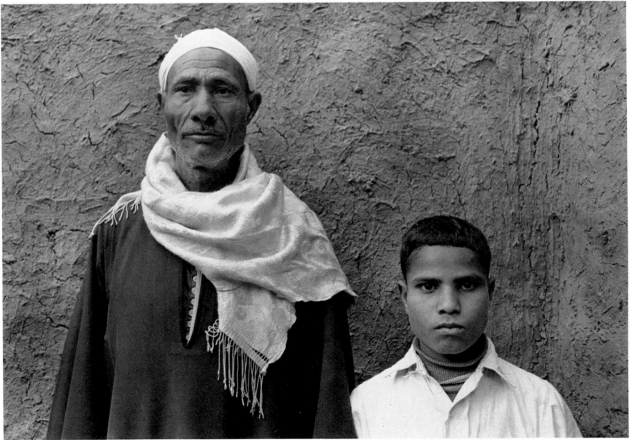

EGYPT Angelo Pacifici

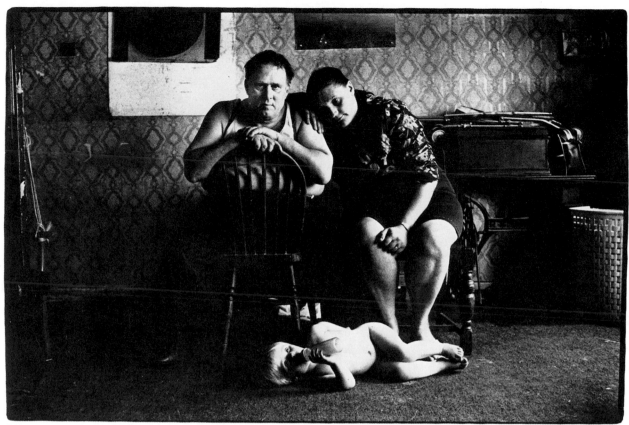

ENGLAND John Garrett/Susan Griggs

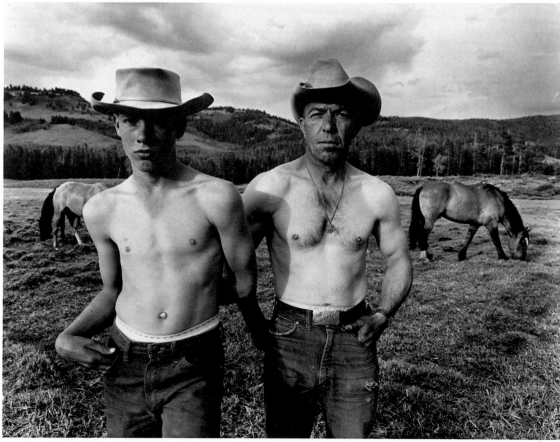

U.S.A. Bruce Davidson/Magnum

31

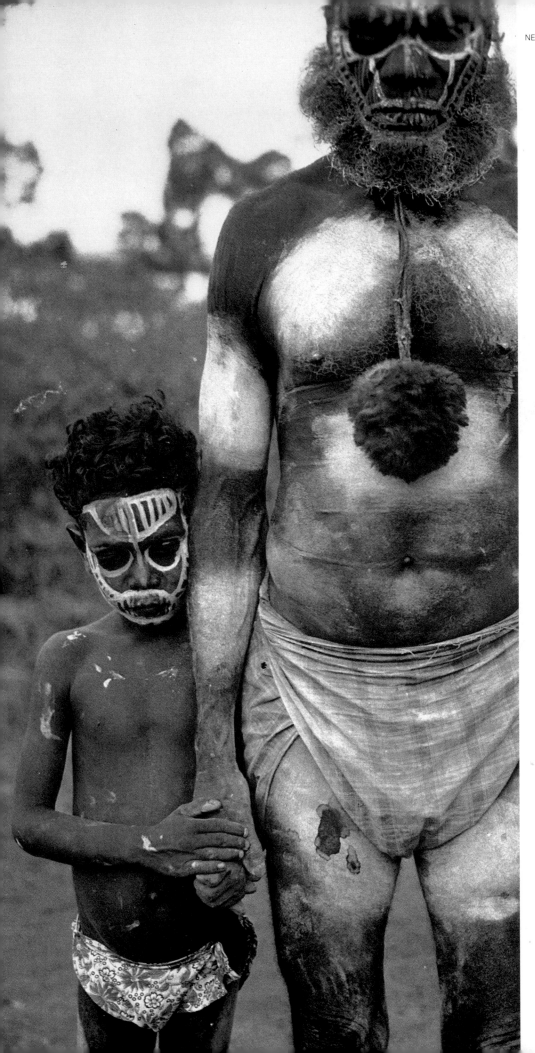

NEW GUINEA Sven Gillsätér/Tio

U.S.A. Mary Ellen Mark/Magnum

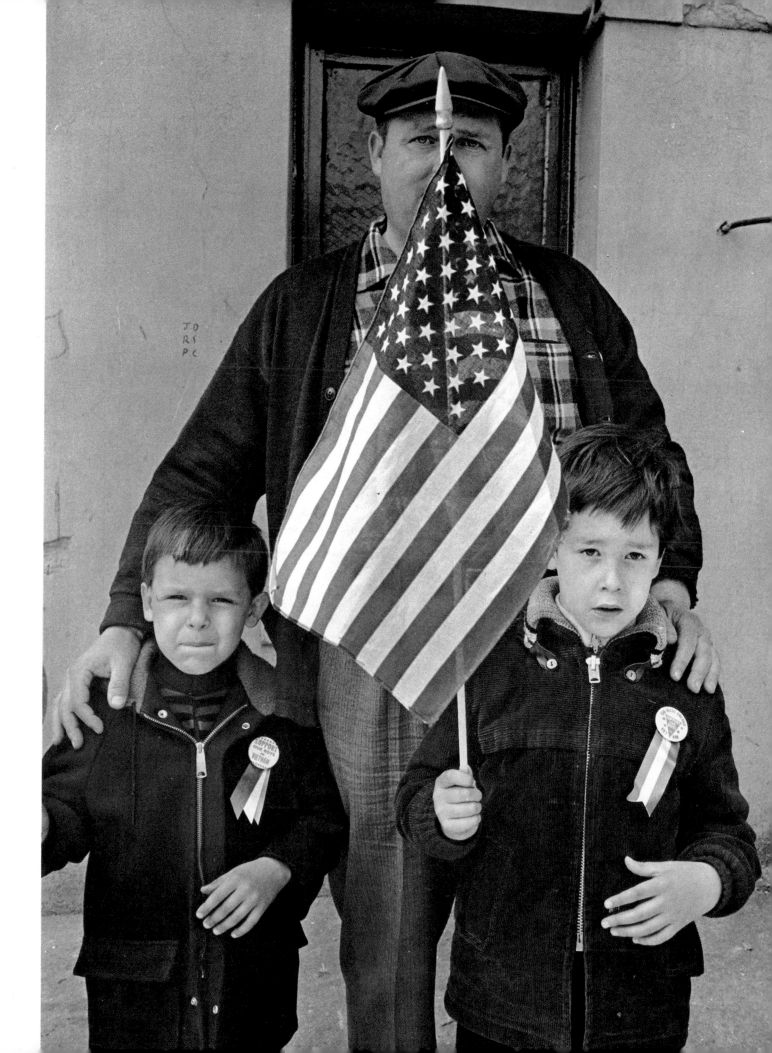

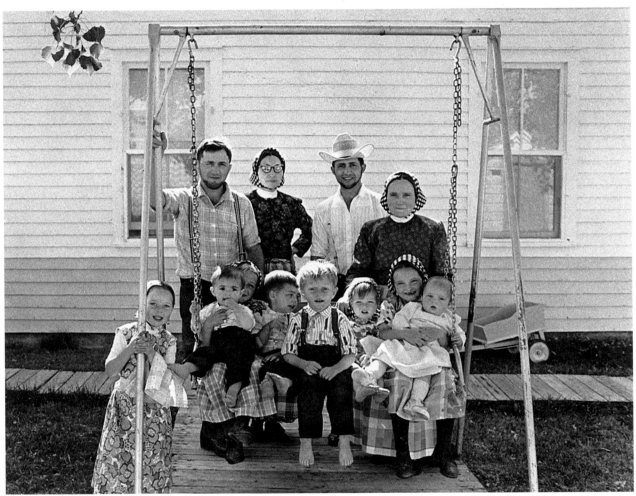

CANADA Mary Koga

When wives and children and their sires are one,
'Tis like the harp and lute in unison. Confucius

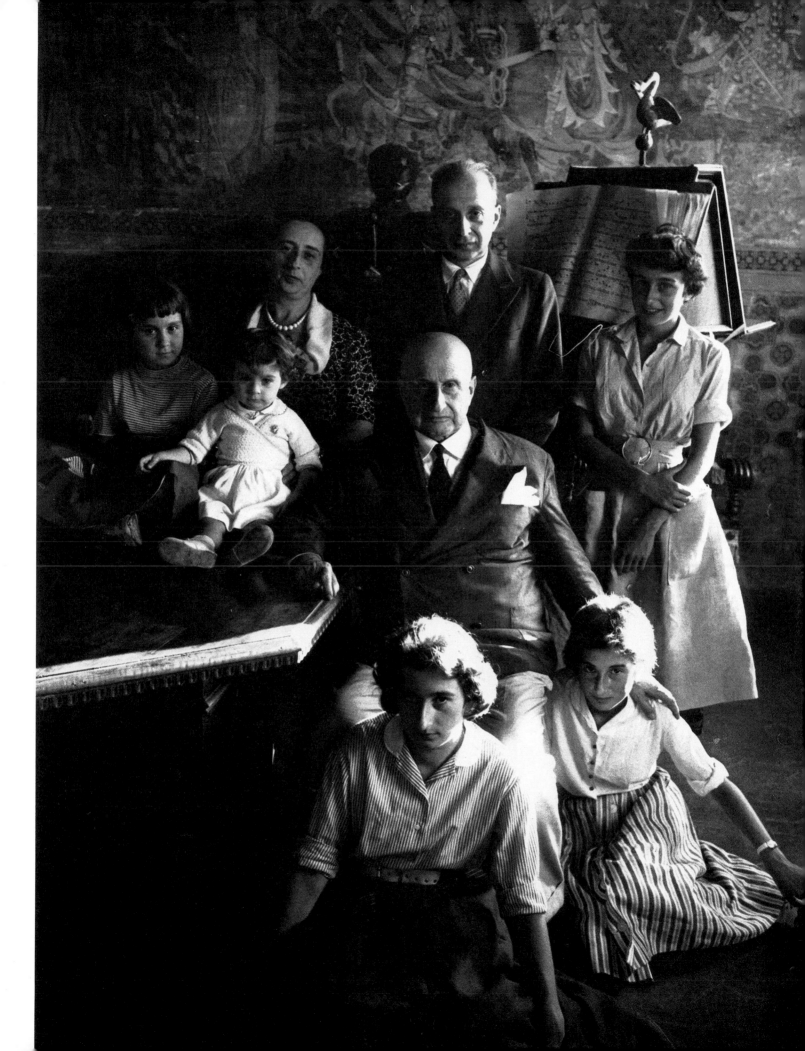

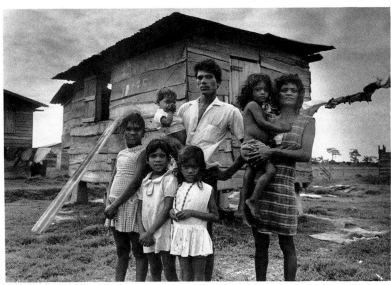

SURINAM Willem Diepraam/Viva

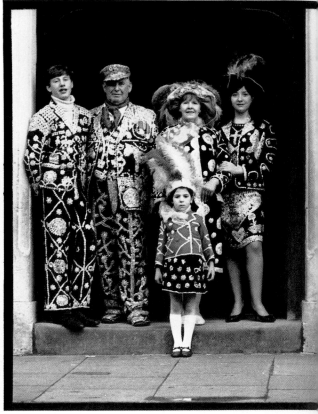

ENGLAND Patrick Ward

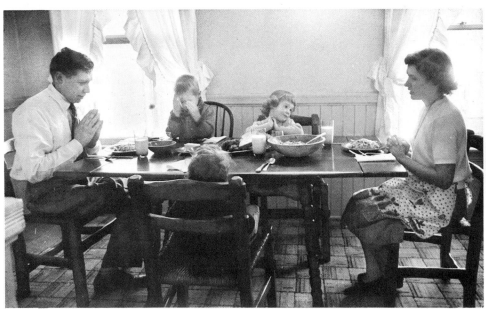

U.S.A. Bob Willoughby

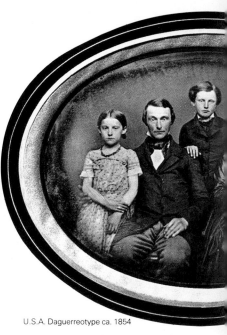

U.S.A. Daguerreotype ca. 1854

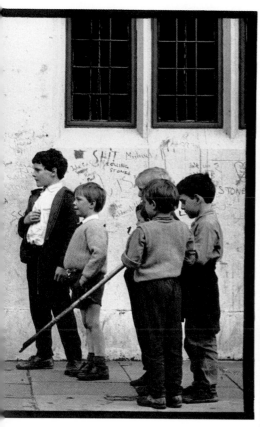

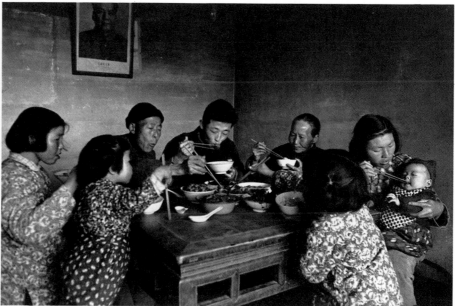

SHANGHAI Rene Burri/Magnum

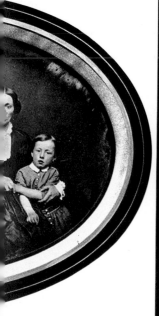

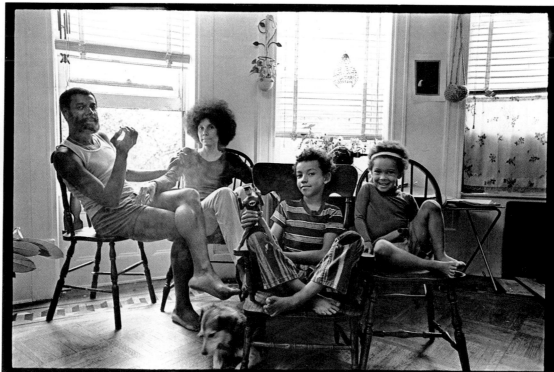

U.S.A. Will Faller

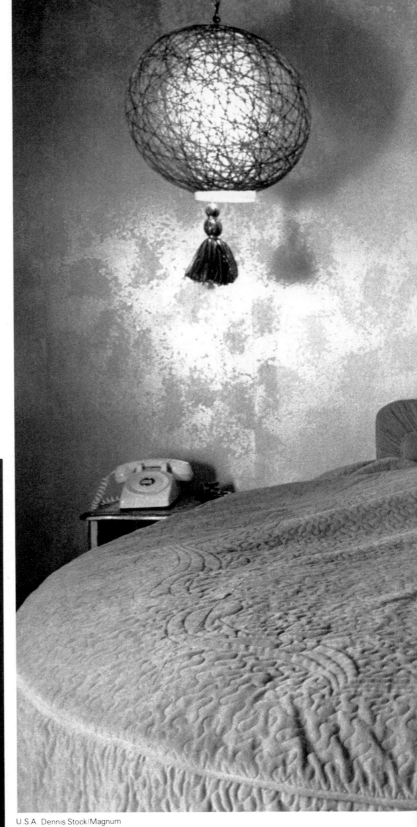

U.S.A. Dennis Stock/Magnum

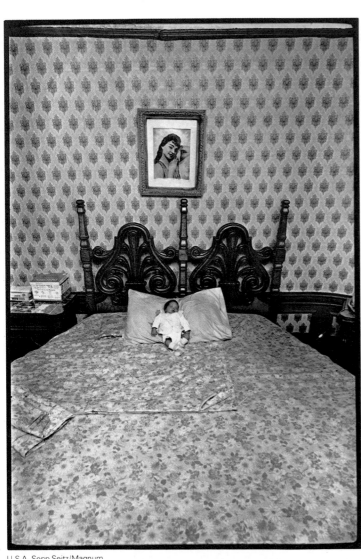

U.S.A. Sepp Seitz/Magnum

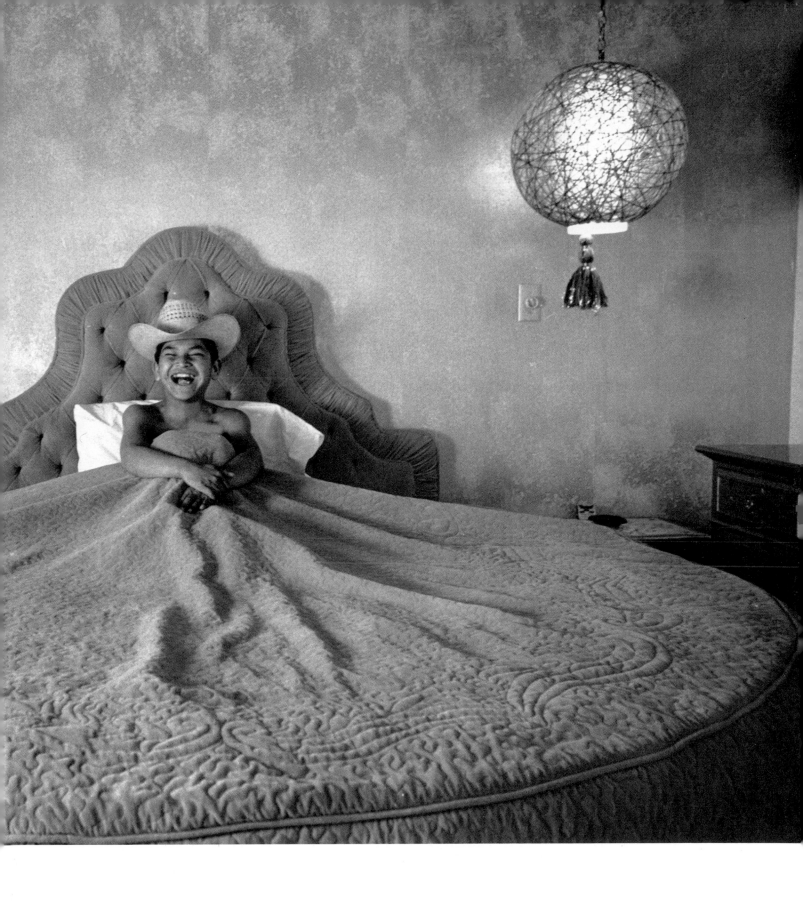

Come back again and wake me up at about half past May. Arnold Lobel

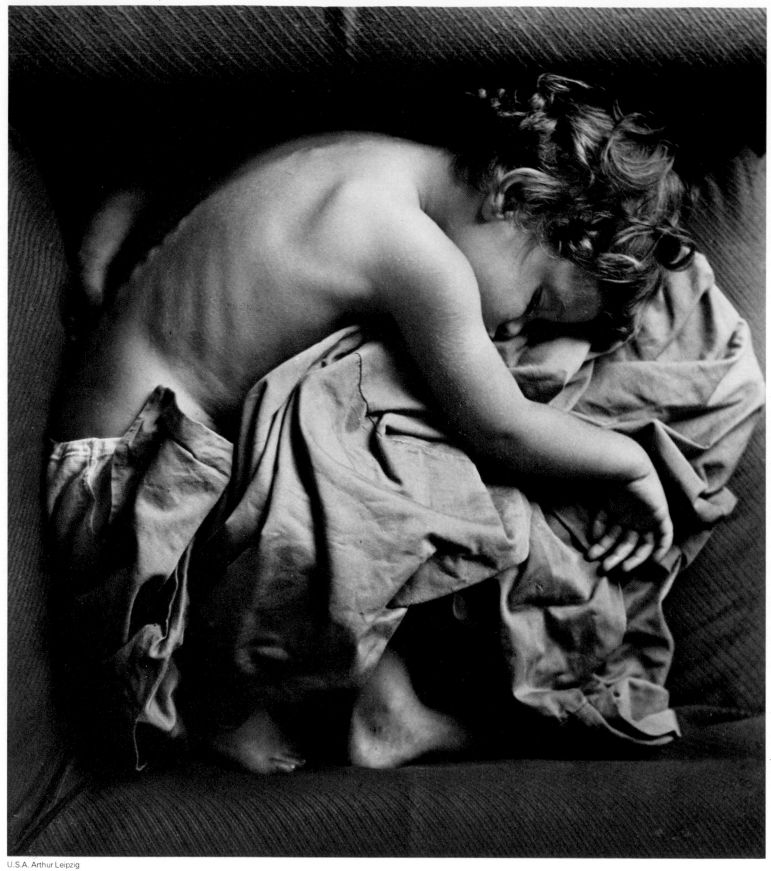

U.S.A. Arthur Leipzig

I said some words to the close and holy darkness, and then I slept. Dylan Thomas

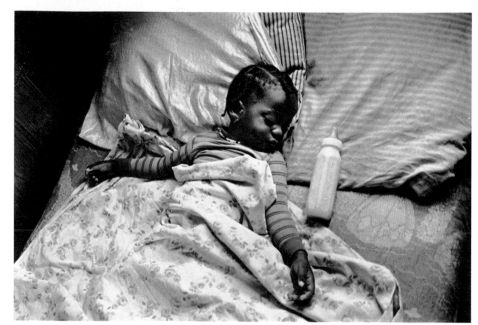

U.S.A. Norman Snyder

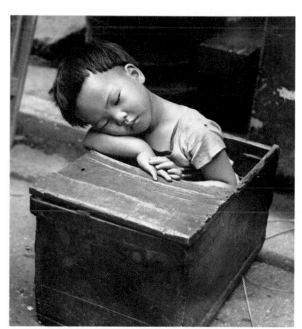

HONG KONG Dominique Darbois

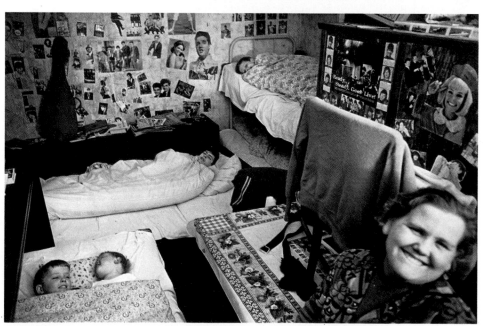

EAST GERMANY Thomas Höpker/Woodfin Camp

You have to ask children and birds how cherries and strawberries taste. Goethe

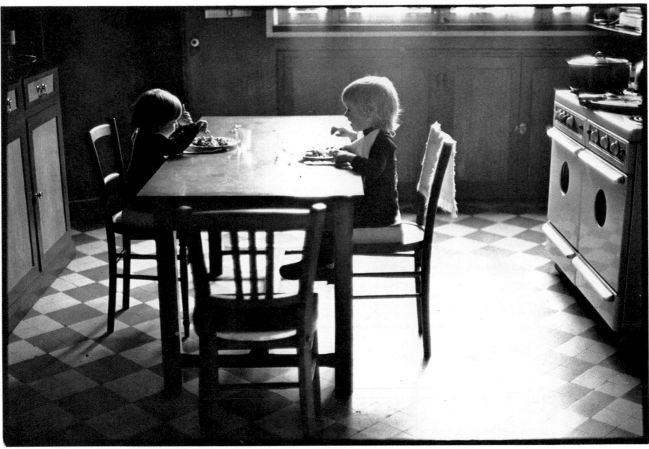

FRANCE Georges Tourdjman

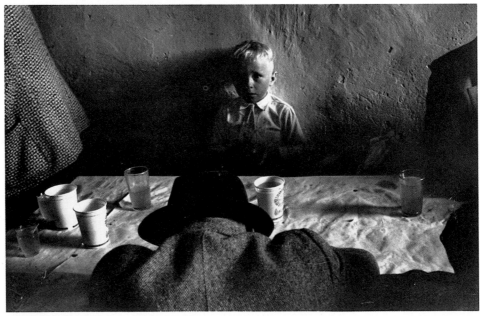

CZECHOSLOVAKIA Magnum

U.S.A. Nathan Farb

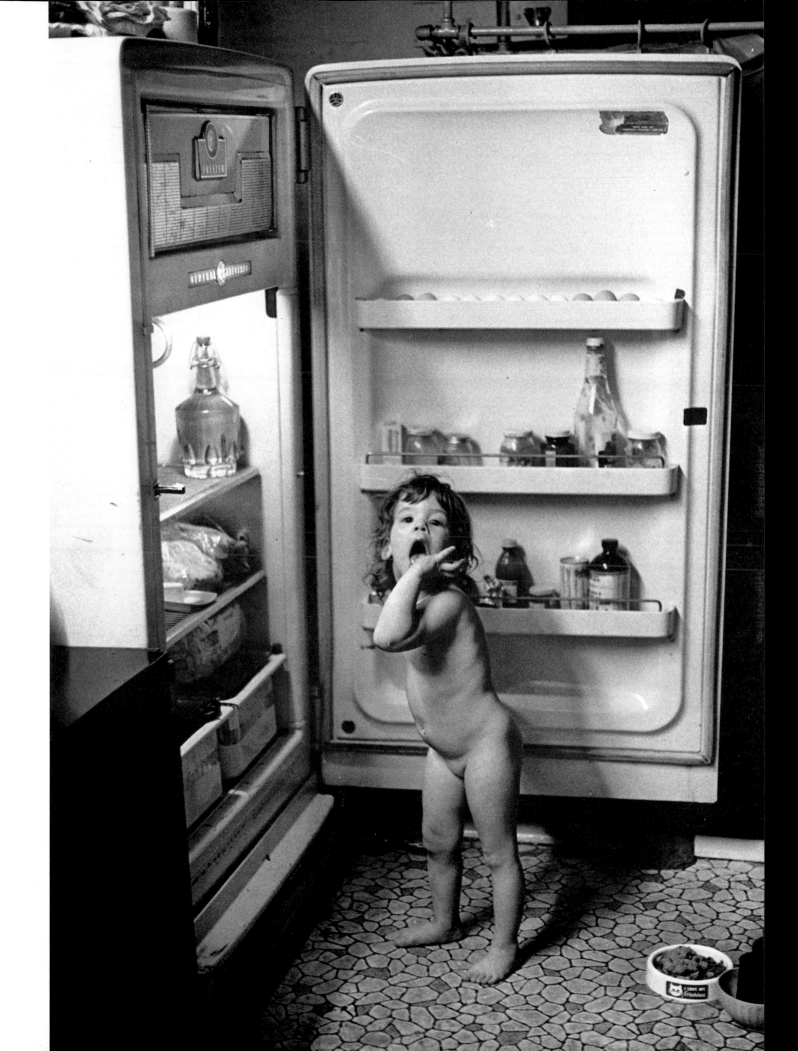

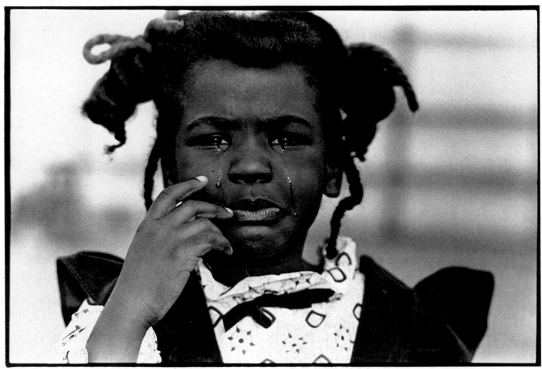

U.S.A. Gil Pruitt

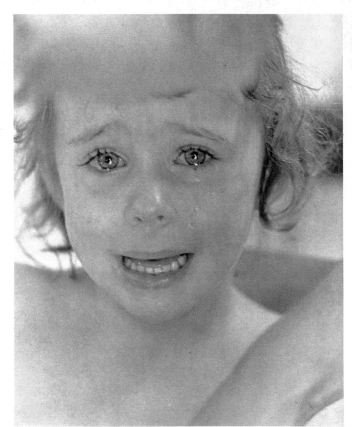

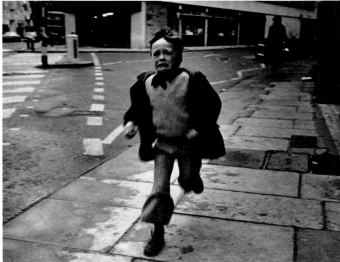

ENGLAND Barry Lewis

FRANCE Phelps/Rapho-Photo Researchers

44

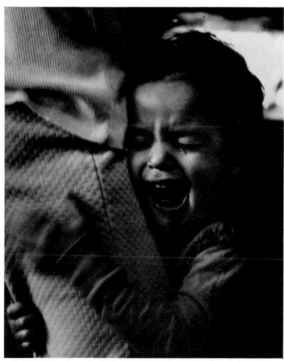

U.S.A. Marcia Fram

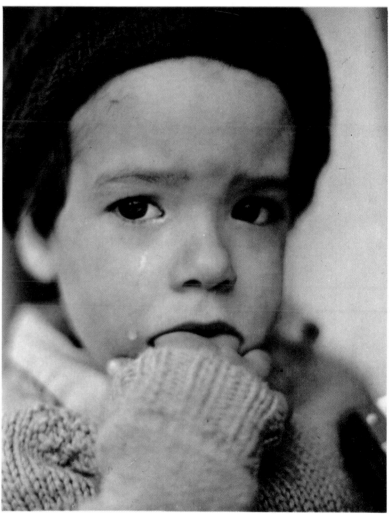

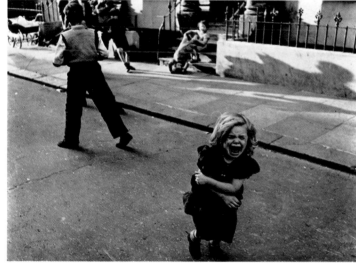

ENGLAND Roger Mayne

U.S.A. Albert Squillace

Child, why are you crying? Where have those smiles gone? Euripides

Trespass not on his solitude.
Ralph Waldo Emerson

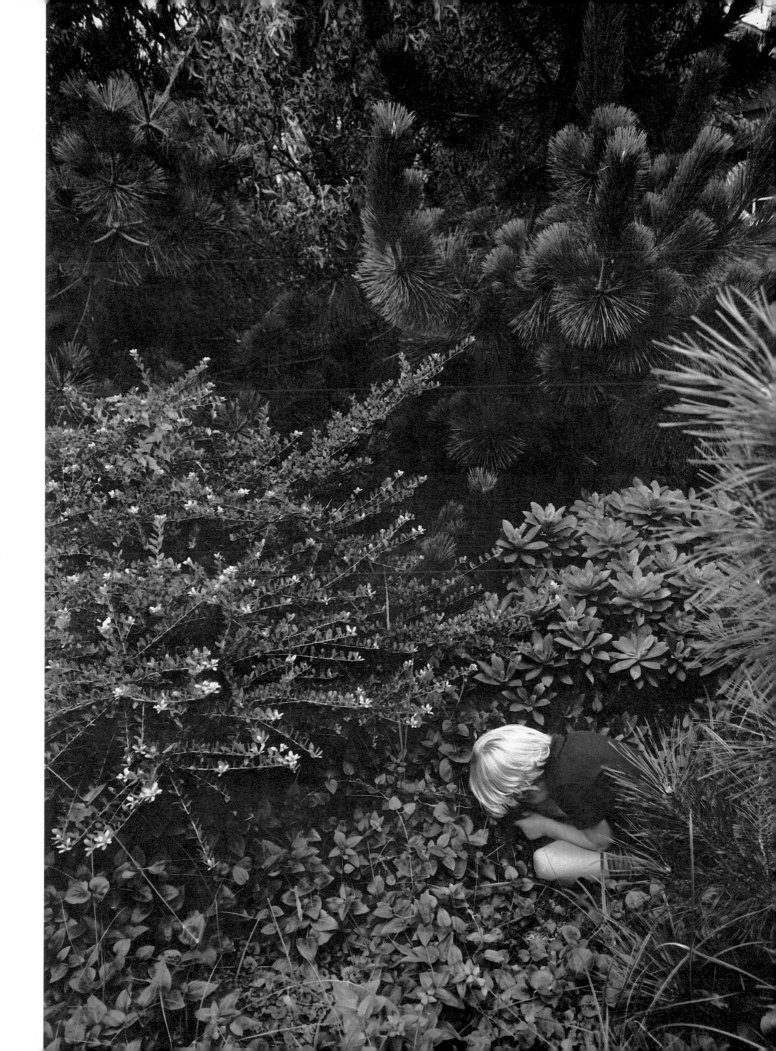

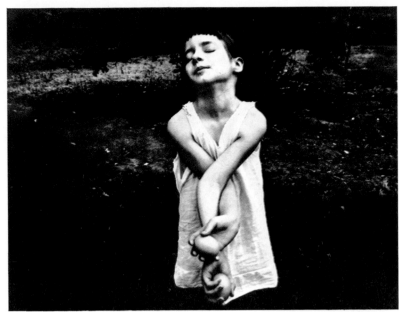

U.S.A. Emmet Gowin

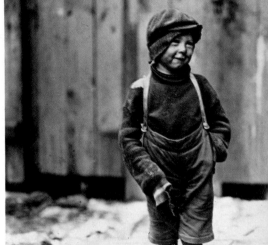

U.S.A. Lewis Hine (1910)

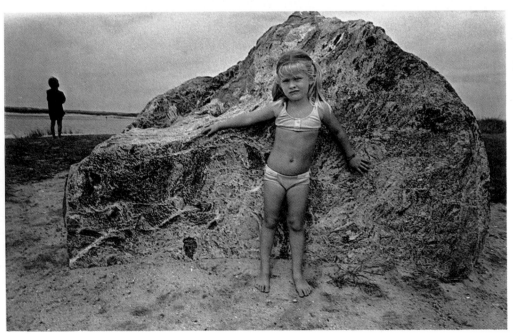

U.S.A. Harvey Stein

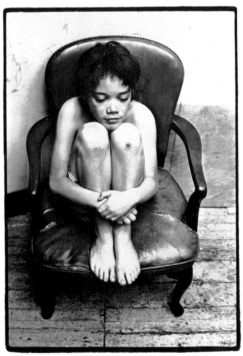

U.S.A. Mary Ellen Andrews

48

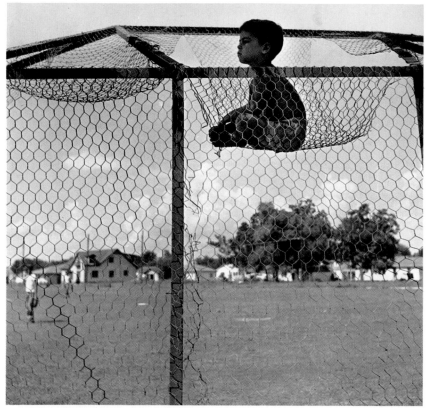

U.S.A. Arthur Leipzig

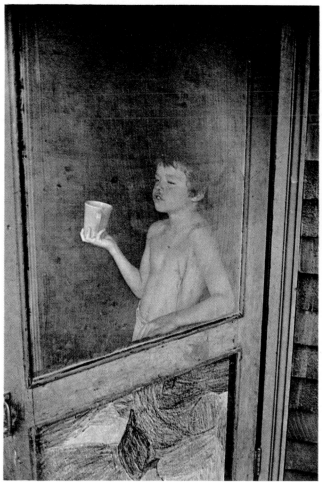

U.S.A. James H. Barker

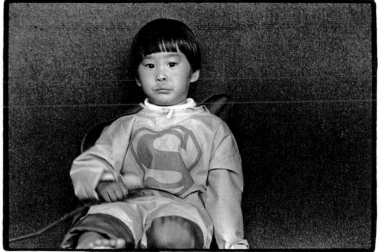

U.S.A. Mary Ellen Andrews

49

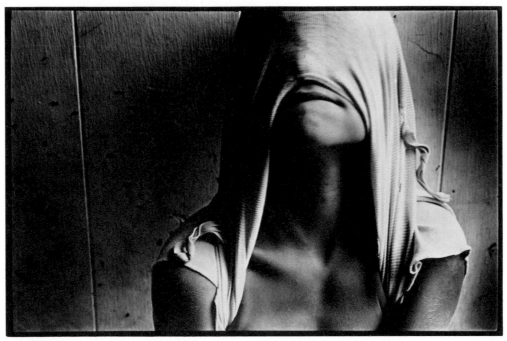

U.S.A. James Joern

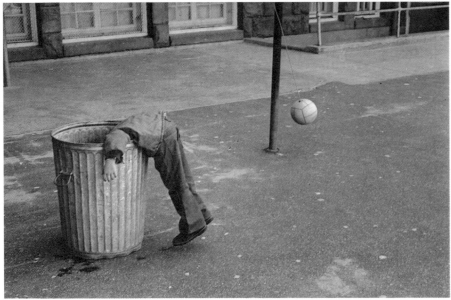

U.S.A. David R. White

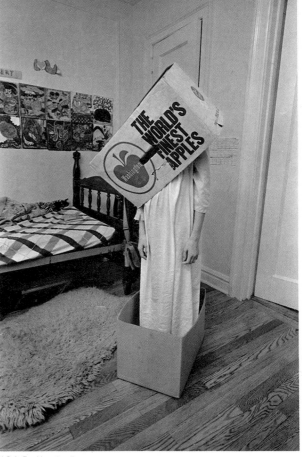

U.S.A. Fred Lombardi

There was a child went forth every day

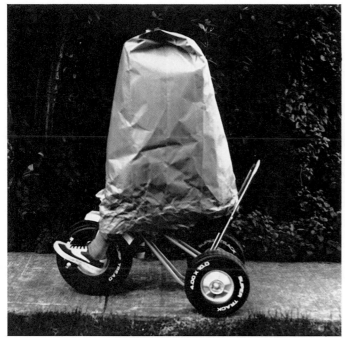

U.S.A. Joanne Leonard/Woodfin Camp

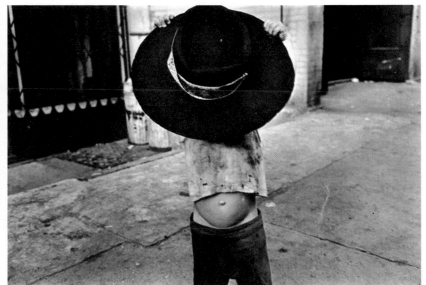

U.S.A. Alan Mercer

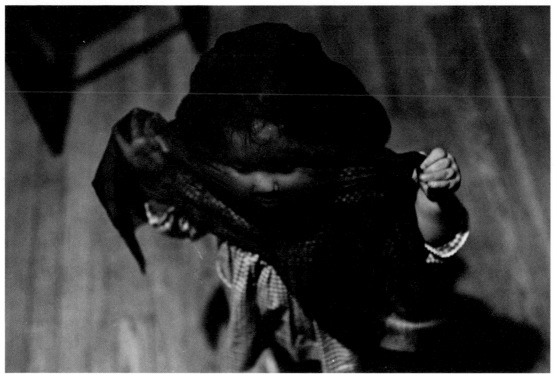

U.S.A. Norman Snyder

/And the first object he look'd upon, that object he became Walt Whitman

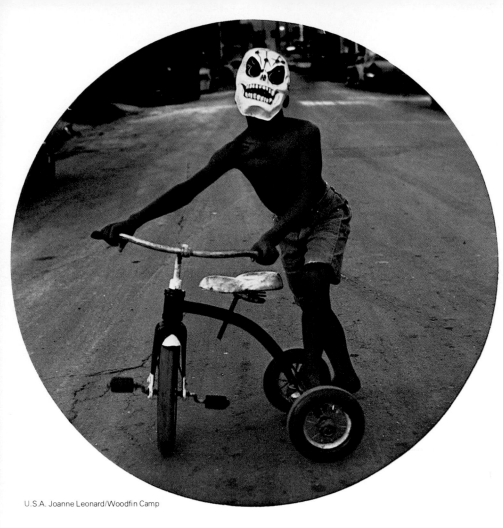

U.S.A. Joanne Leonard/Woodfin Camp

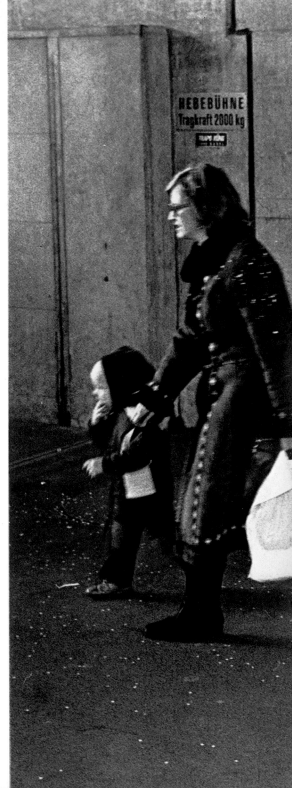

SWITZERLAND V. Dukat/Magnum

52

Only the magic and the dream are true Jean Rhys

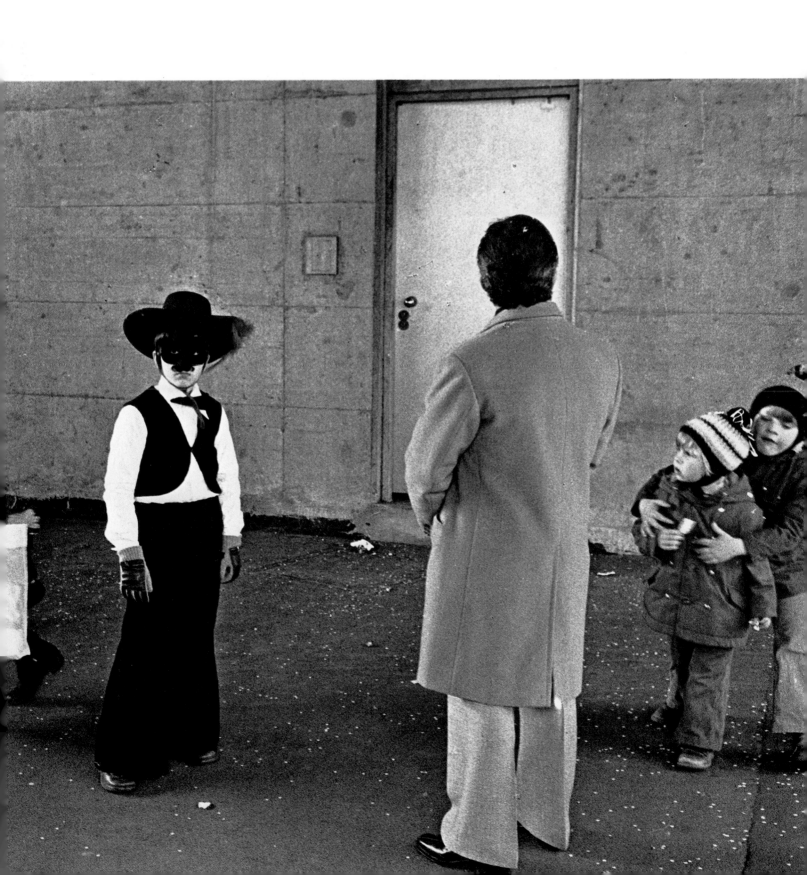

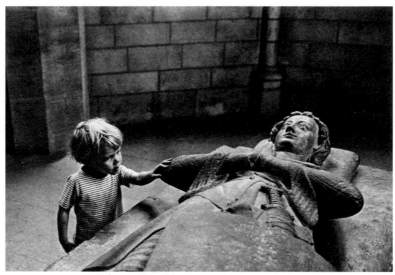

U.S.A. Dena

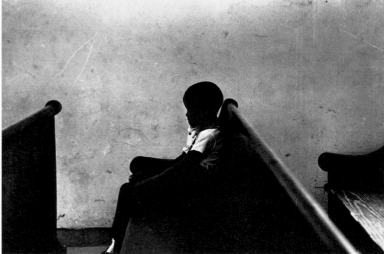

U.S.A. George Krause

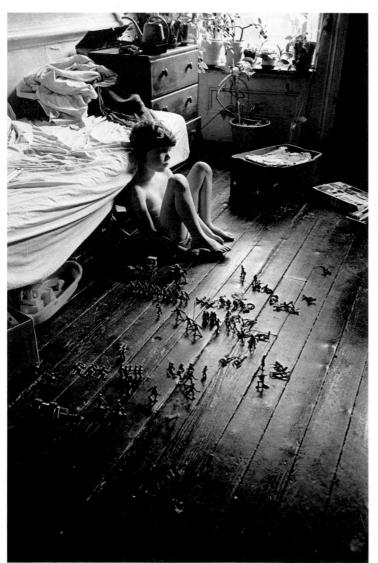

U.S.A. Will Faller

NEW ORLEANS Arthur Tress/Woodfin Camp

I mean that the bells that the children could hear were inside them. Dylan Thomas

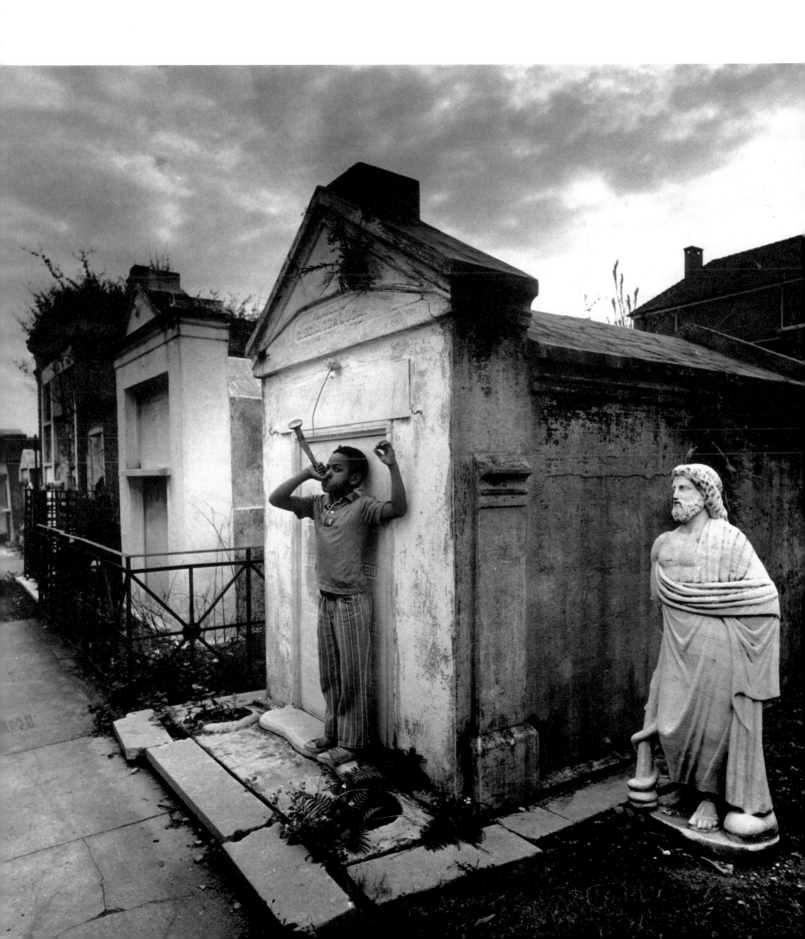

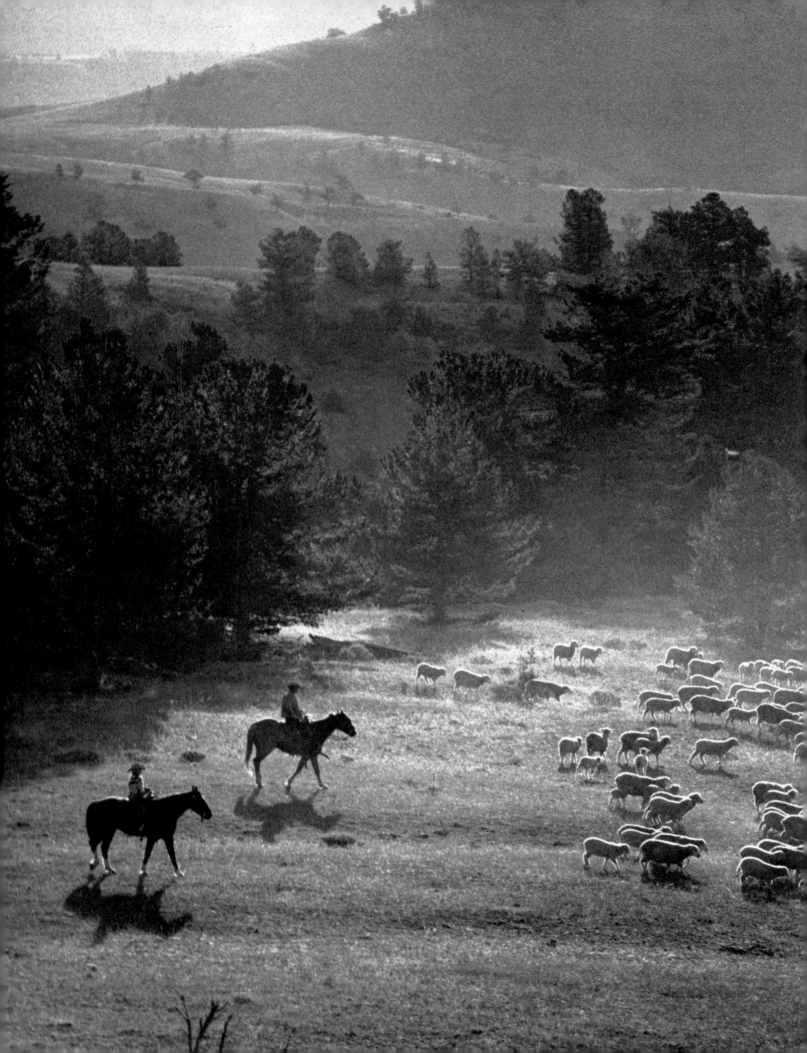

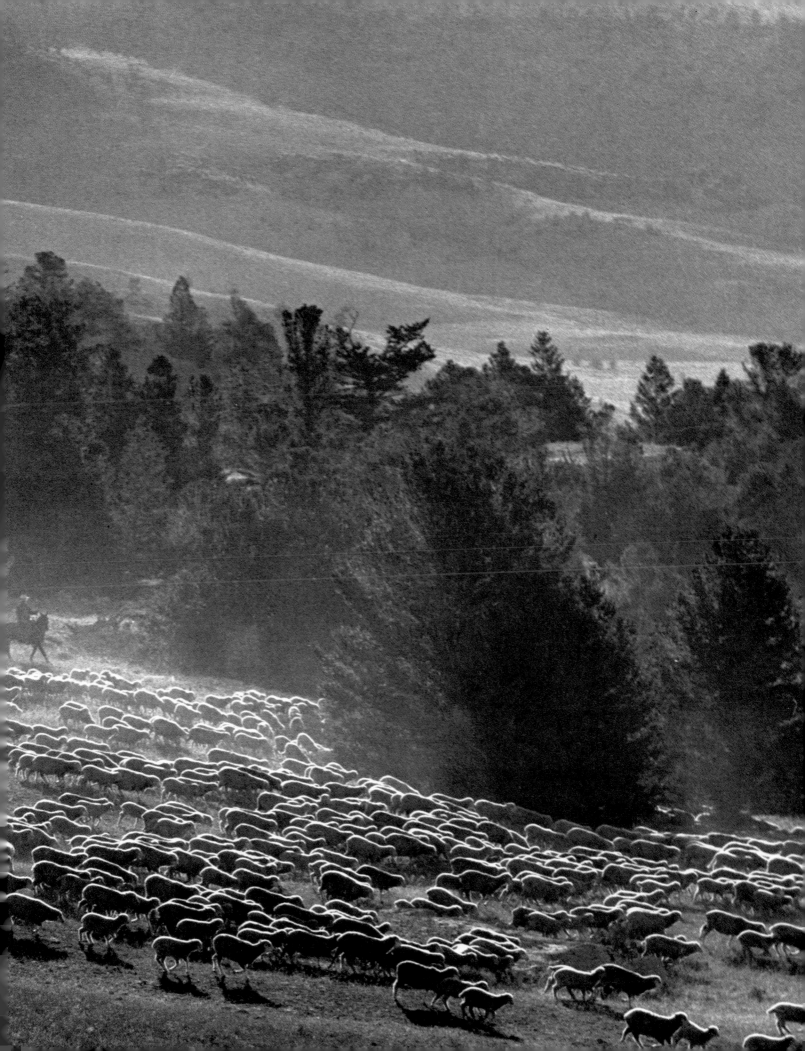

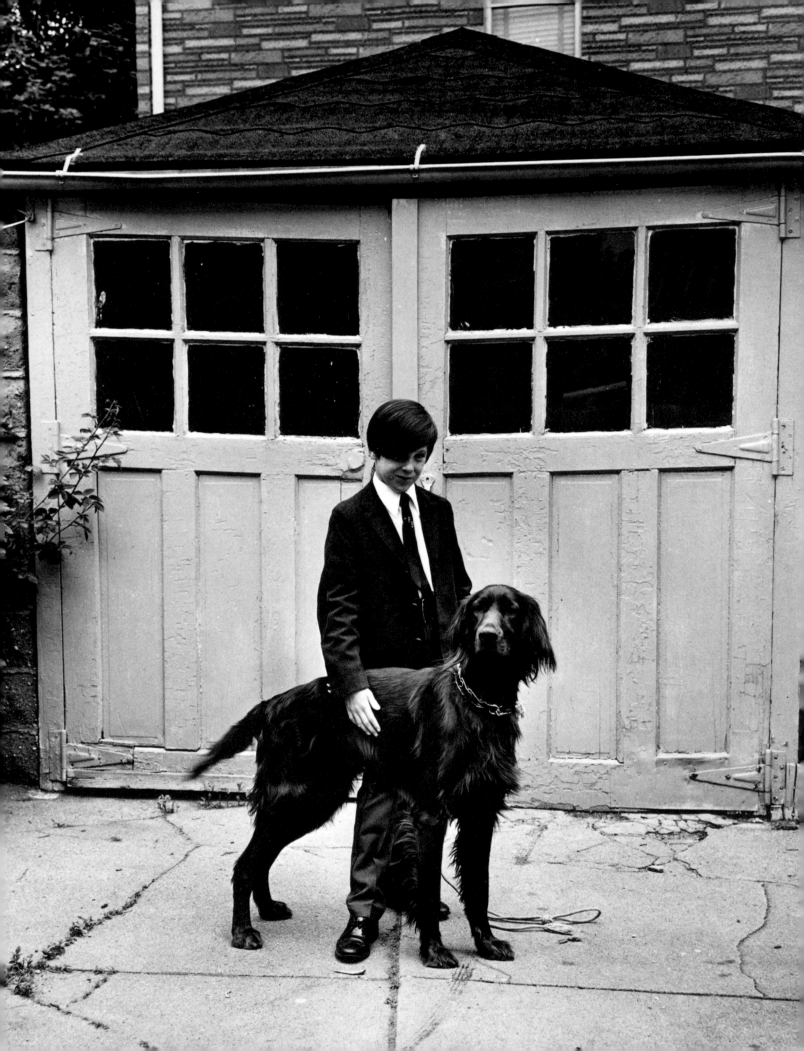

But ask now the beasts, and they shall teach thee;
and the fowls of the air, and they shall tell thee. Job 12:7

U.S.A. Wayne Miller/Magnum

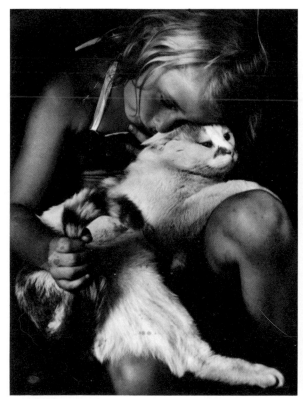

U.S.A. Dena

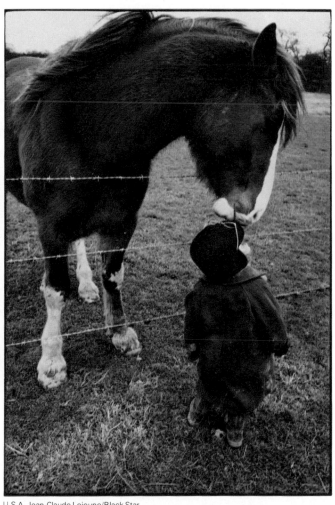

U.S.A. Jean-Claude Lejeune/Black Star

Preceding pages: WYOMING Burk Uzzle/Magnum

U.S.A. Norman Snyder

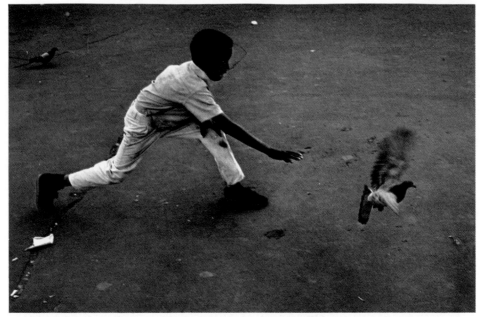

U.S.A. Ken Firestone

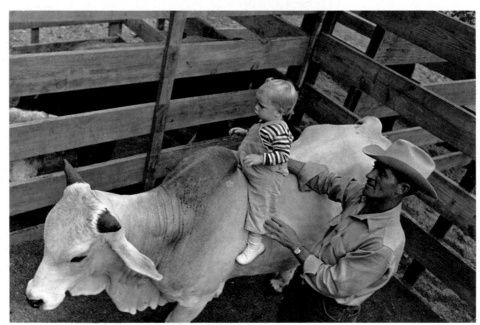

U.S.A. Guy Gillette

SICILY Bruce Davidson/Magnum

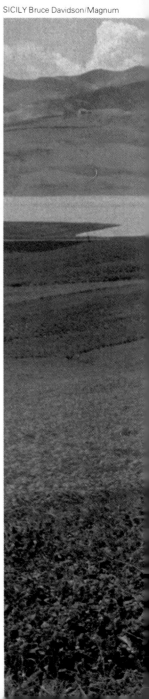

U.S.A. Bill Binzen

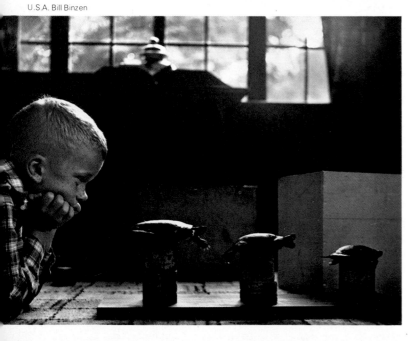

Several of nature's people
I know, and they know me;
I feel for them a transport
Of cordiality Emily Dickinson

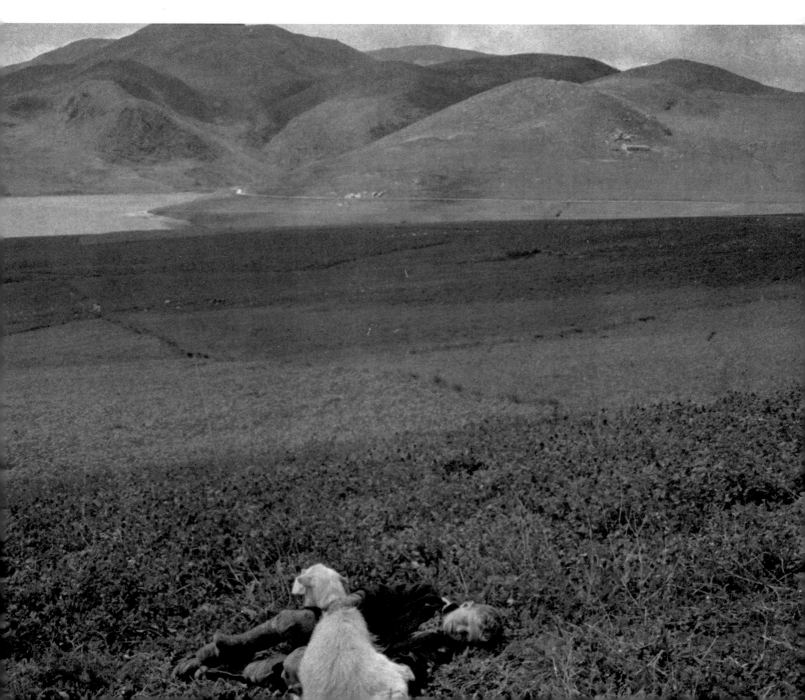

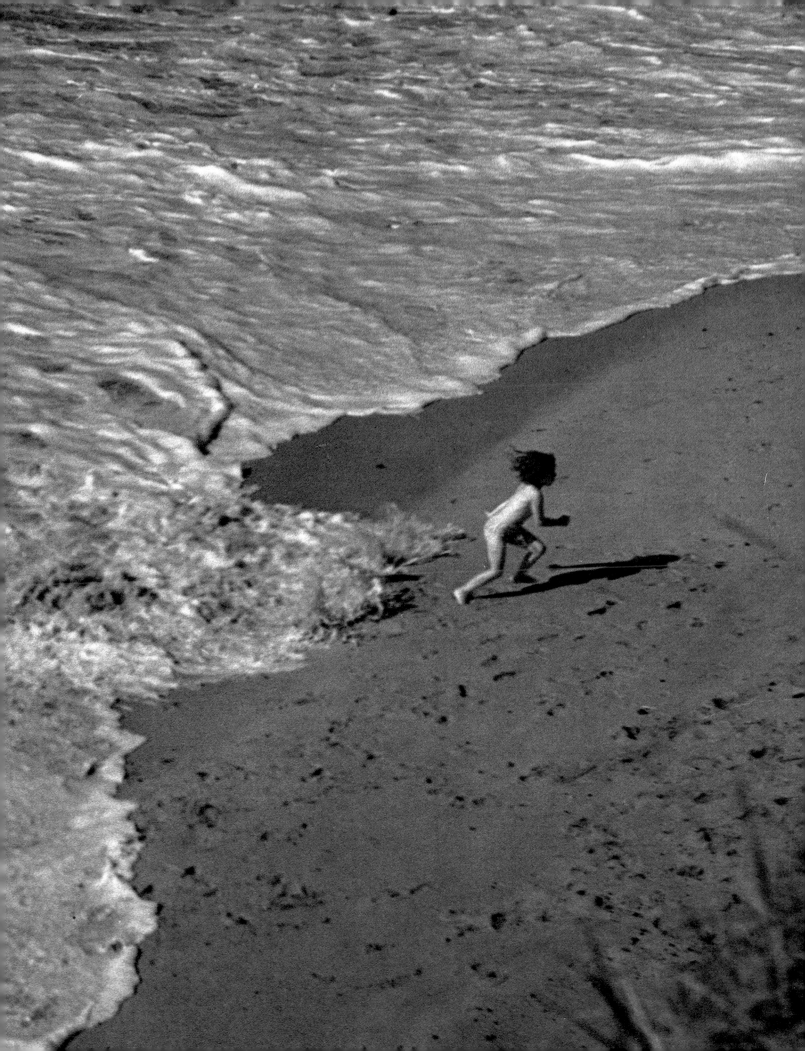

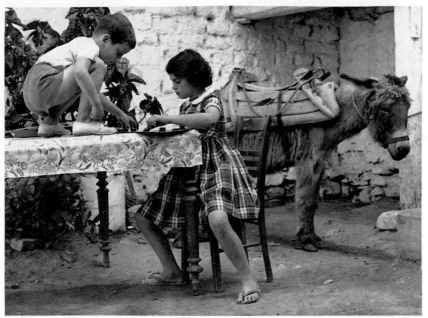

GREECE Constantine Manos/Magnum

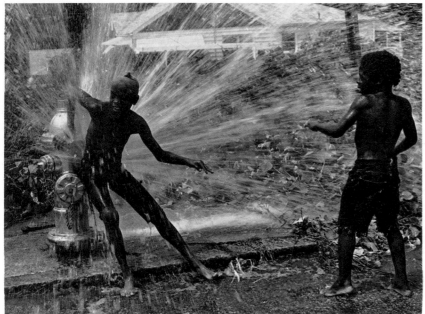

U.S.A. Ted Kallman

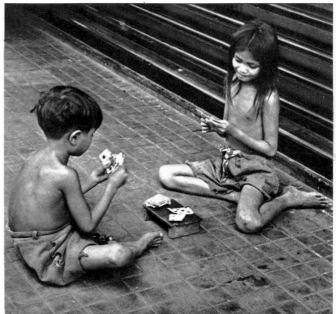

SAIGON Paul Almasy

Feel the dignity of a child. Do not feel superior to him, for you are not. Robert Henri

Preceding pages: FRANCE J. H. Lartigue (1917)

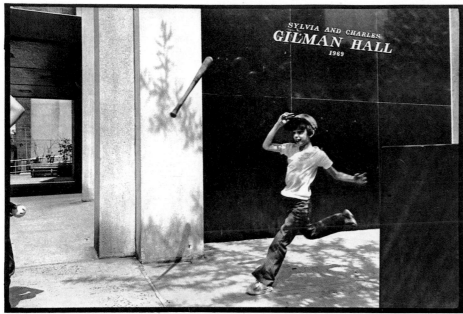

U.S.A. Bernard Pierre Wolf

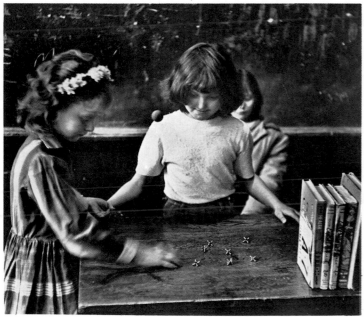

U.S.A. Jack Corn/Image Inc.

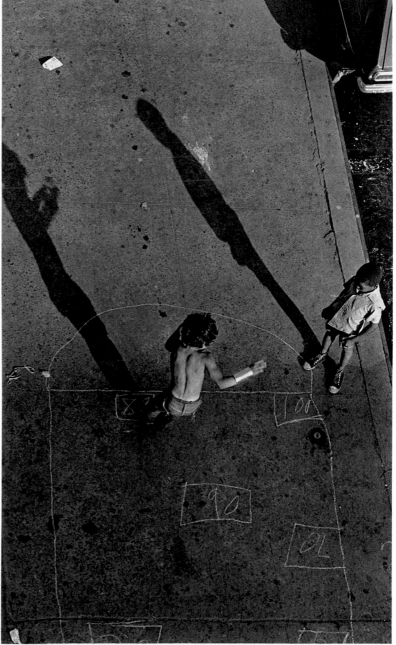

U.S.A. Kathleen Foster

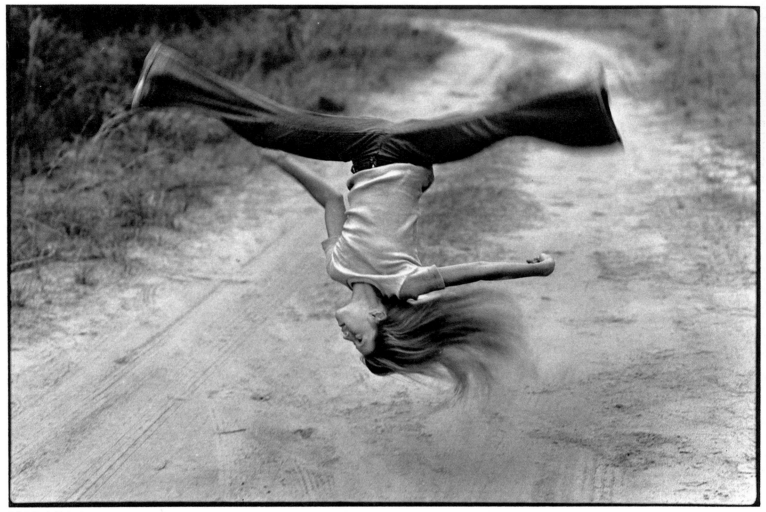

I merely leap and pause. Vaslav Nijinsky

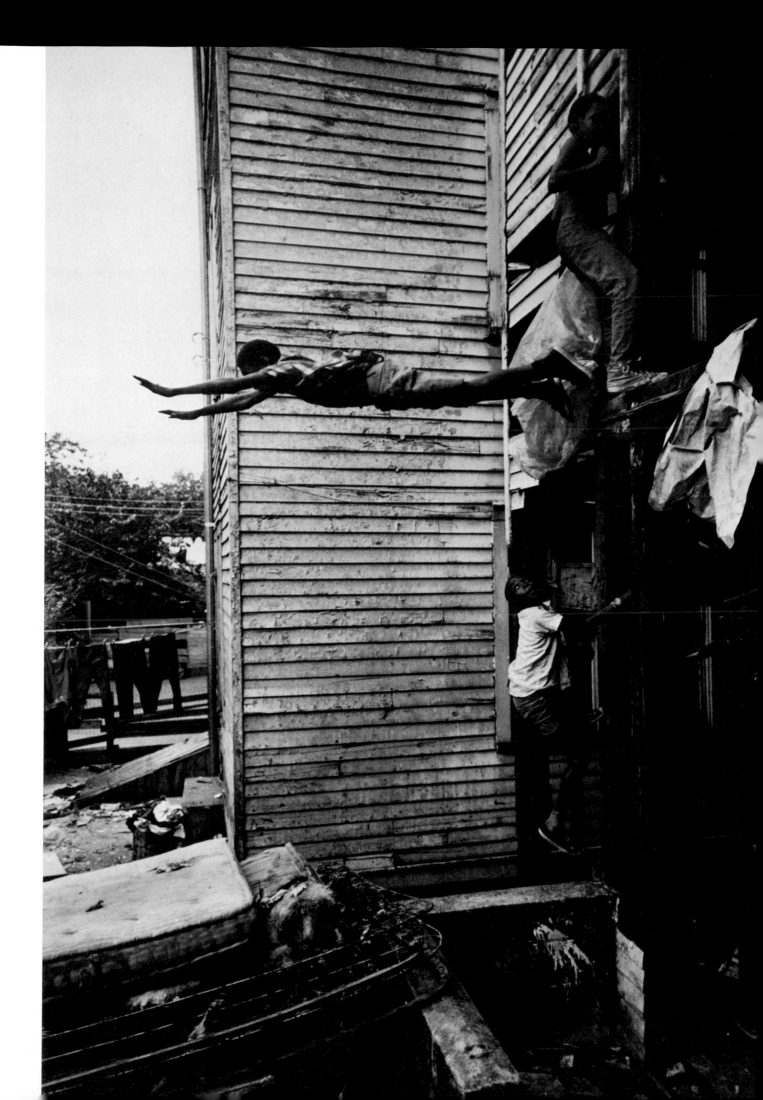

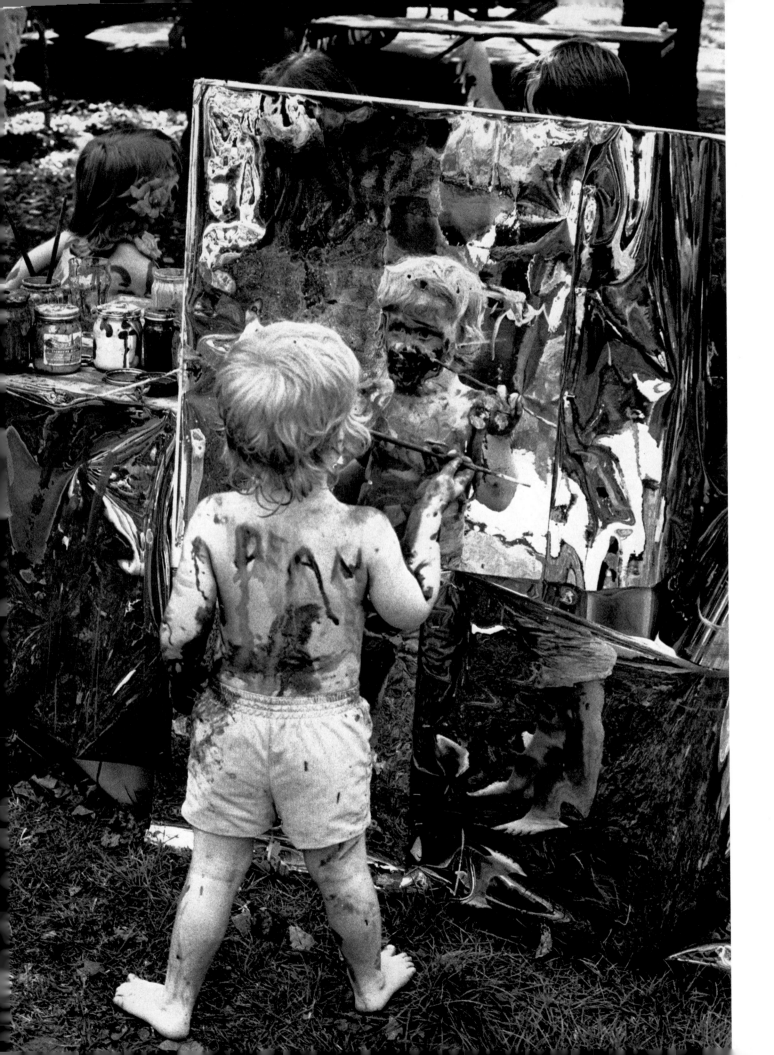

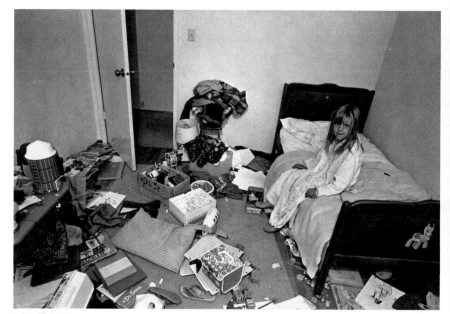

U.S.A. Bill Owens

U.S.A. Mark Haven

U.S.A. Harvey Stein

NEW MEXICO Danny Lyon/Magnum

U.S.A. Suzanne Szasz

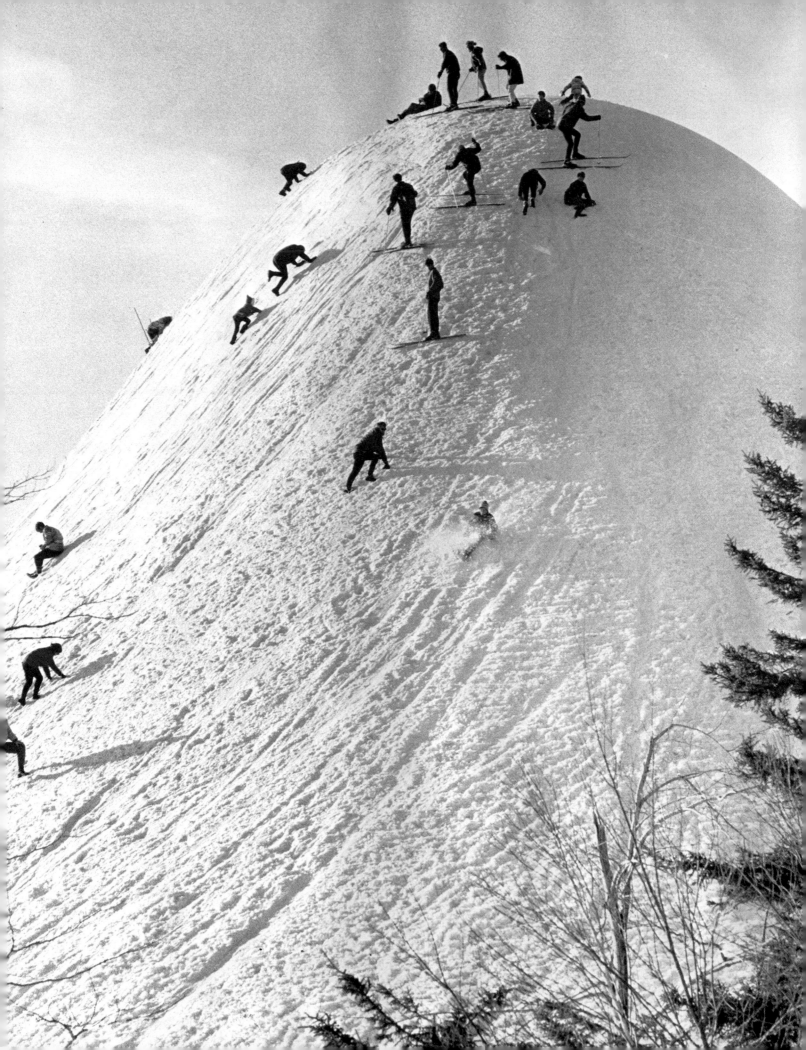

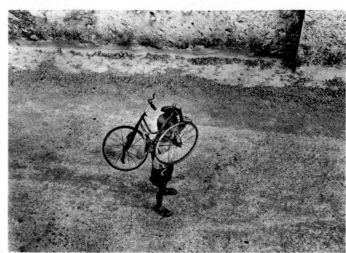

MAJORCA Dena

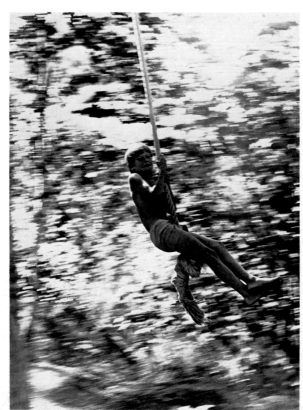

SWEDEN Tore Johnson/Tio

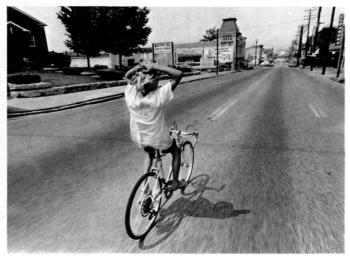

U.S.A. Bryan Moss

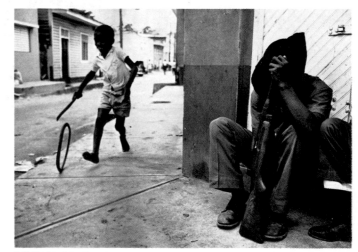

DOMINICAN REPUBLIC Thomas Höpker/Woodfin Camp

...and striding
High there, how he rung upon the rein of a wimpling wing
In his ecstasy! then off, off forth on swing... Gerard Manley Hopkins

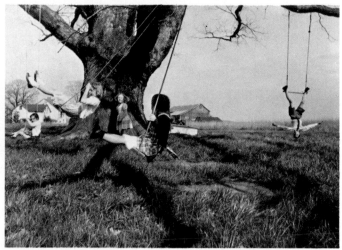
U.S.A. Frances McLoughlin-Gill

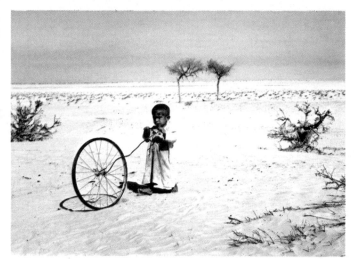
UNITED ARAB EMIRATES Mathias Oppersdorff

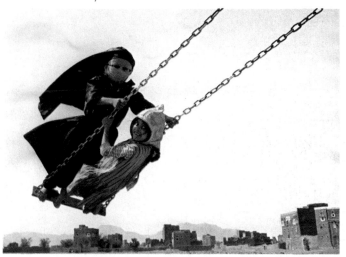
YEMEN Michael Hardy/The John Hillelson Agency

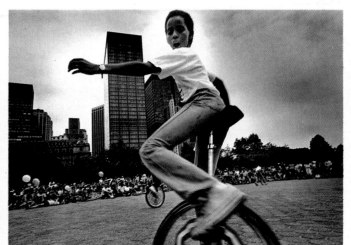
U.S.A. James Joern

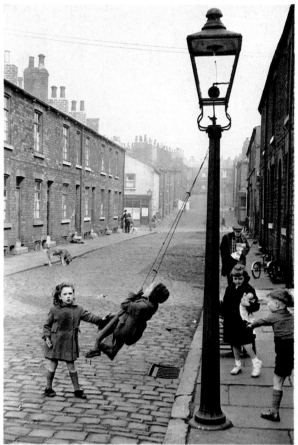
ENGLAND Marc Riboud/Magnum

73

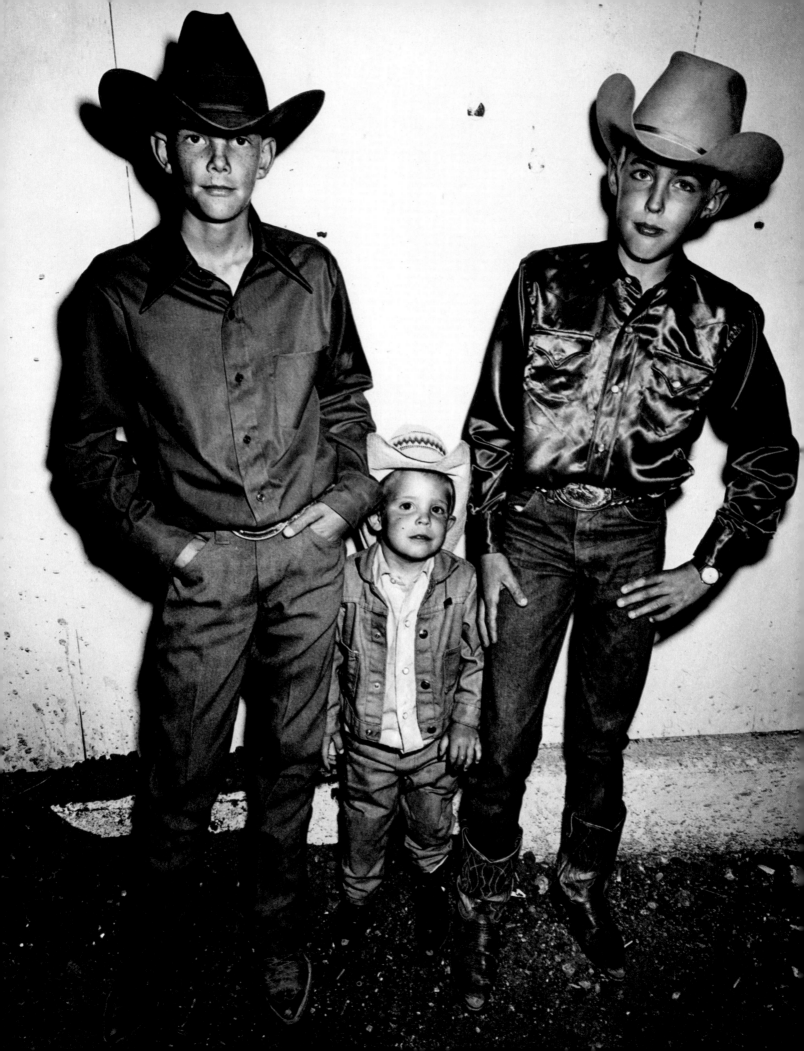

A brother is a friend given by nature. Gabriel Marie Jean Baptiste Legouvé

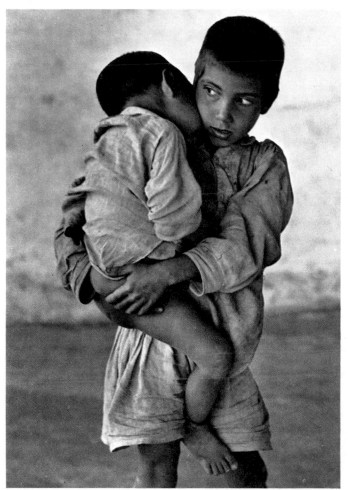

INDIA Rune Hassner/Tio

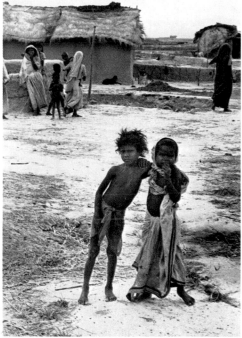

INDIA Thomas Höpker/Woodfin Camp

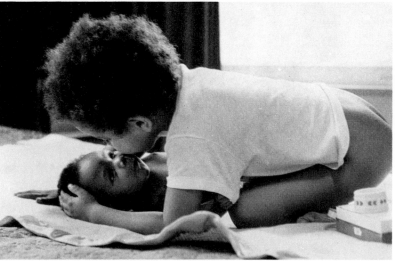

U.S.A. Suzanne Szasz

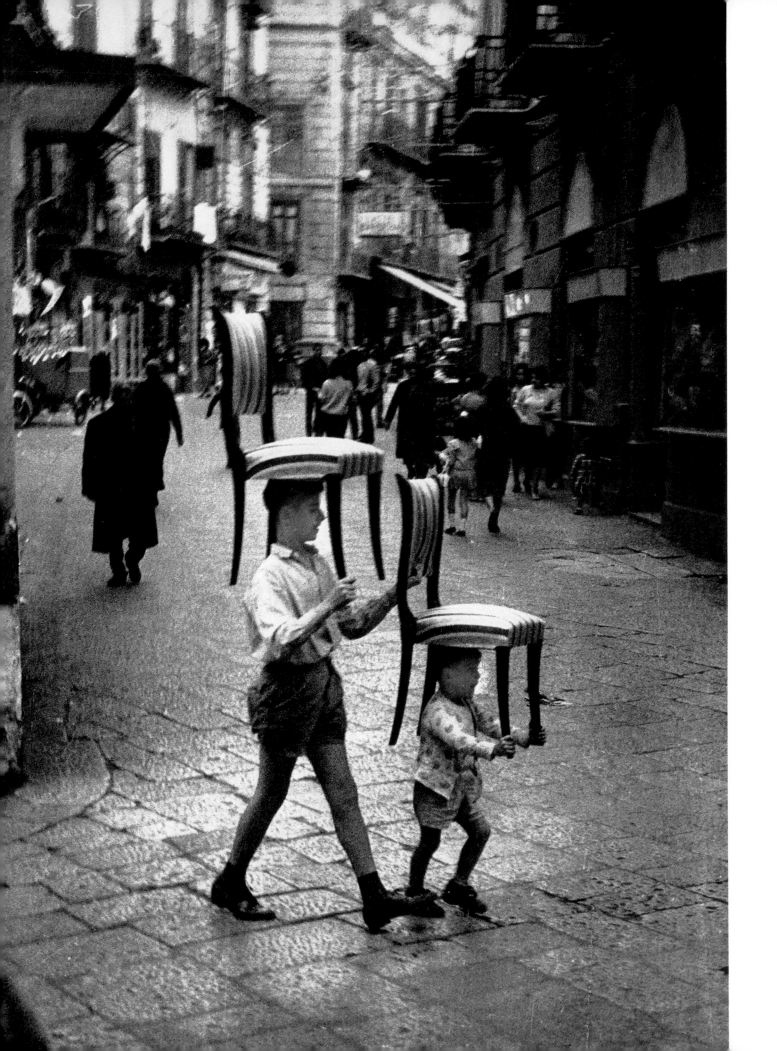

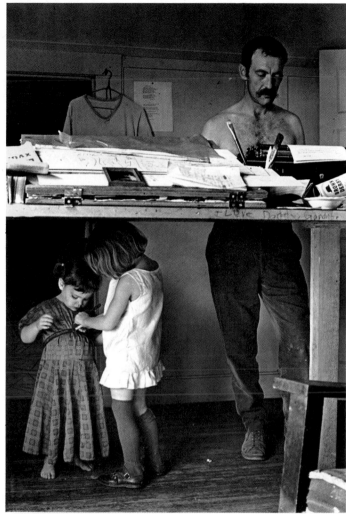

ALASKA James H. Barker

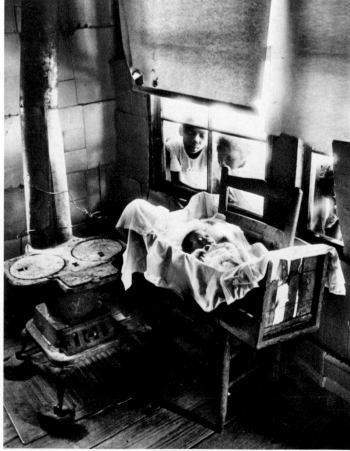

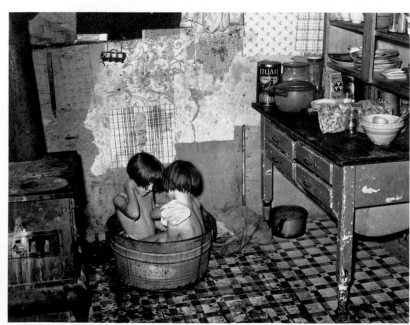

U.S.A. Russell Lee/Library of Congress (1939)

U.S.A. W. Eugene Smith

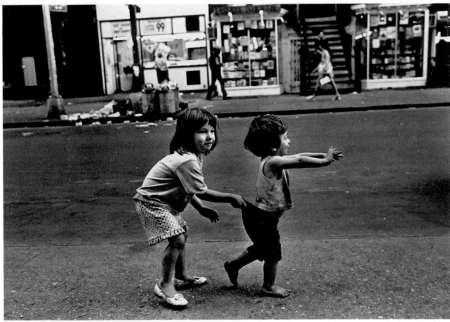

U.S.A. Alan Mercer

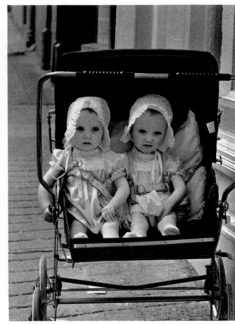

U.S.A. Joe Greene

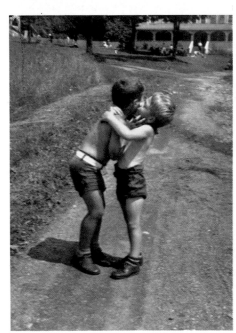

U.S.A. Ceil Peltzman

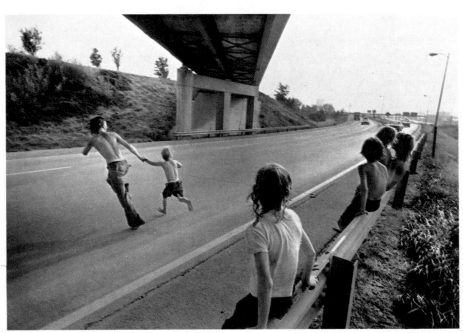

U.S.A. Bryan Moss

BANGLADESH J. P. Laffont/Sygma

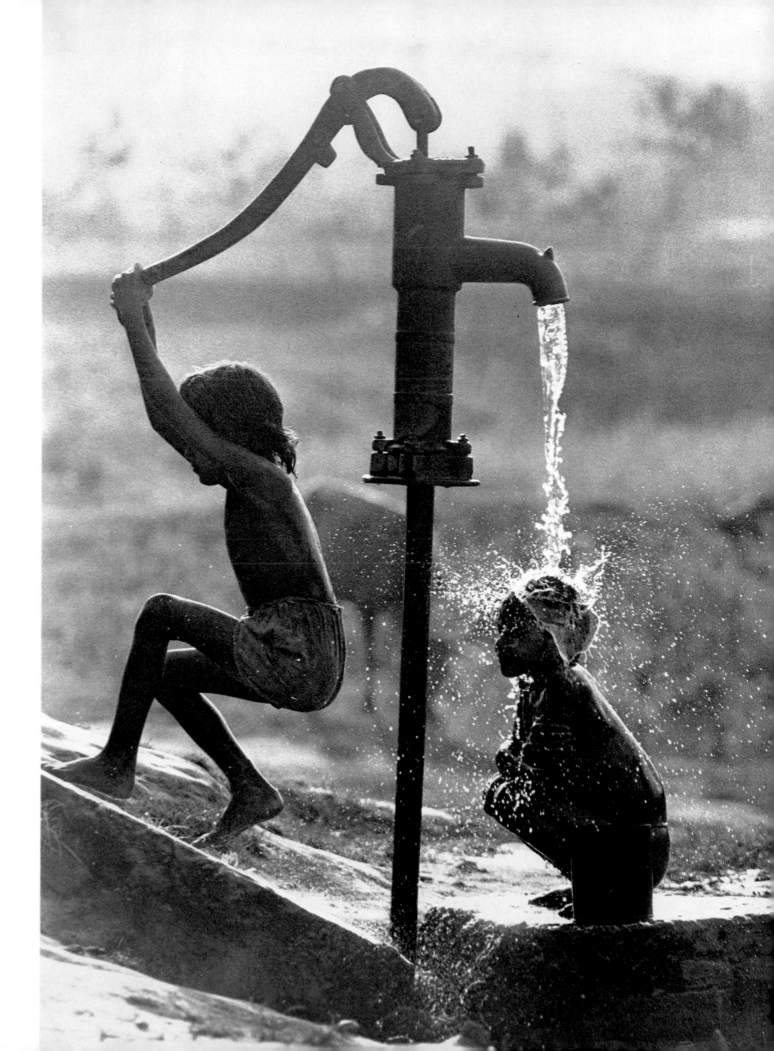

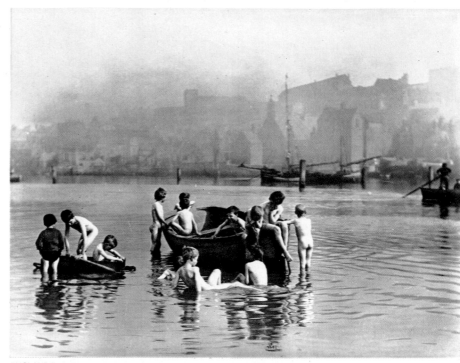
ENGLAND Frank Meadow Sutcliffe (1886)

SWEDEN Monika Englund-Johansson

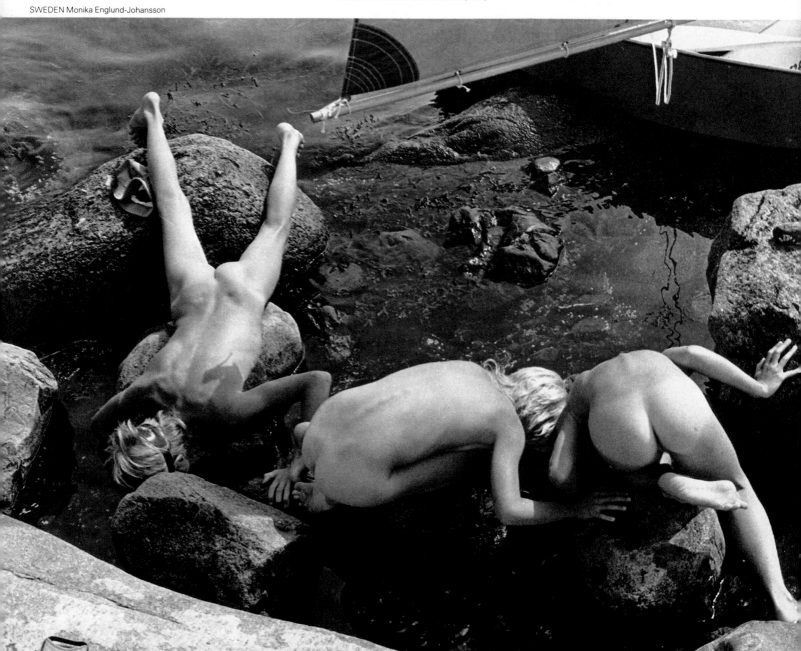

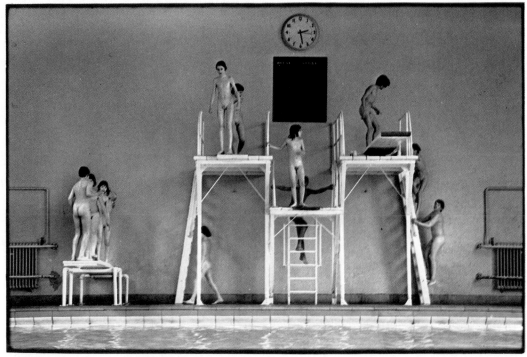

ENGLAND Chris Steele-Perkins/Viva

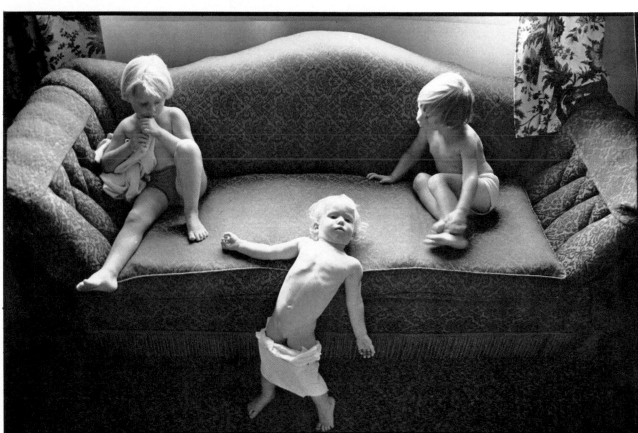

U.S.A. Richard Albertine

In my new clothing
I feel so different
I must
Look like someone else. Basho

FRANCE Marc Riboud/Magnum

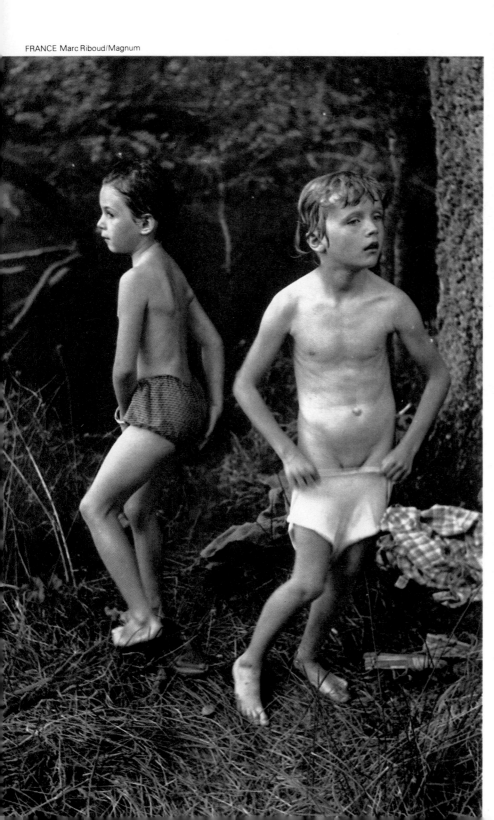

SWEDEN Nils-Johan Norenlind/Tio

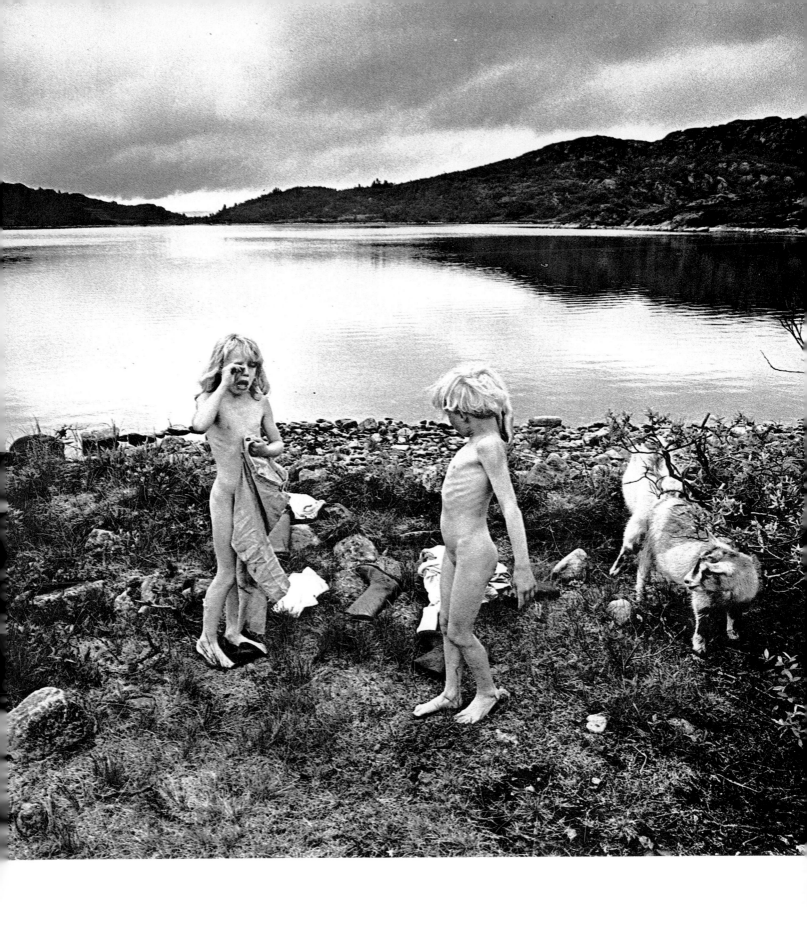

I will praise thee; for I am fearfully and wonderfully made. Psalms 139:14

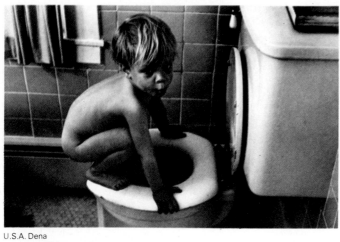

U.S.A. Dena

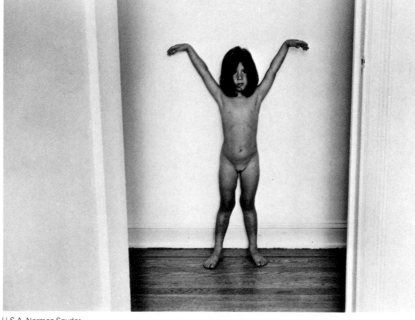

U.S.A. Terry Evans

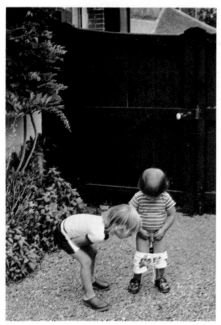

FRANCE Georges Tourdjman

U.S.A. Norman Snyder

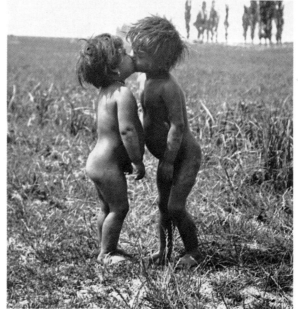

HUNGARY André Kertész (1917)

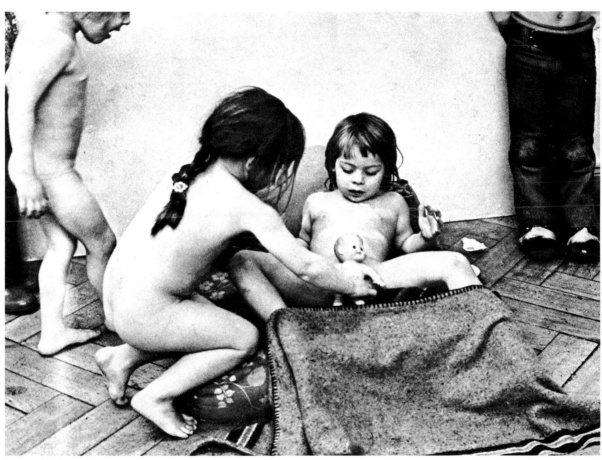

WEST GERMANY Jean-Gil Bonne

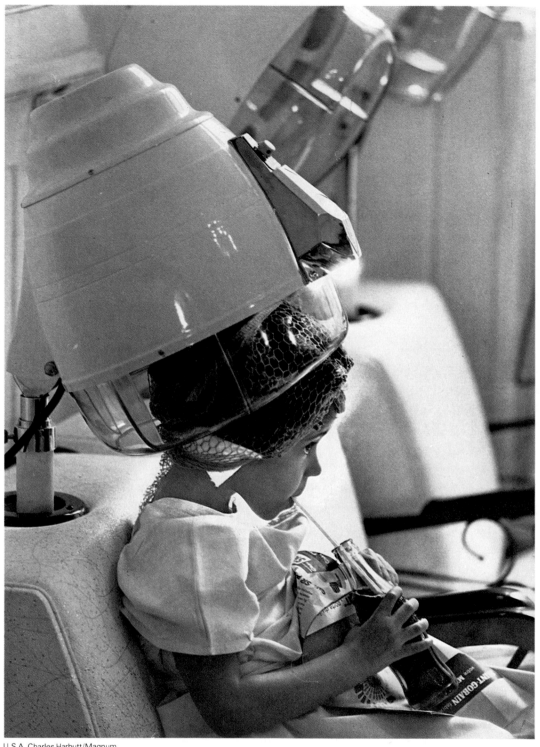

U.S.A. Charles Harbutt/Magnum

So why can't I
Do like papa do,
Like papa do,
Like papa do now

Joe Tex

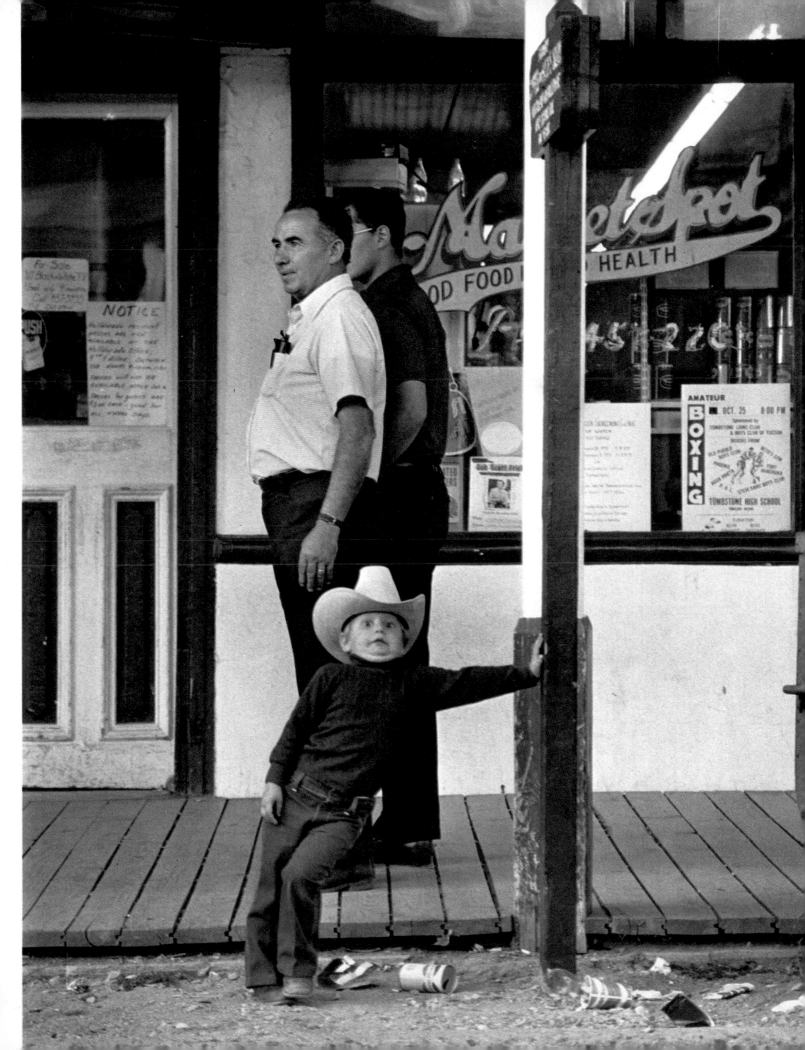

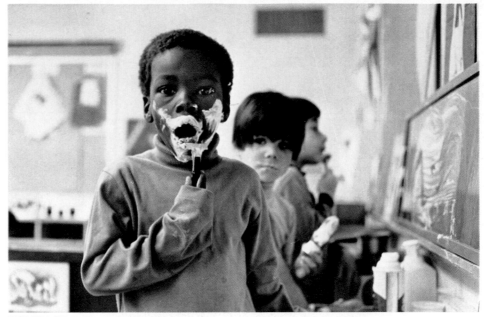

U.S.A. Michall Heron/Woodfin Camp

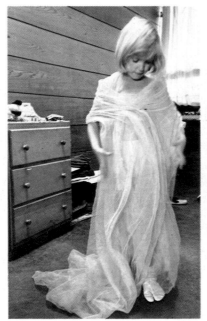

U.S.A. Wayne Miller/Magnum

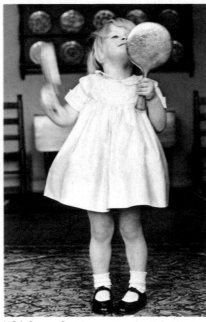

U.S.A. Suzanne Szasz

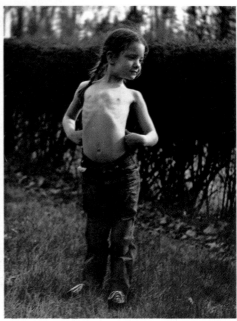

U.S.A. Marjorie Pickens

As if his whole vocation/Were endless imitation. William Wordsworth

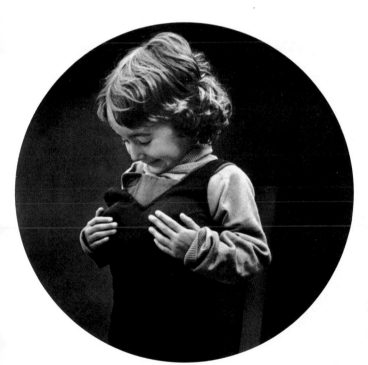

U.S.A. Joanne Leonard/Woodfin Camp

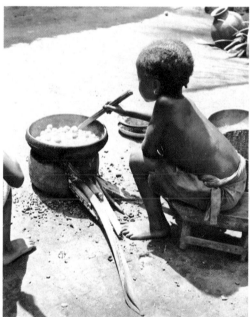

DAHOMEY Dominique Darbois

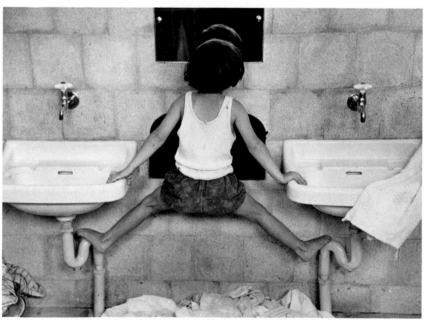

ISRAEL Ruth Orkin

89

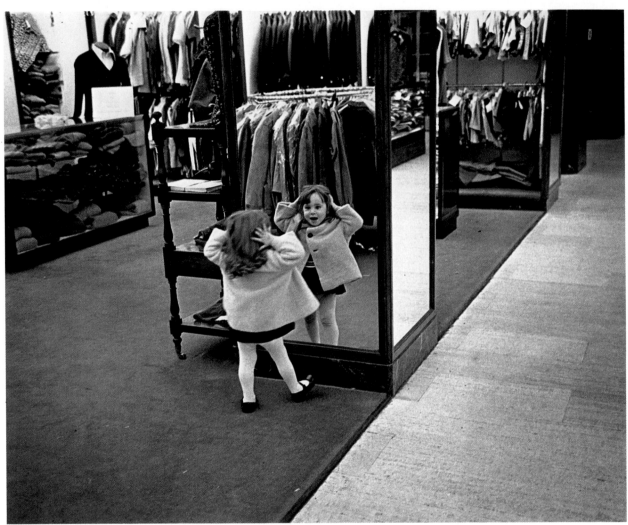

U.S.A. Dick Swift

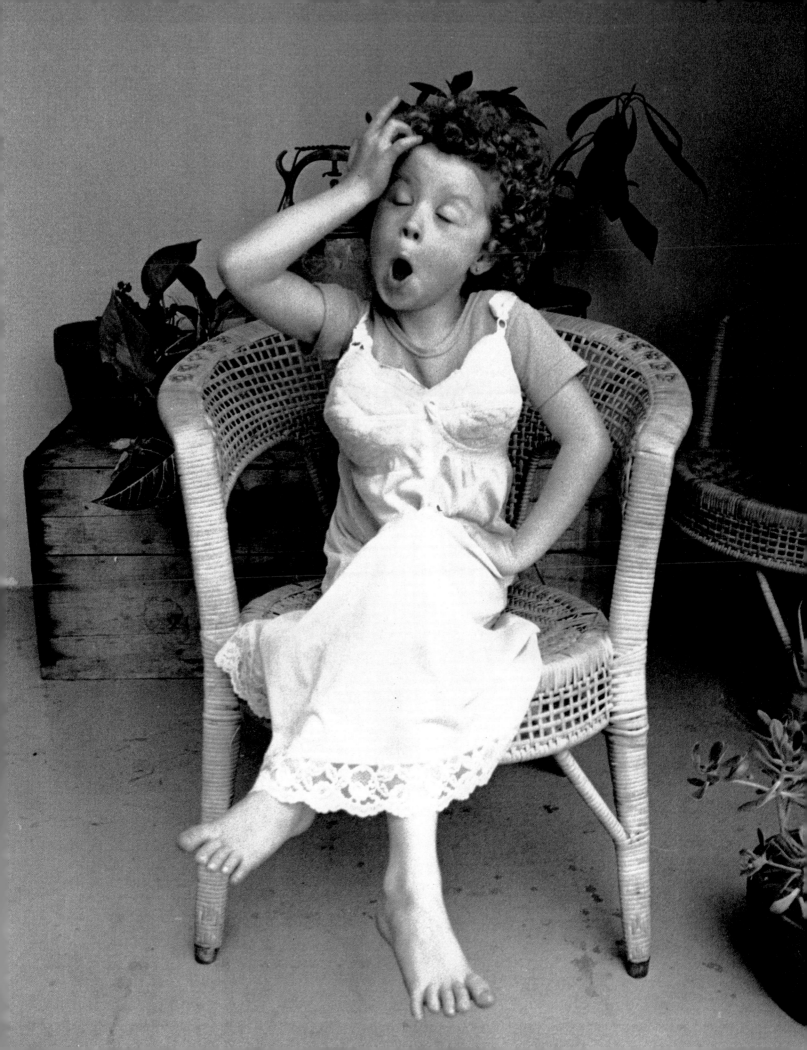

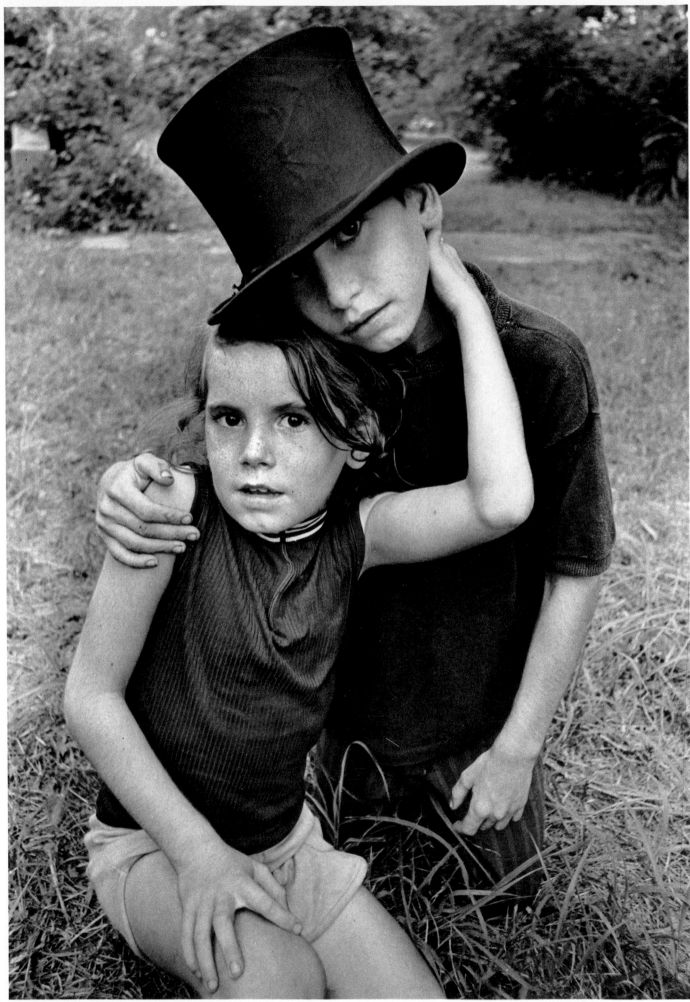

U.S.A. Allen Frame

For every he has got him a she.

Anonymous

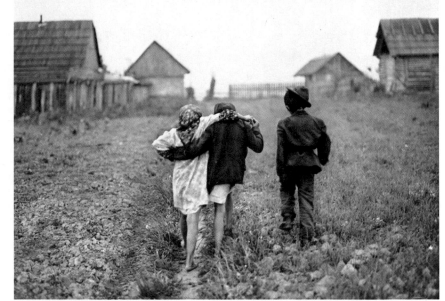

RUMANIA Nathan Farb

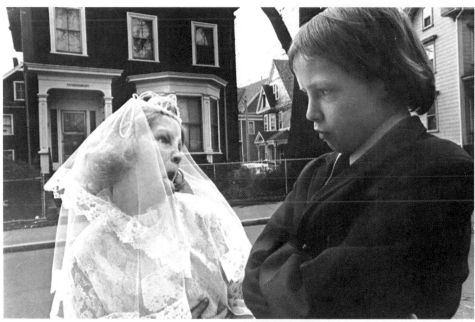

U.S.A. Eugene Richards

U.S.A. Daguerreotype ca. 1848

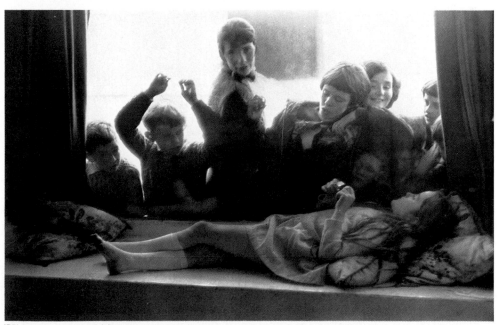

IRELAND Monika Englund-Johansson

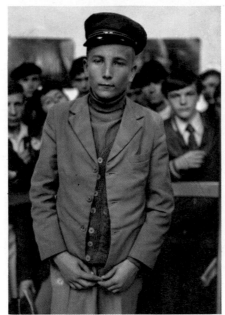

RUMANIA Nathan Farb

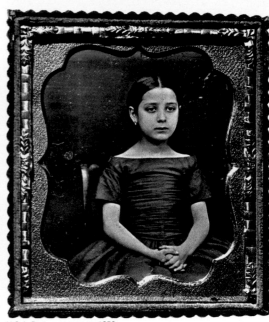

U.S.A. Daguerreotype ca. 1850

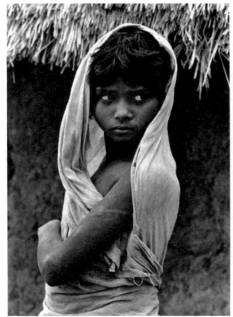

INDIA Thomas Höpker/Woodfin Camp

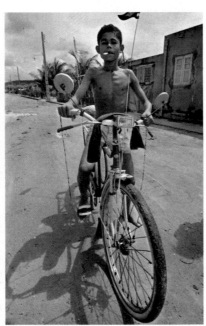

BRAZIL Joe Greene

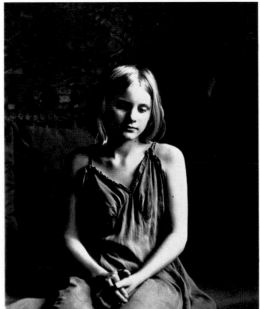

U.S.A. Ede Rothaus

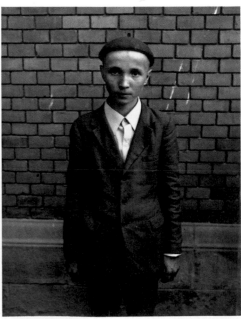

RUMANIA Nathan Farb

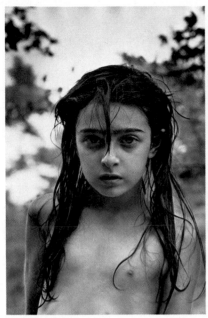

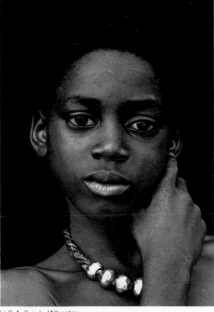

This face you got,
This here phizzog you carry around,
You never picked it out for yourself,
 at all, at all—did you?
This here phizzog—somebody handed it
 to you—am I right? Carl Sandburg

U.S.A. Joan Liftin/Woodfin Camp

U.S.A. Eric L. Wheater

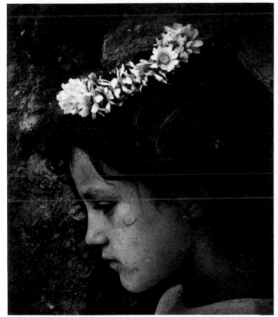

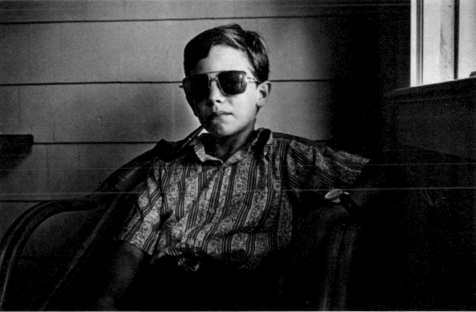

SPAIN George Krause

U.S.A. Dick Swift

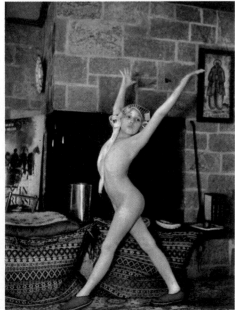

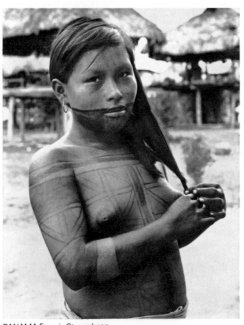

U.S.A. Inge Morath/Magnum

PANAMA Francis Stoppelman

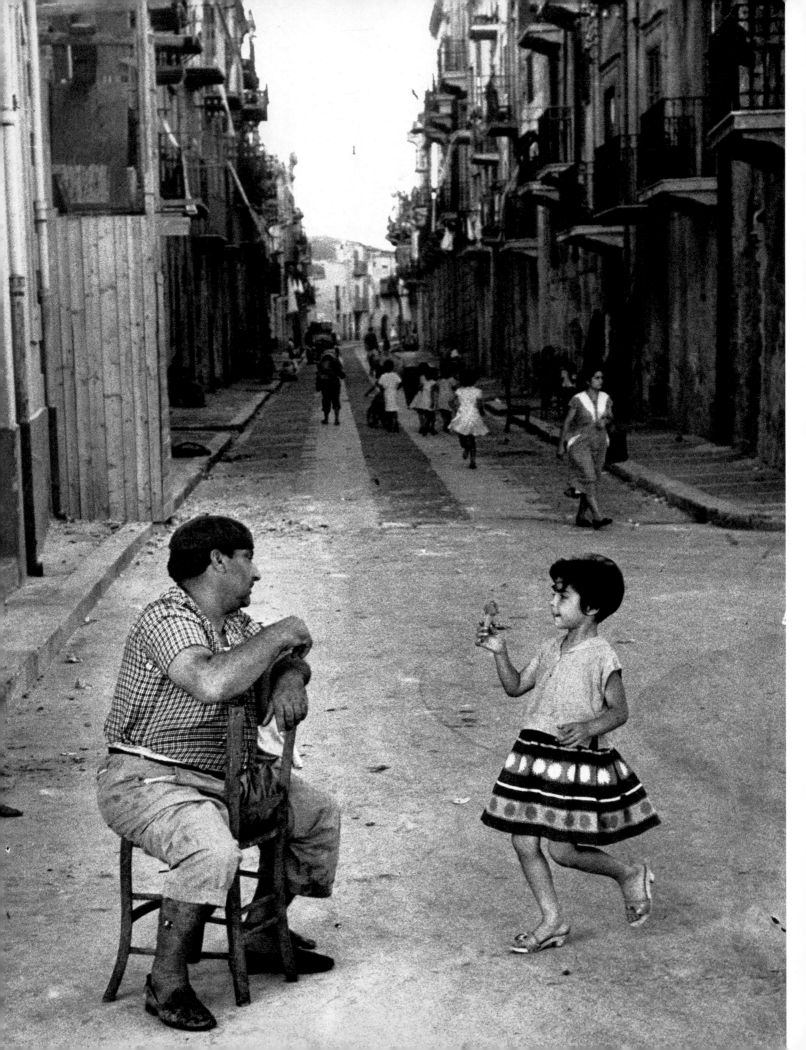

Children's children are the crown of old men. Proverbs 17:6

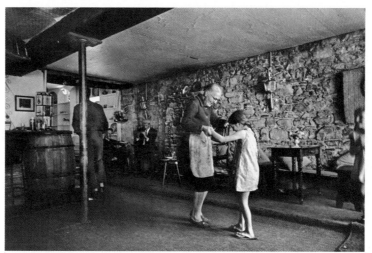
IRELAND Monika Englund-Johansson

SAUDI ARABIA Mathias Oppersdorff

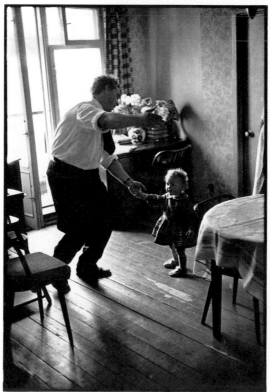
U.S.S.R. Howard Sochurek/Woodfin Camp

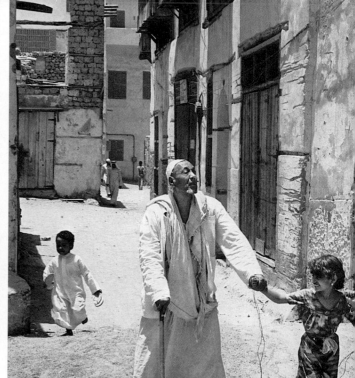

SICILY Enzo Sellerio

All my children are prodigies. Proverb

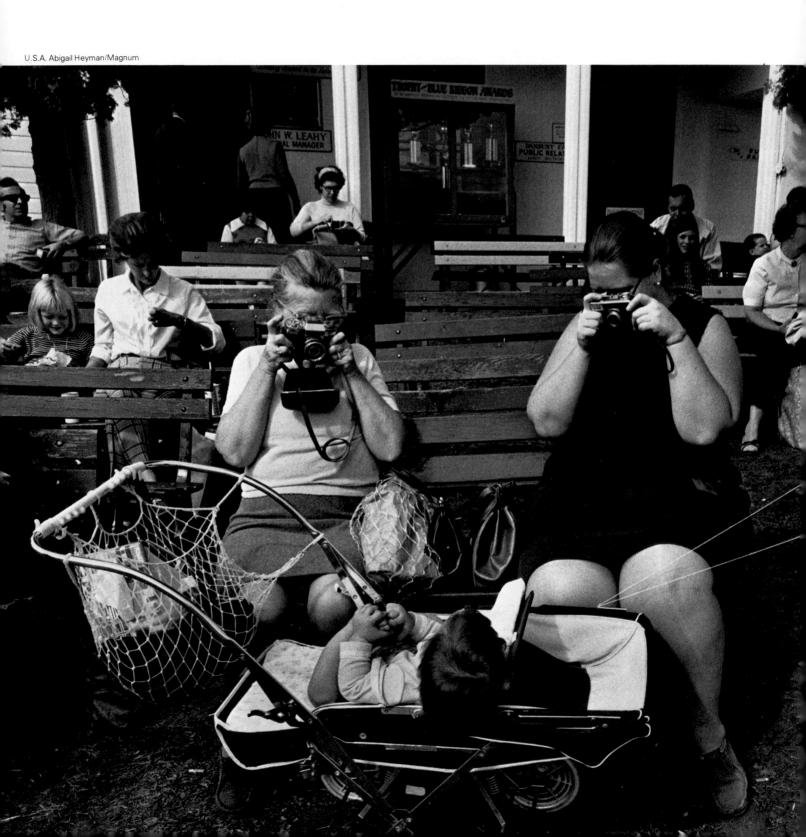

U.S.A. Robert Zuckerman

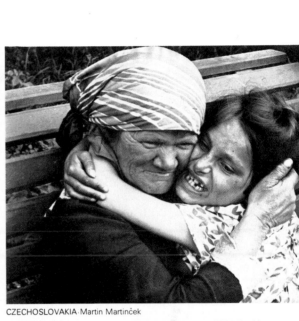

CZECHOSLOVAKIA Martin Martinček

PERU Ken Heyman

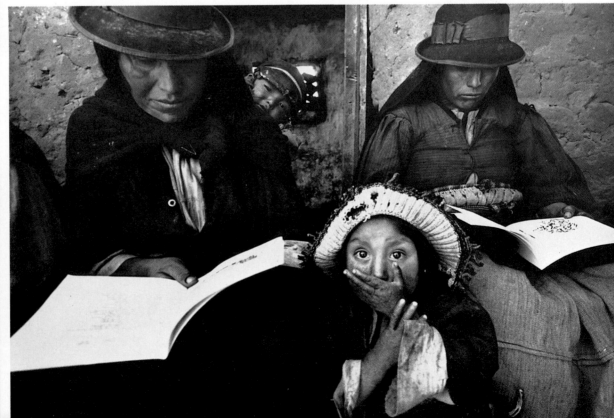

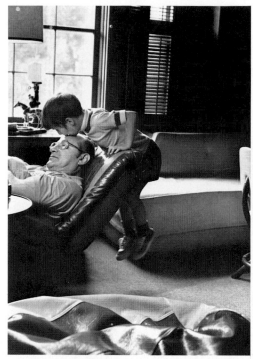

U.S.A. Leonard McCombe/LIFE

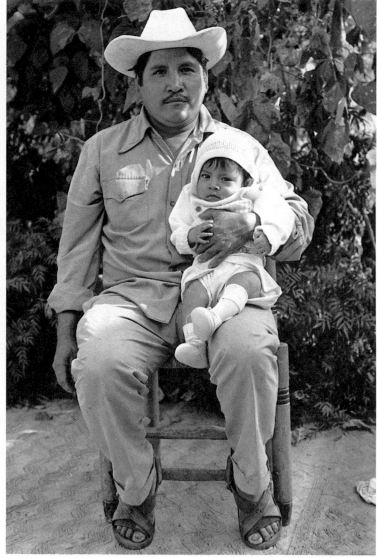

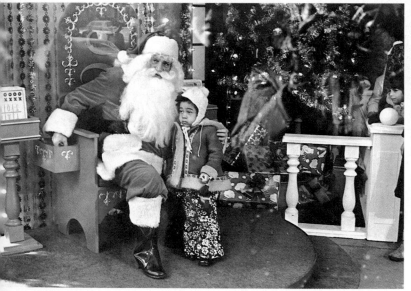

U.S.A. Suellen Snyder

MEXICO Gail Fisher-Taylor

U.S.A. Eugene Richards

U.S.A. David Strickler

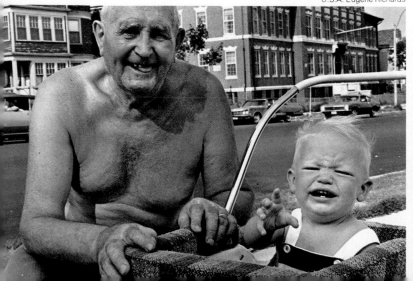

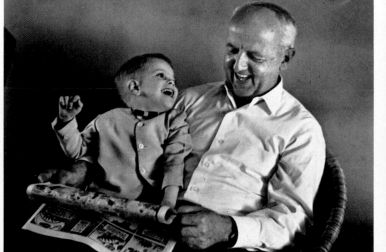

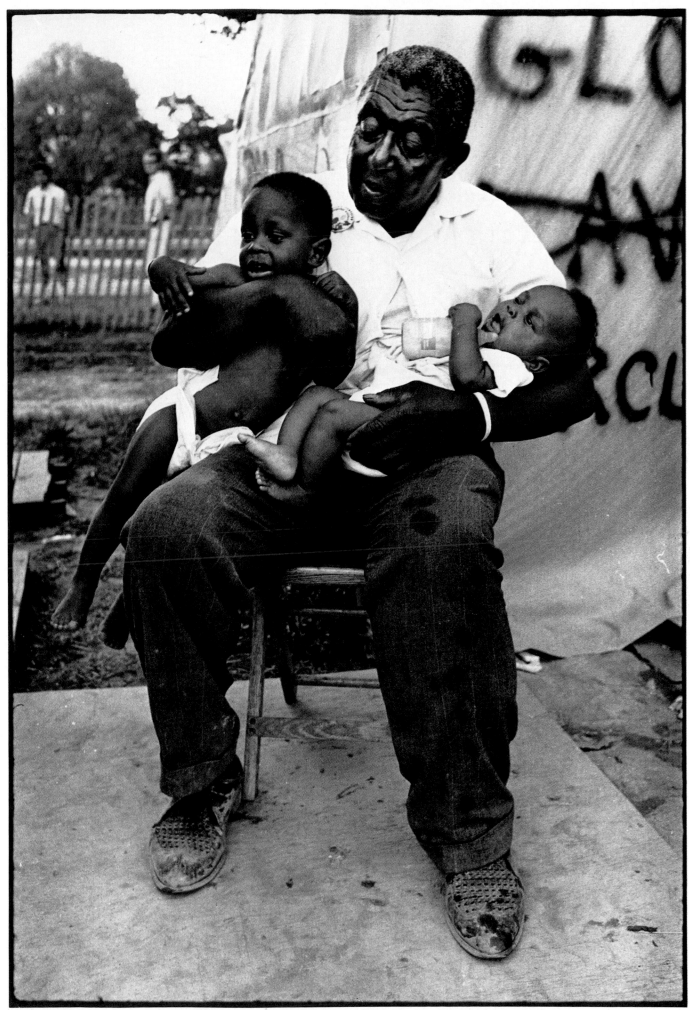

U.S.A. Jill Freedman

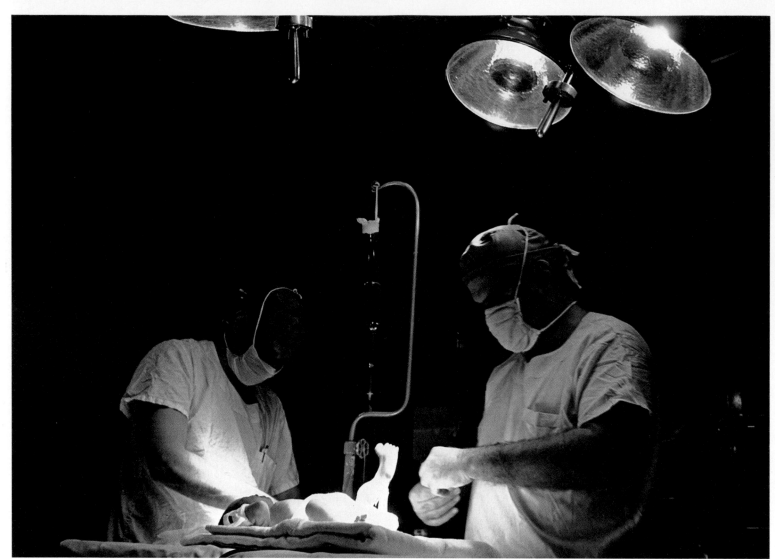

U.S.A. Arthur Leipzig

For our children lie there beyond us/In the still, foreign city of pain James Dickey

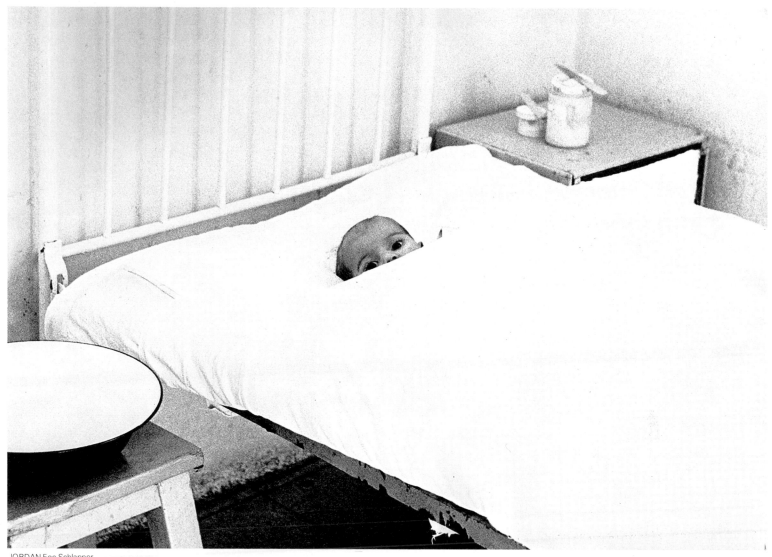

JORDAN Fee Schlapper

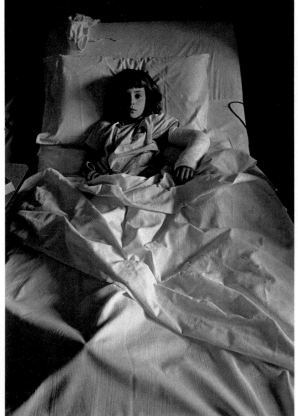

CANADA Neil Newton

CAMEROON Ian Berry/Magnum

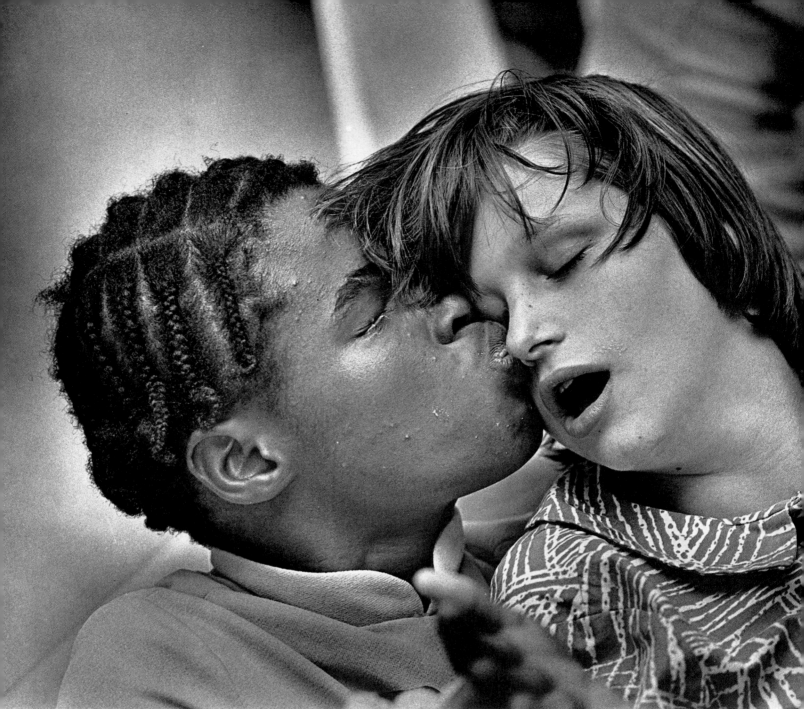

U.S.A. Sunland Center (Institute for the Retarded) Michael O'Brien

In the deserts of the heart
Let the healing fountain start W. H. Auden

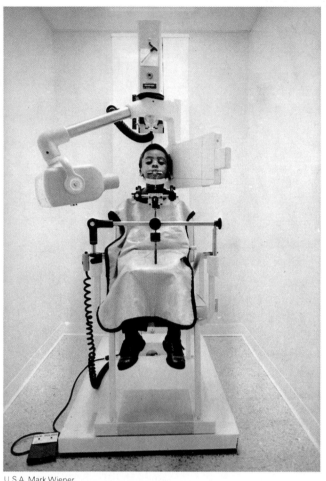

U.S.A. Mark Wiener

U.S.A. Charles Harbutt/Magnum

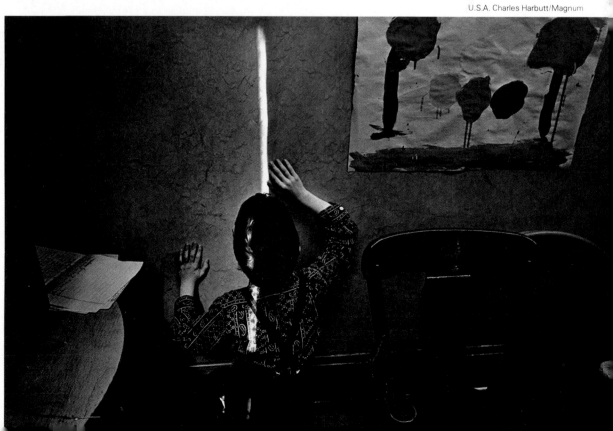

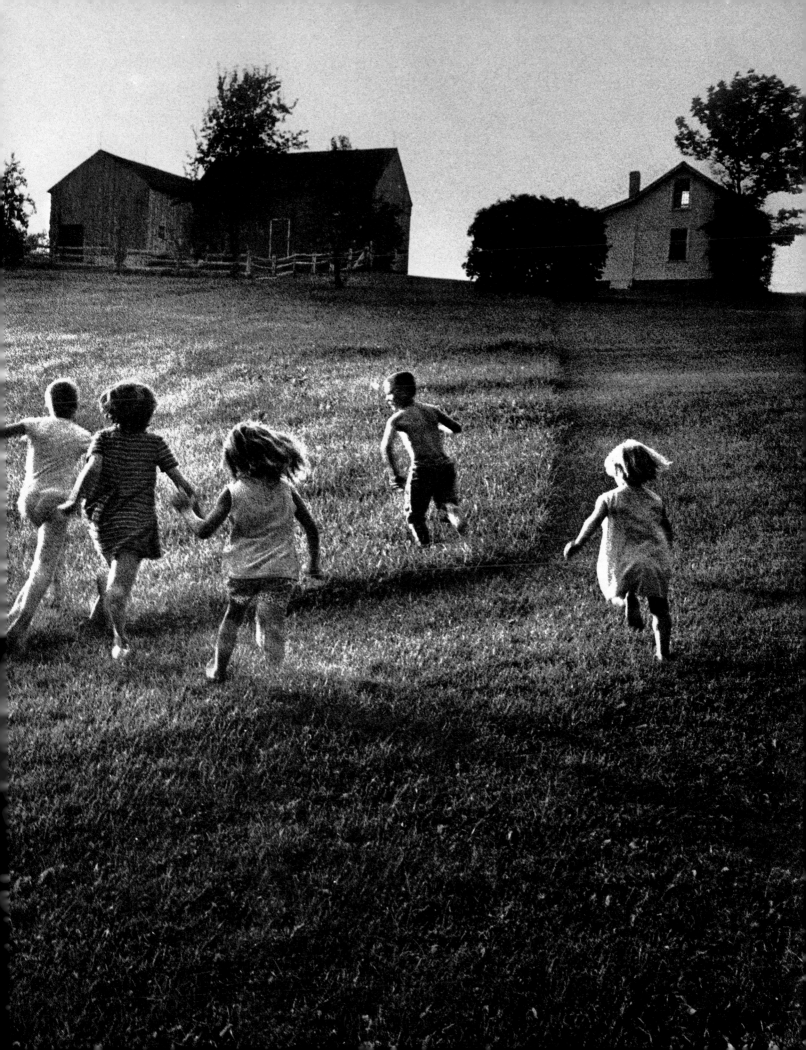

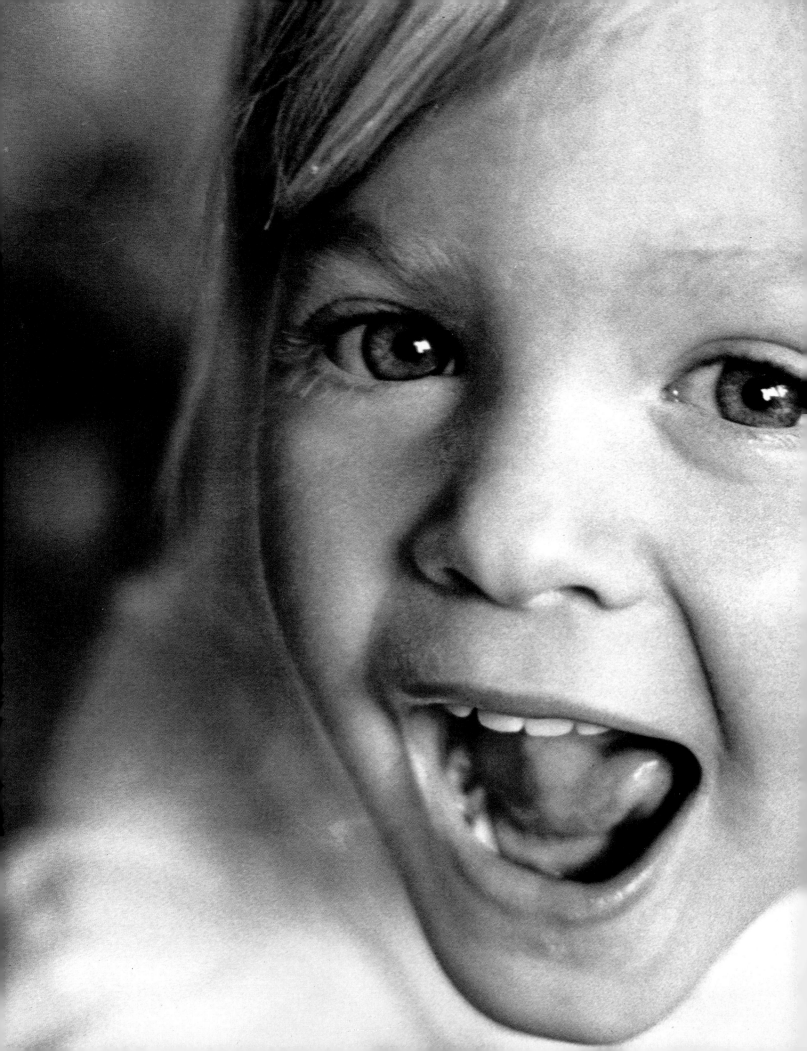

In the house of long life, there I wander.
In the house of happiness, there I wander.
Beauty before me...
Beauty behind me...
Beauty below me...
Beauty all around me American Indian

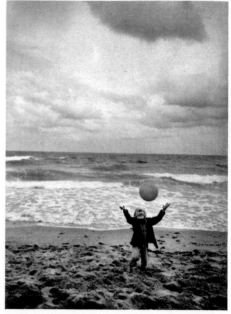
U.S.A. Ken Heyman

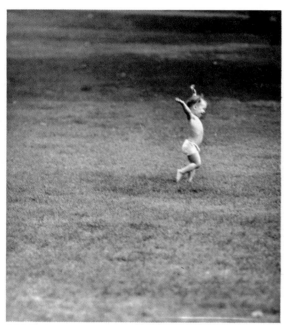
U.S.A. Ken Heyman

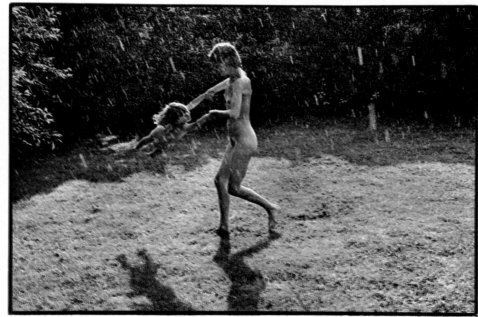
SWEDEN Jens S. Jensen

Preceding pages: U.S.A. Ken Heyman

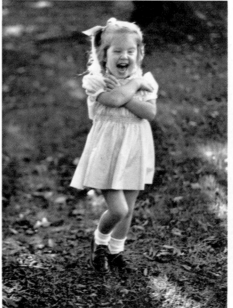
U.S.A. Susie Fitzhugh

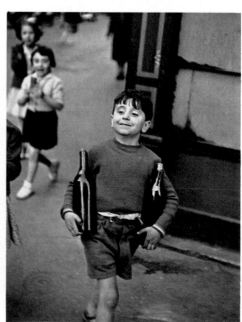
FRANCE H. Cartier-Bresson/Magnum

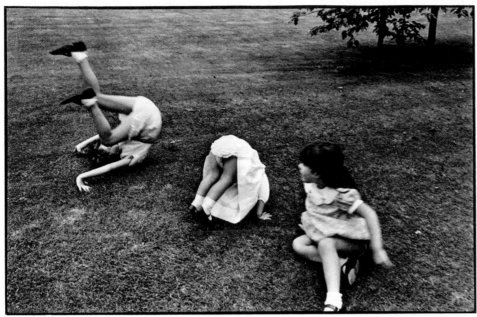

ENGLAND Dena

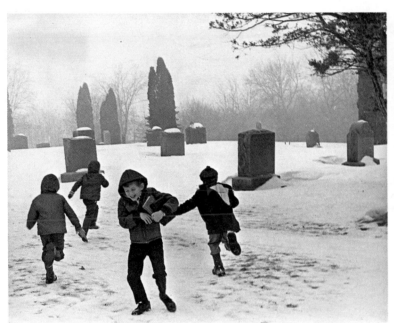

U.S.A. Rohn Engh

U.S.A. Albert Squillace

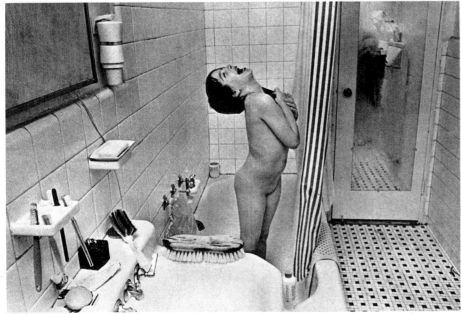

U.S.A. Arthur Freed

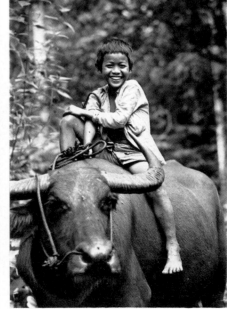

THAILAND Eric L. Wheater

111

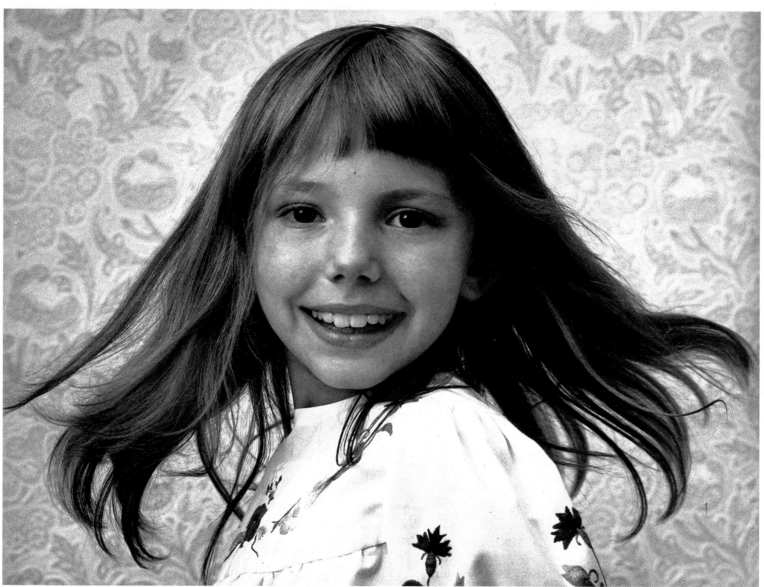

POLAND Krzysztof Kaminski

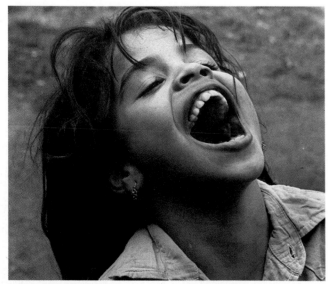

PUERTO RICO Nelson Garcia

CHINA Per-Olle Stackman/Tio

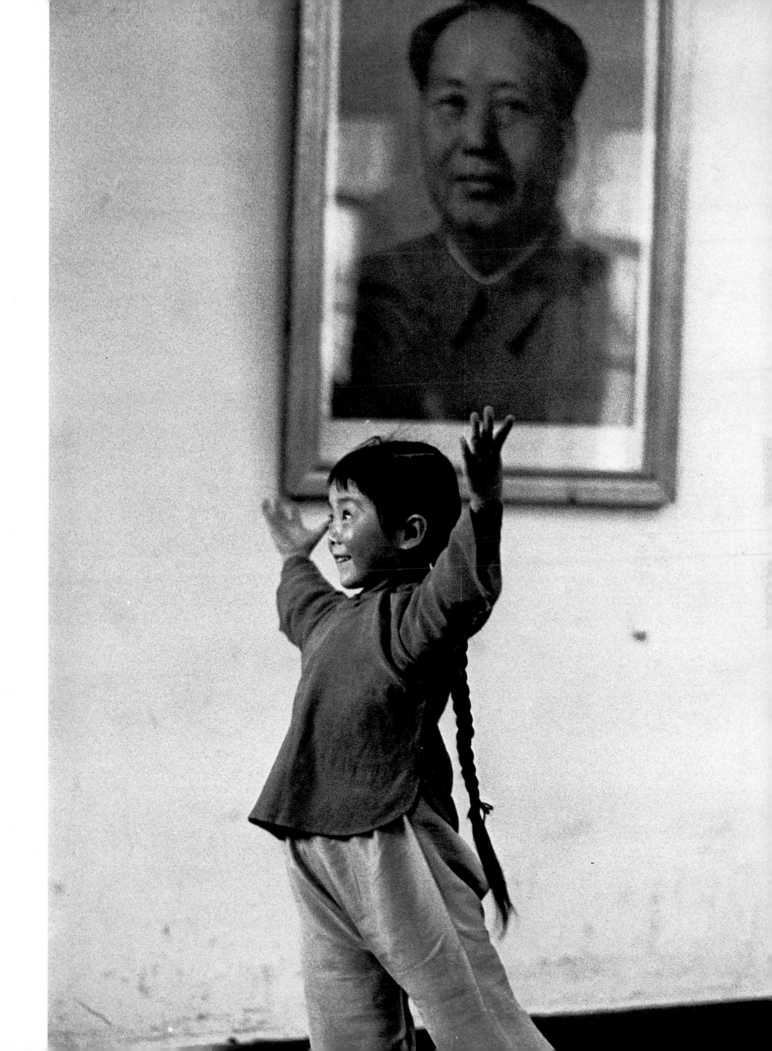

This is my sad time of day. Arnold Lobel

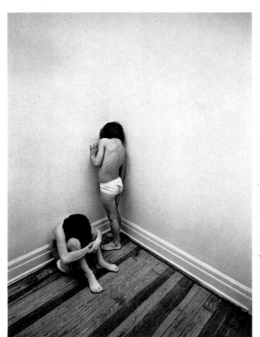

U.S.A. David R. White/Woodfin Camp

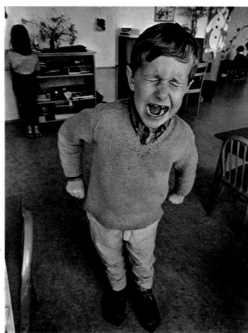

SWEDEN Nils-Johan Norenlind/Tio

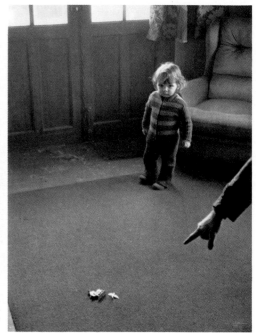

FRANCE Alain Dagbert/Viva

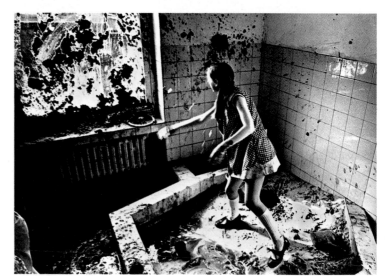

WEST GERMANY Henning Christoph

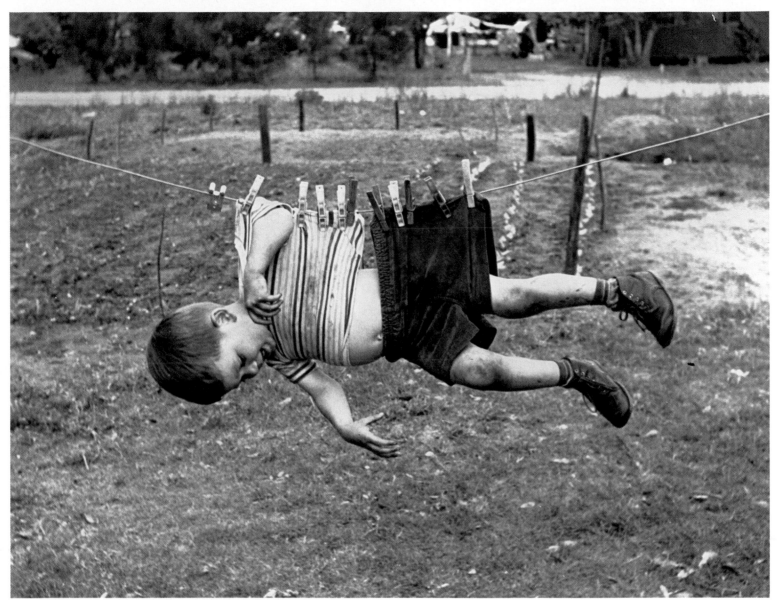

U.S.A. Joe Rainaldi

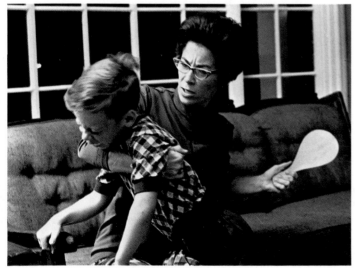

U.S.A. Bruce Roberts/Rapho-Photo Researchers

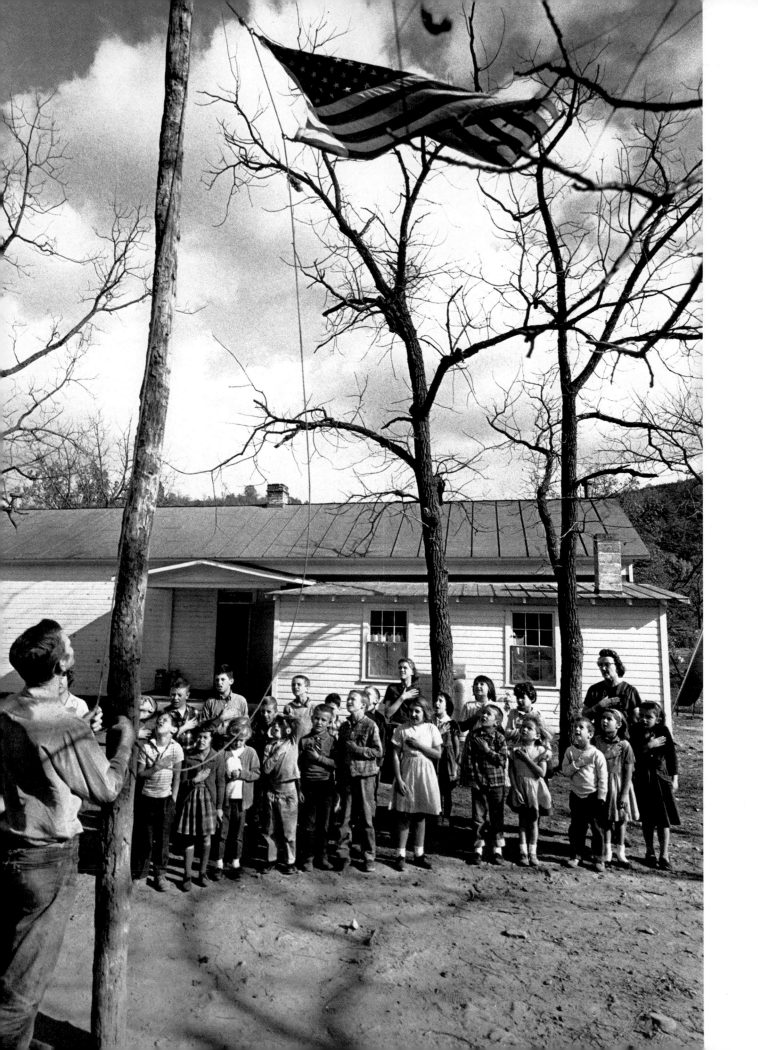

Where is the way where light dwelleth? Job 38:19

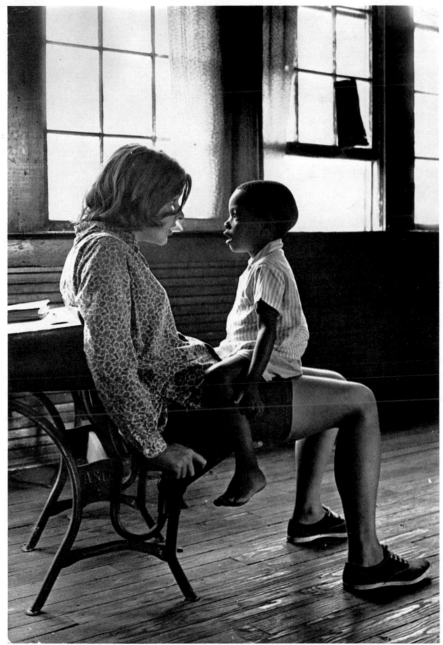

U.S.A. Bruce Roberts/Rapho-Photo Researchers

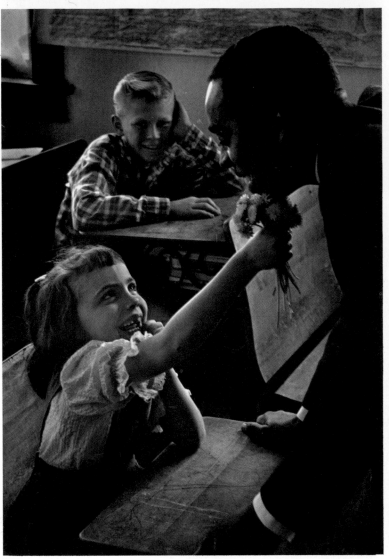

U.S.A. James H. Karales

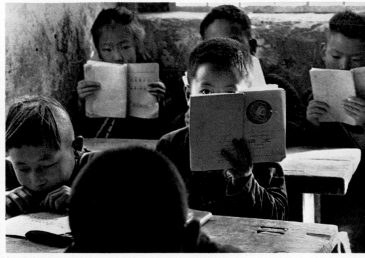

CHINA Gun Kessle/Tio

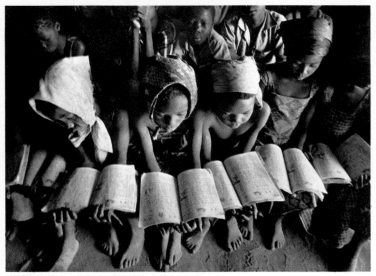

CHAD Leon Herschritt/Rapho-Photo Researchers

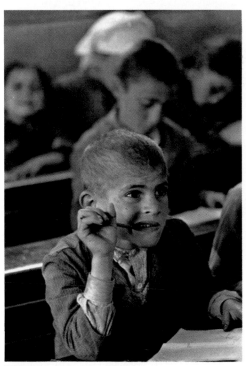

GREECE Constantine Manos/Magnum

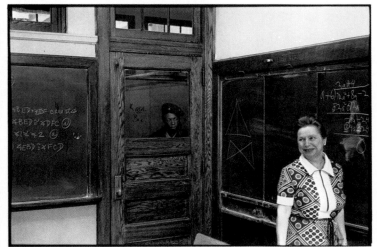

U.S.A. Ken Light

Such knowledge is too wonderful for me;

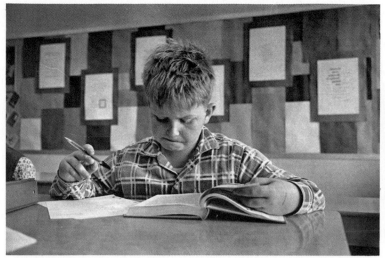

U.S.A. Bob Adelman

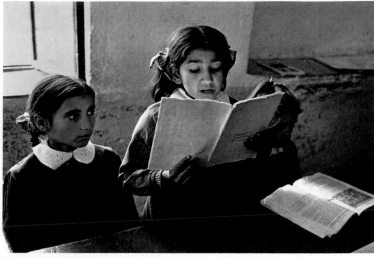

TURKEY Lennart Olson/Tio

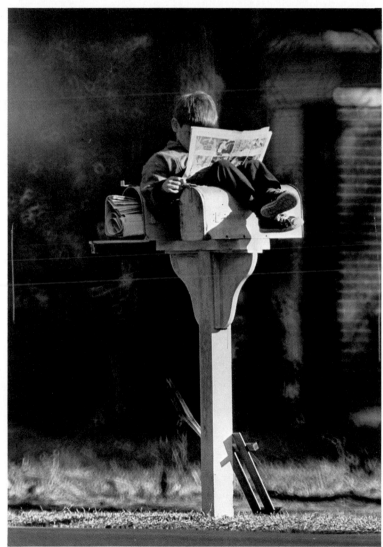

U.S.A. Jessie O'Connell Gibbs/Black Star

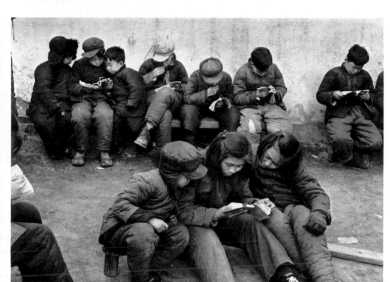

CHINA Marc Riboud/Magnum

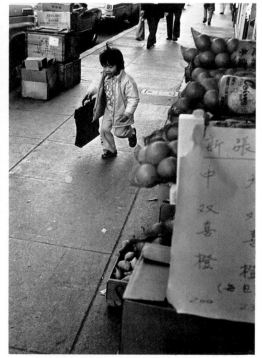

SAN FRANCISCO John Maher

/it is high; I cannot attain unto it. Psalms 139:6

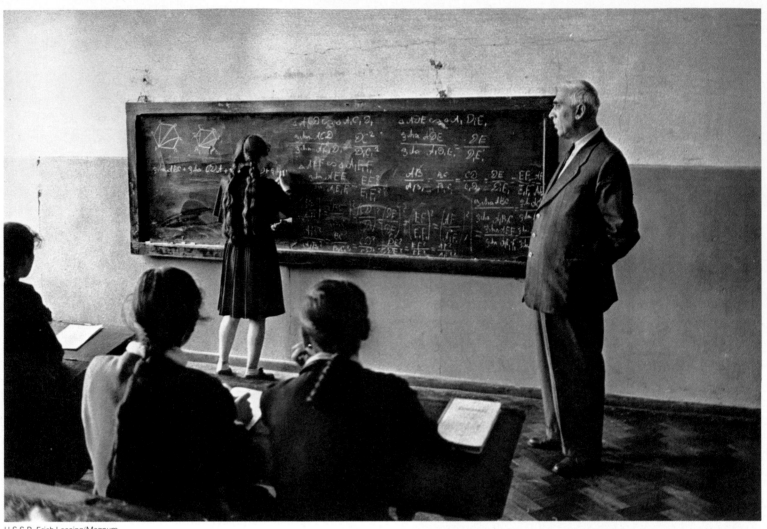

U.S.S.R Erich Lessing/Magnum

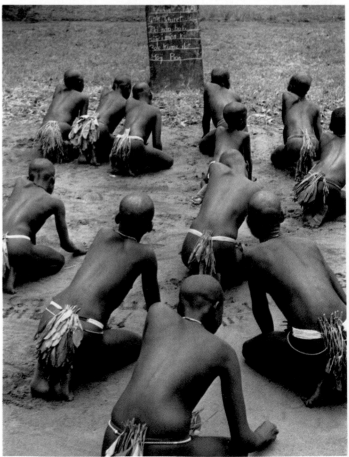

SUDAN George Rodger/Magnum

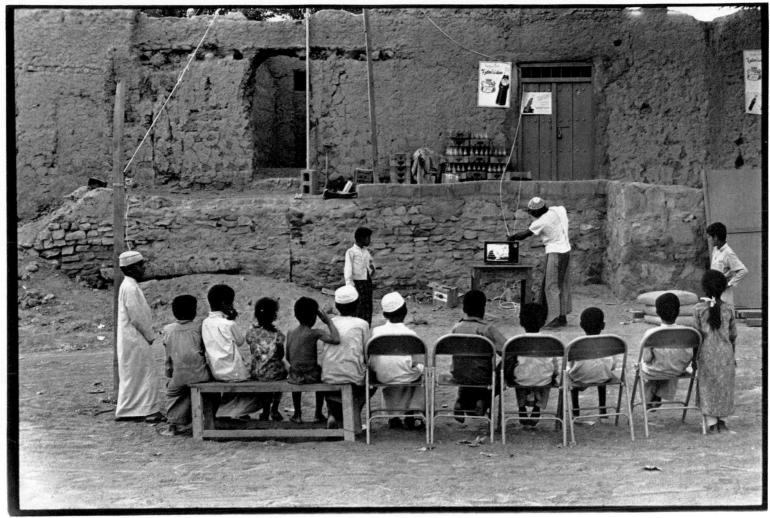

OMAN Mathias Oppersdorff

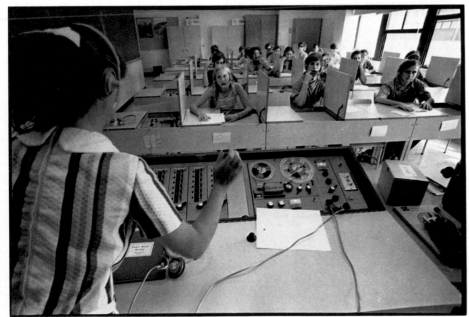

U.S.A. Bob Adelman

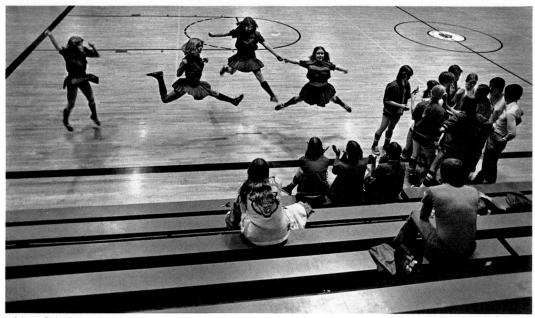

U.S.A. Jim Richardson

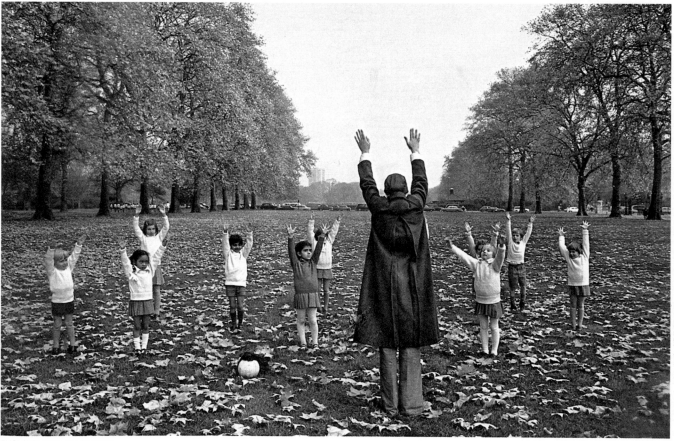

ENGLAND Jessie Ann Matthew

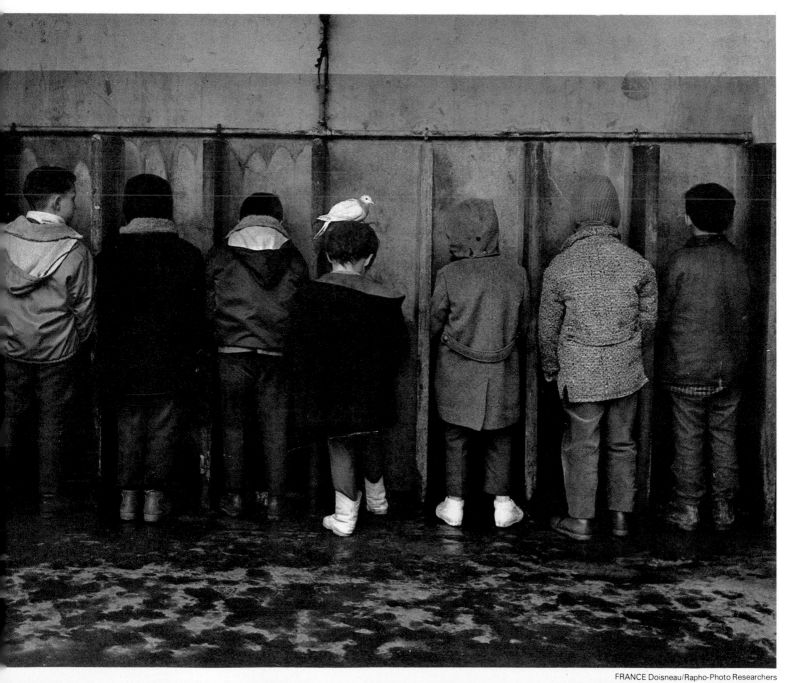

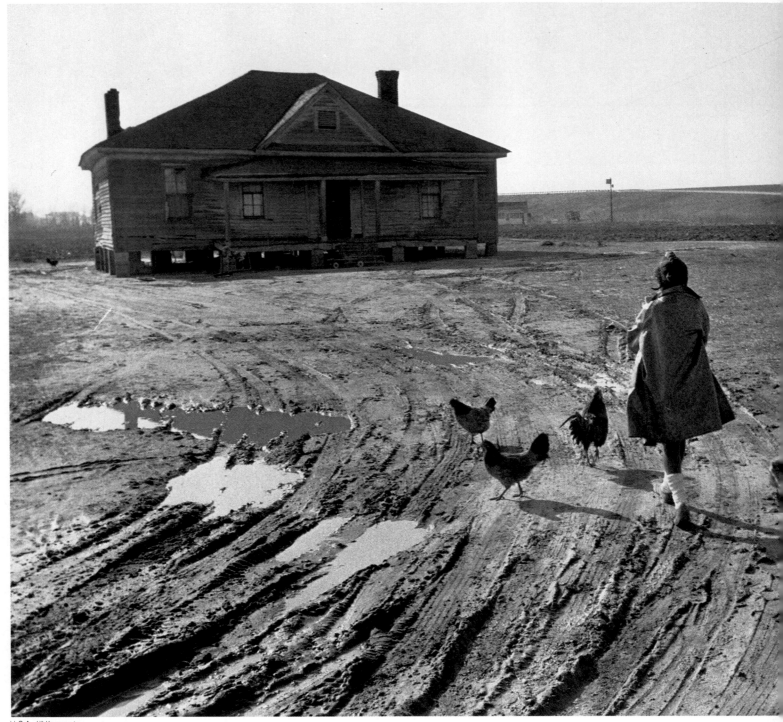

U.S.A. Jill Krementz

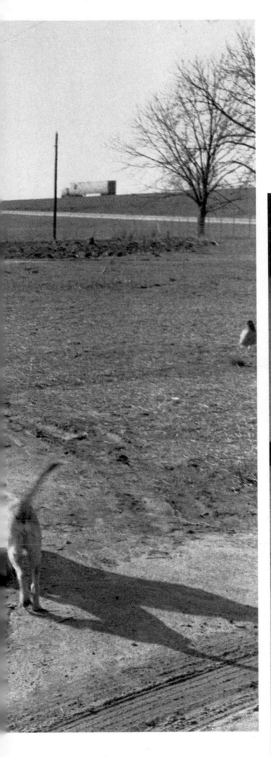

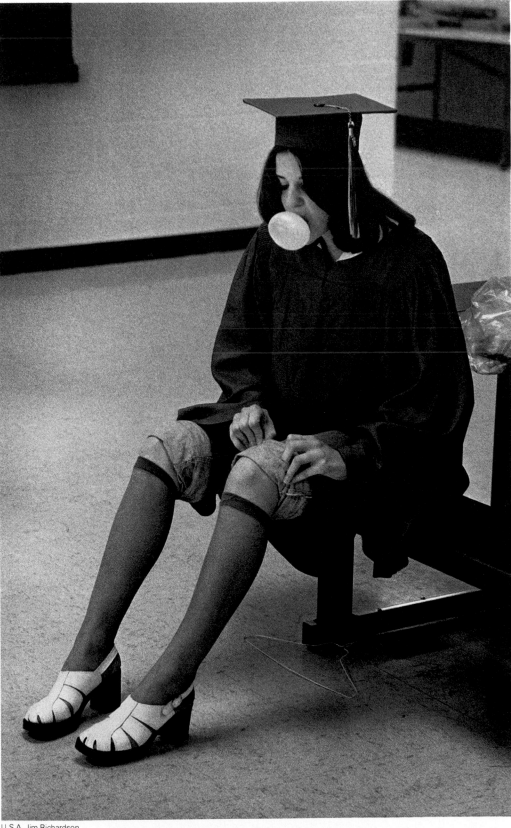

U.S.A. Jim Richardson

There was such speed in her little body,

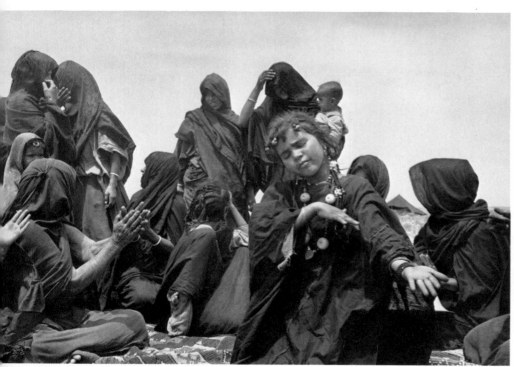

MOROCCO Sabine Weiss

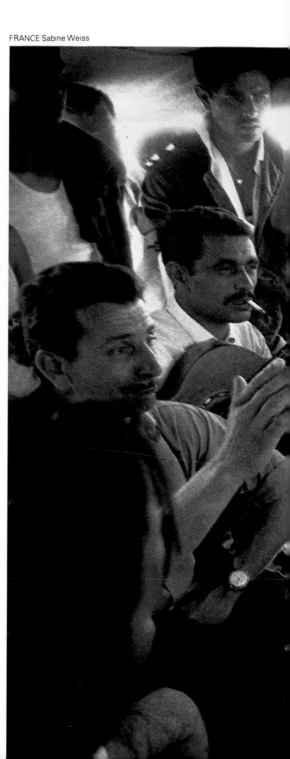

FRANCE Sabine Weiss

126

/And such lightness in her footfall. John Crowe Ransom

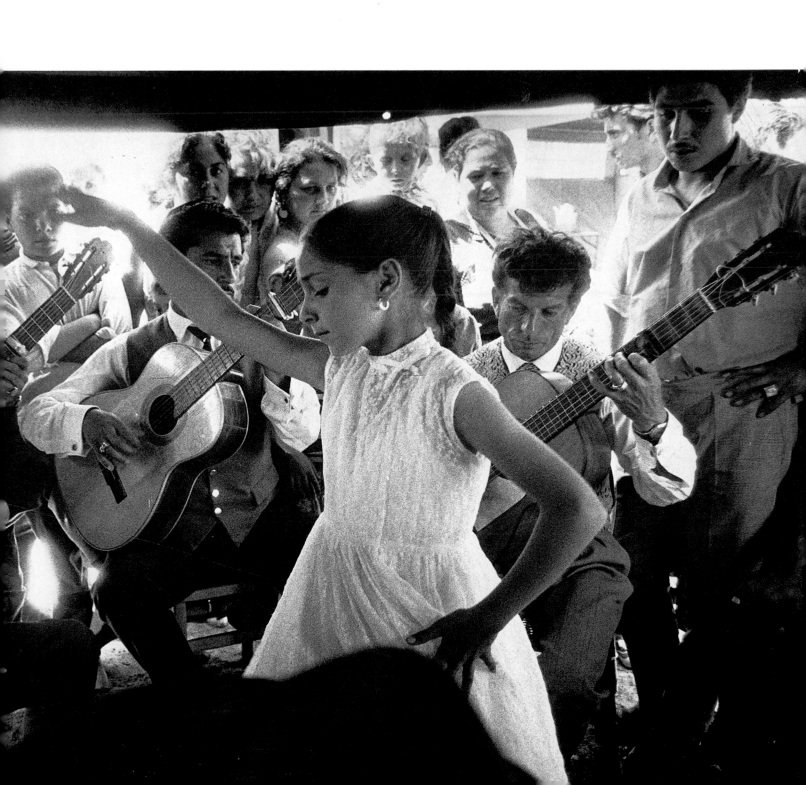

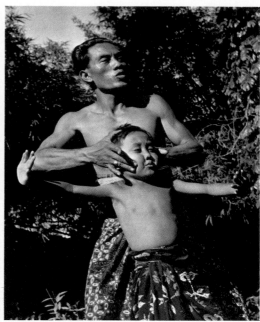

BALI Dominique Darbois

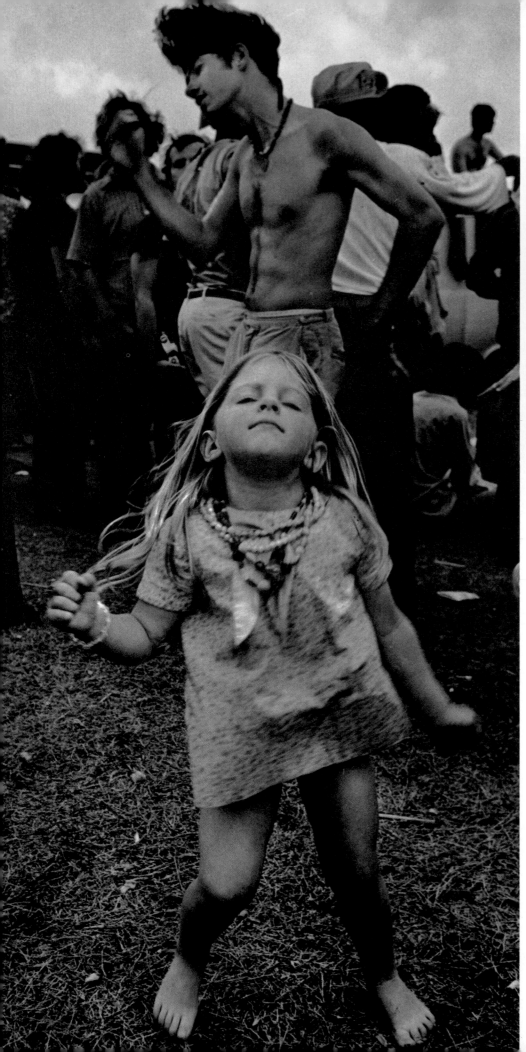

U.S.A. George W. Gardner

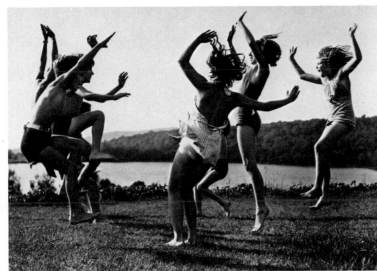

U.S.A. Barbara Morgan

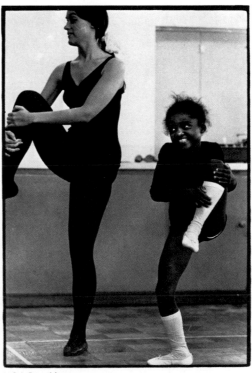

U.S.A. Bryan Moss

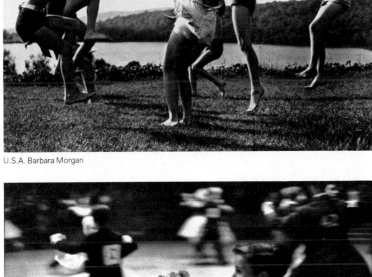

ENGLAND David Hurn/Magnum

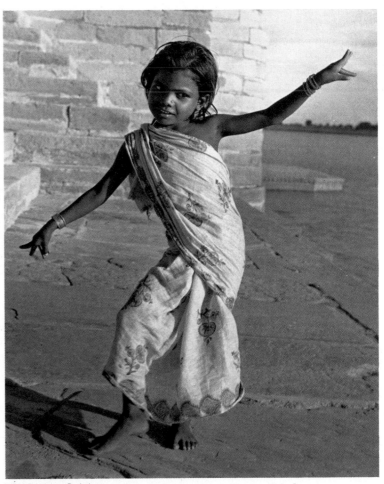

INDIA Dominique Darbois

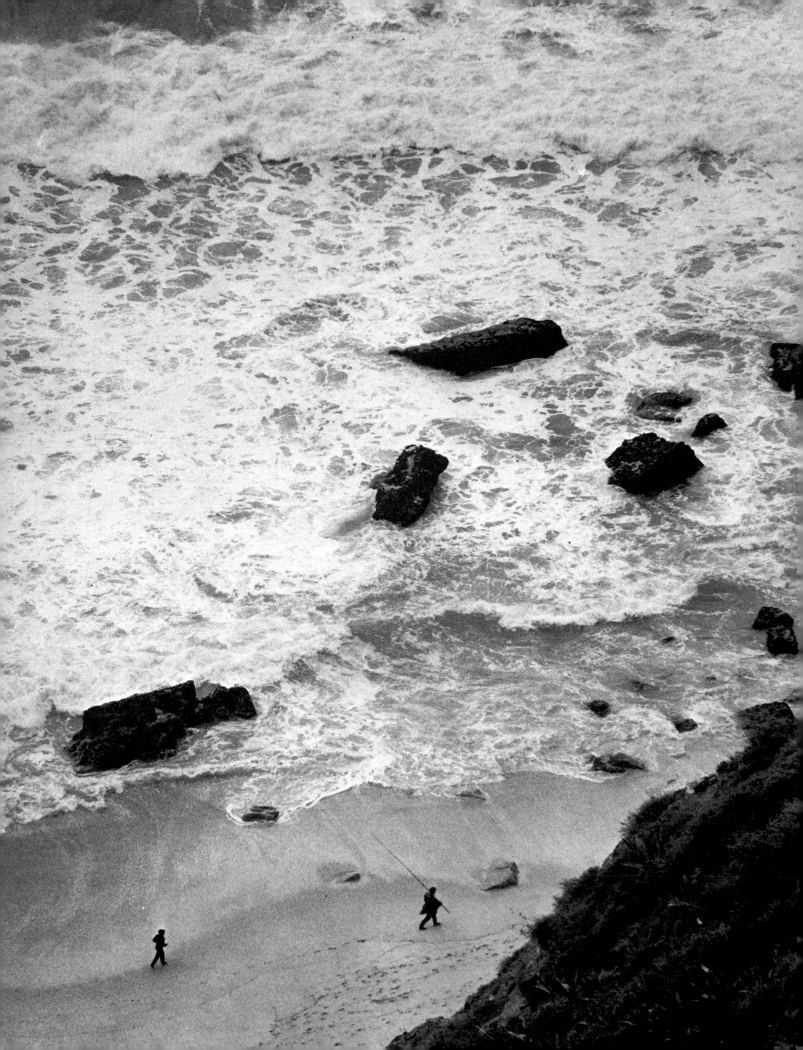

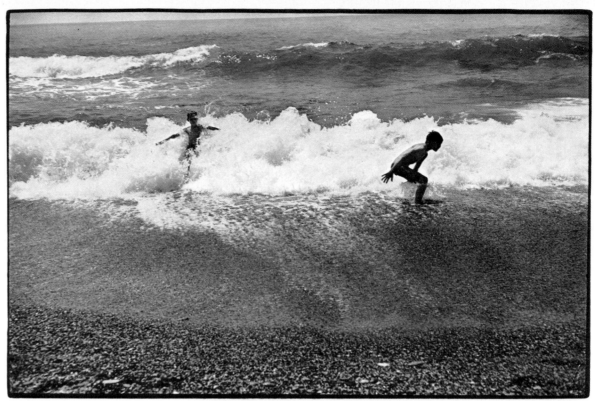

SICILY Monika Englund-Johansson

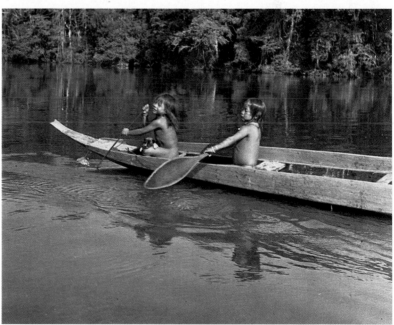

GUYANA Dominique Darbois

The big day dawns.
Boundless is our adventure. Karin Boye

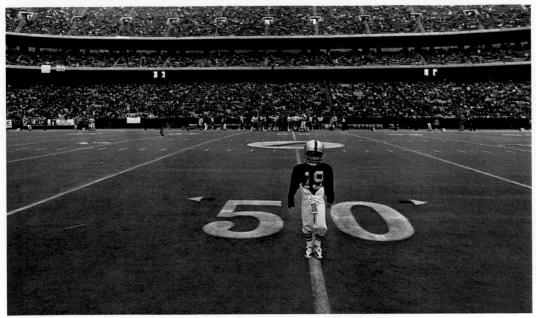

U.S.A. Brian Lanker

U.S.A. Brian Lanker

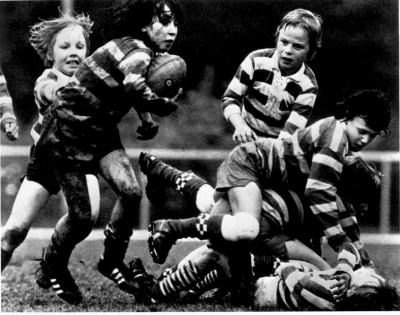

ENGLAND Dieter Bauman/Camera Press

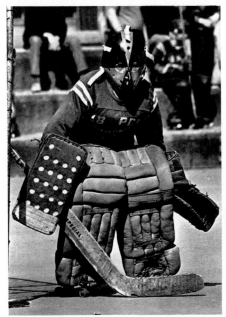

U.S.A. Mel DiGiacomo

ZAIRE Abbas/Gamma Liaison

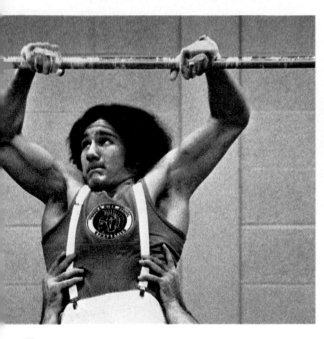

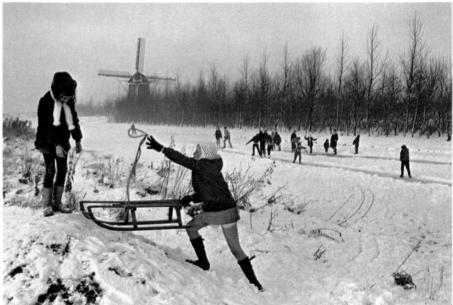

THE NETHERLANDS Leonard Freed/Magnum

The glory of young men is their strength.

Proverbs 20:29

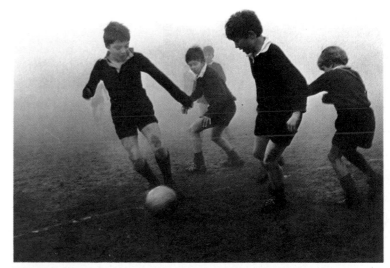

ENGLAND Mel DiGiacomo

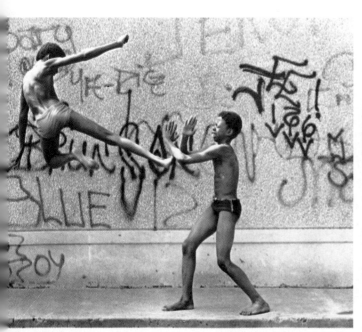

U.S.A. Eric L. Wheater

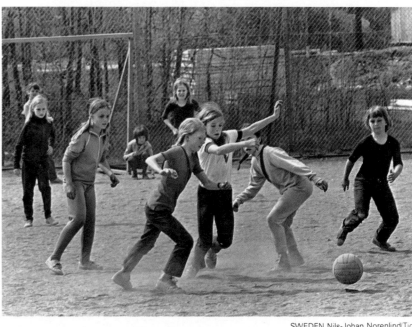

SWEDEN Nils-Johan Norenlind/Tio

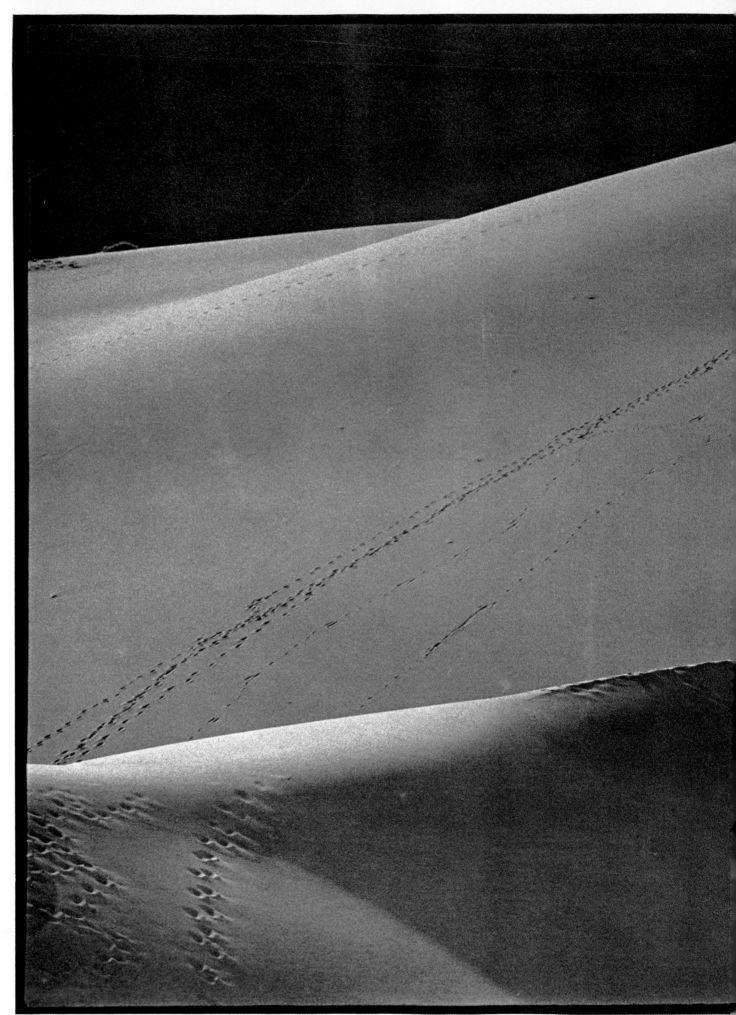

COLORADO Rich Clarkson

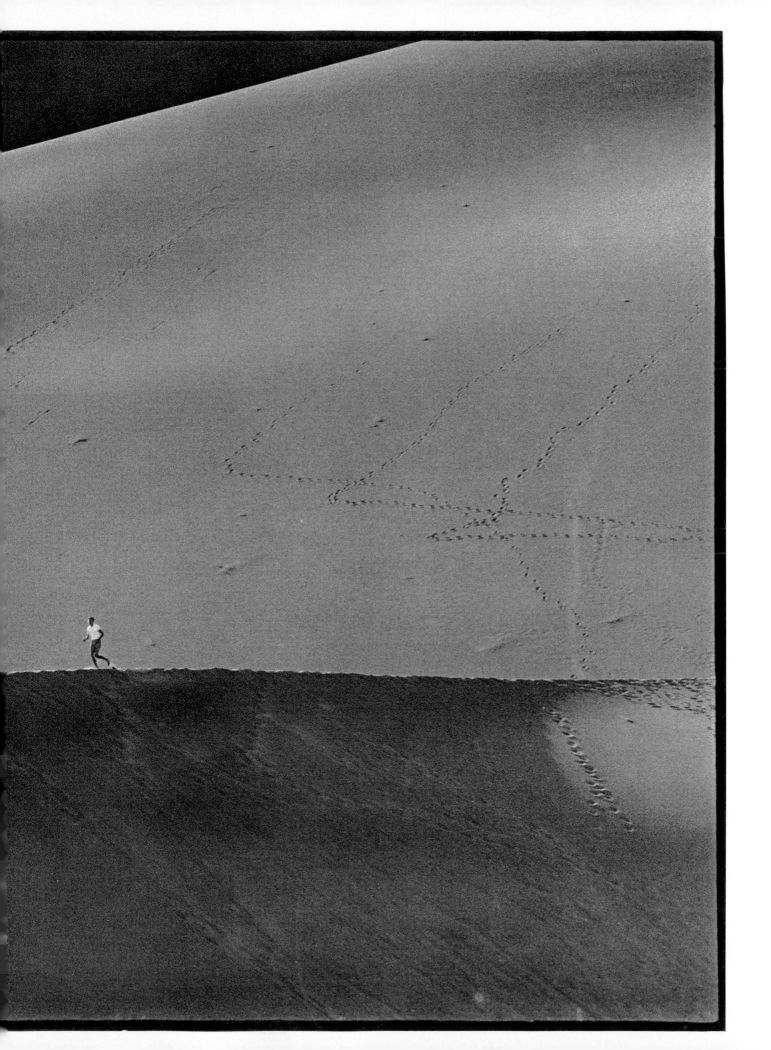

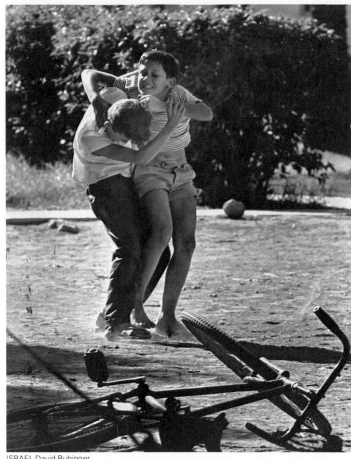

ISRAEL David Rubinger

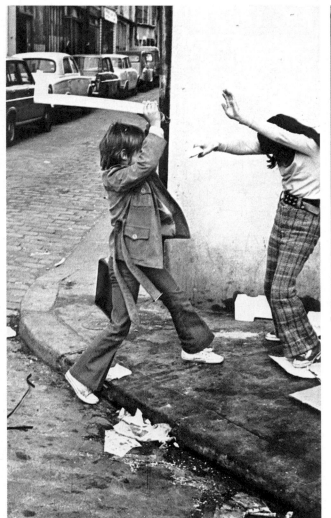

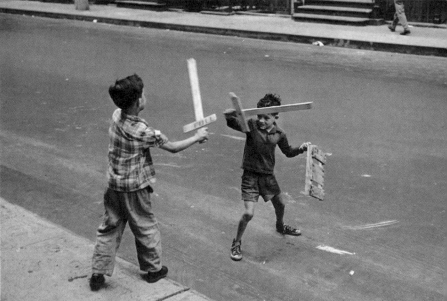

U.S.A. Sid Kaplan

FRANCE Phelps/Rapho-Photo Researchers

I was angry with my friend:
I told my wrath, my wrath did end.
I was angry with my foe:
I told it not, my wrath did grow. William Blake

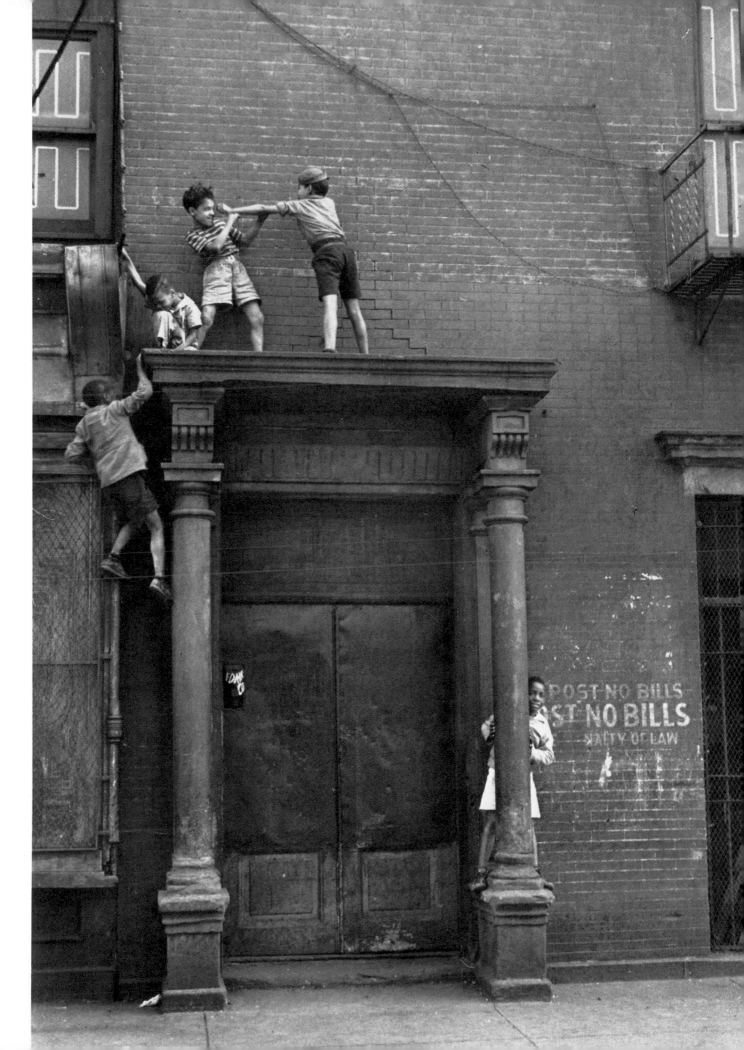

Oh, children, children, how fraught with peril are your years! Fyodor Dostoevsky

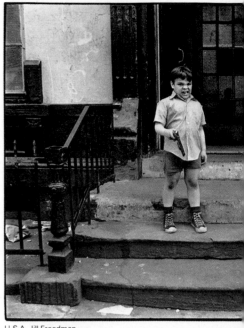

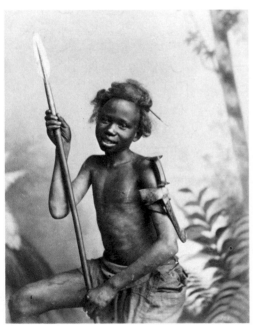

SUDAN ca. 1890

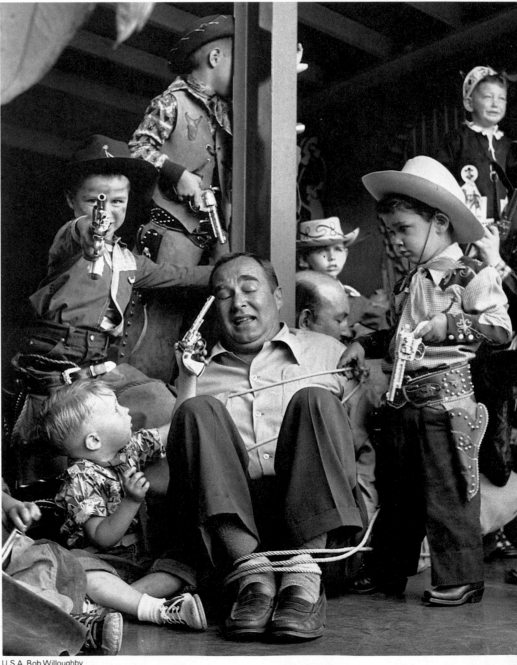

138

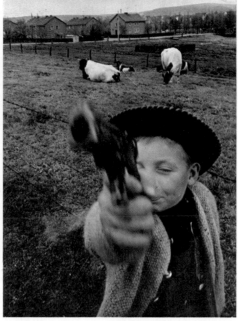

EAST GERMANY Thomas Höpker/Woodfin Camp

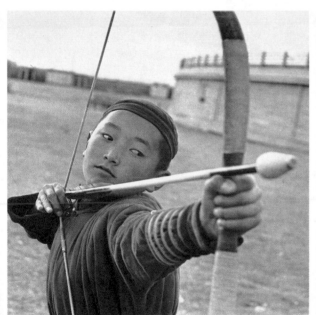

MONGOLIA Dominique Darbois

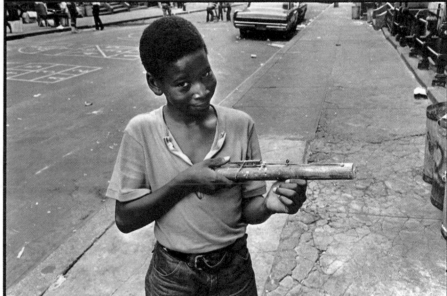

U.S.A. Jaydie Putterman

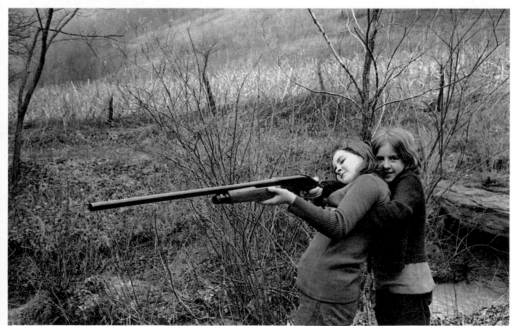

U.S.A. Mary Ellen Mark/Magnum

139

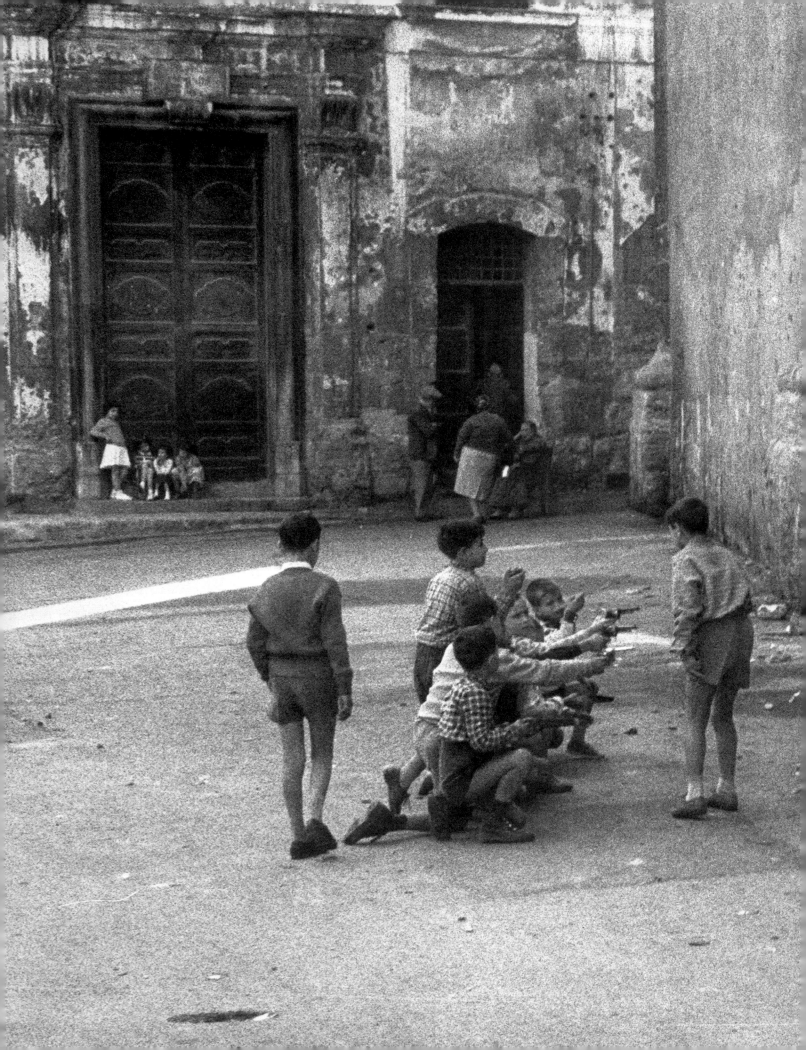

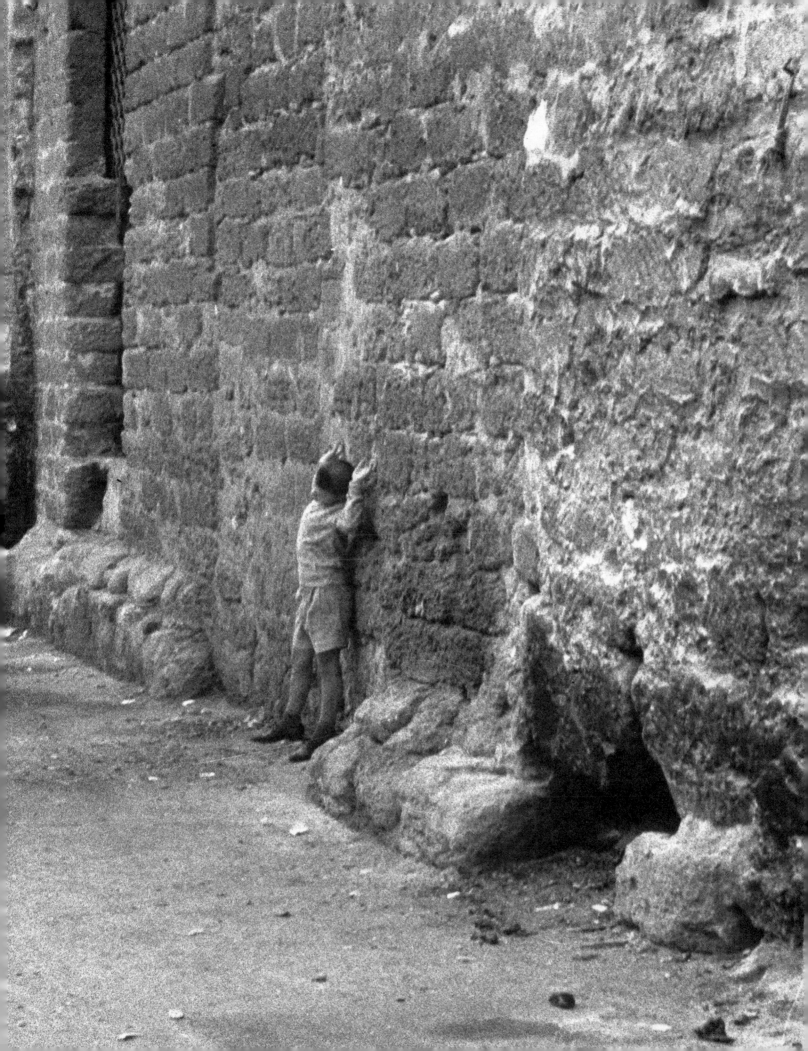

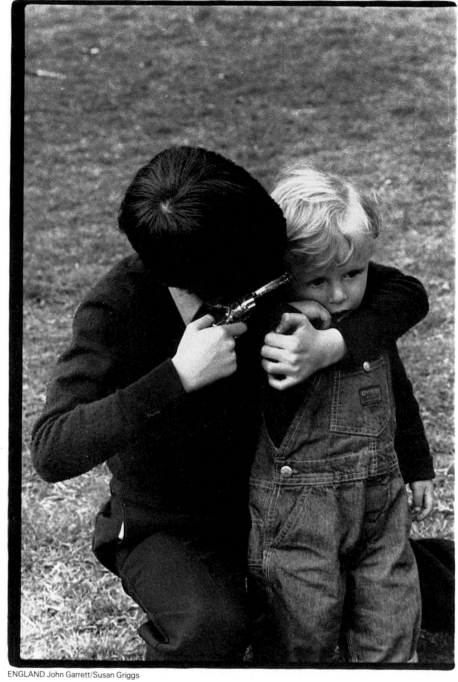

ENGLAND John Garrett/Susan Griggs

for I have savage cause William Shakespeare

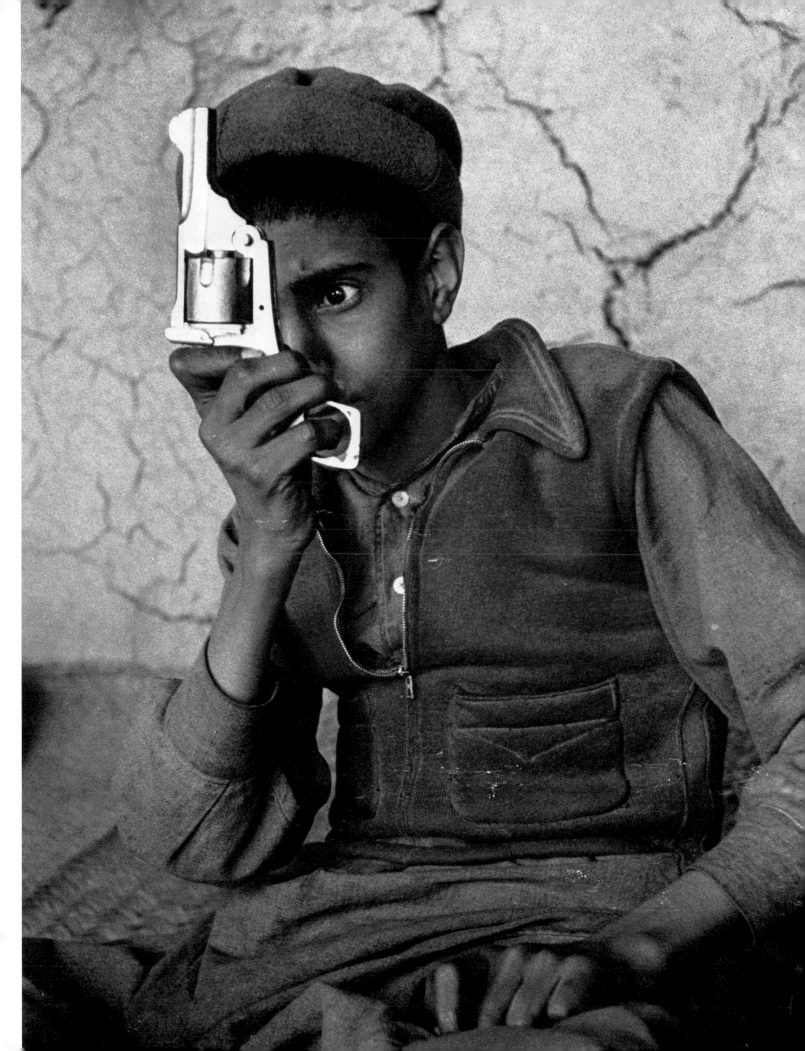

Let the boy try along this bayonet-blade

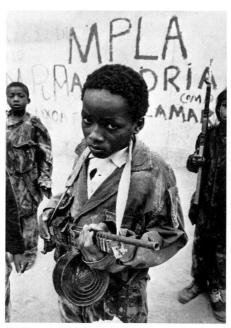

ANGOLA J. P. Laffont/Sygma

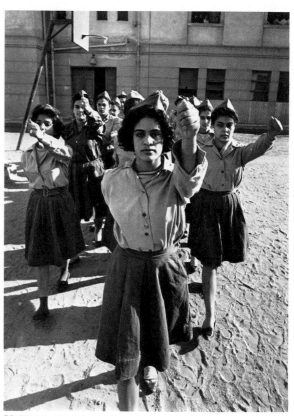

EGYPT Michael Friedel

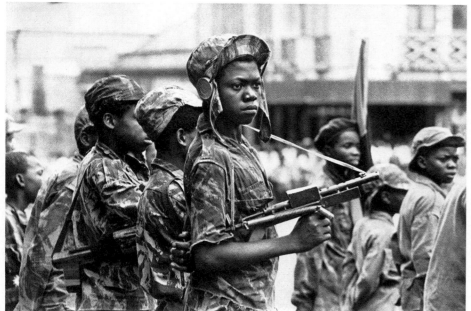

ANGOLA J. P. Laffont/Sygma

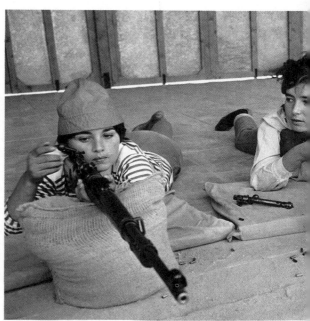

ISRAEL Michael Friedel

How cold steel is, and keen with hunger of blood Wilfred Owen

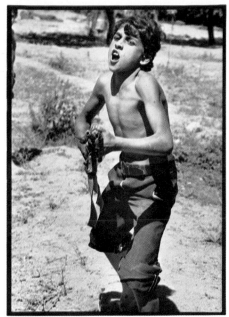

SYRIA Allen Green/Contact

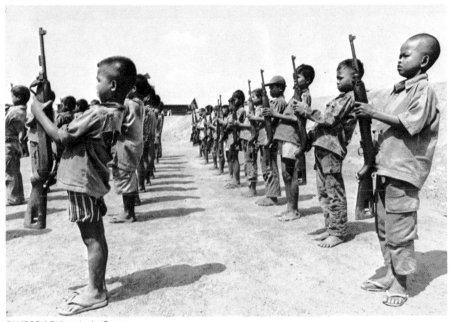

CAMBODIA Philippe Ledru/Sygma

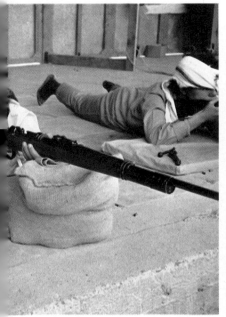

PERU Michael Friedel

War is for everyone, for children too. Robert Frost

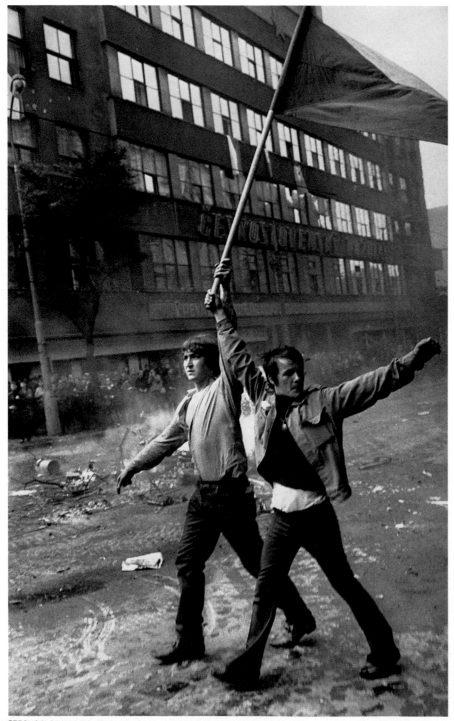

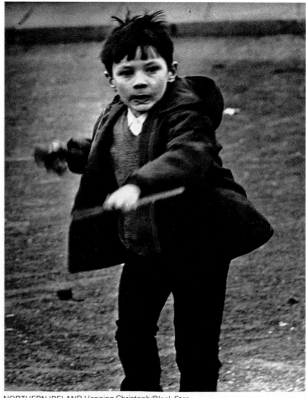

CZECHOSLOVAKIA P.P./Magnum

NORTHERN IRELAND Henning Christoph/Black Star

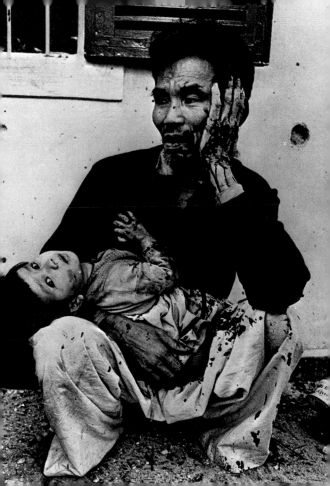

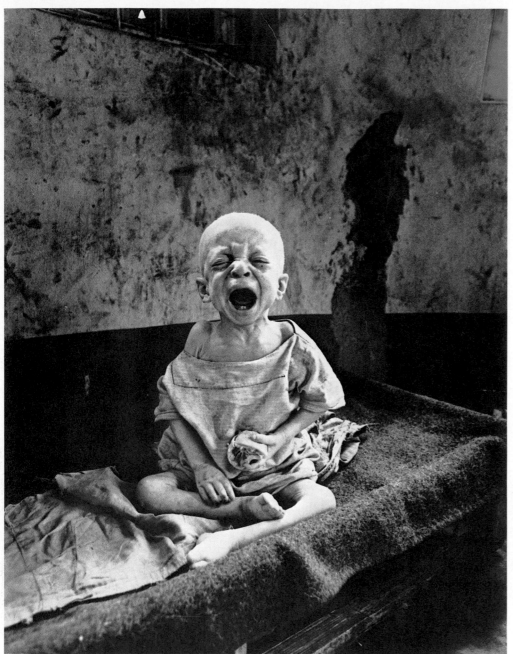

BIAFRA Al Clayton

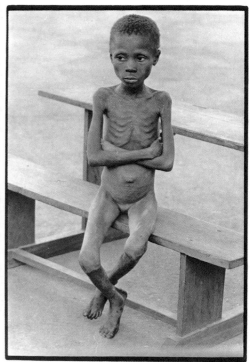

BIAFRA Genevieve Chauvel/Sygma

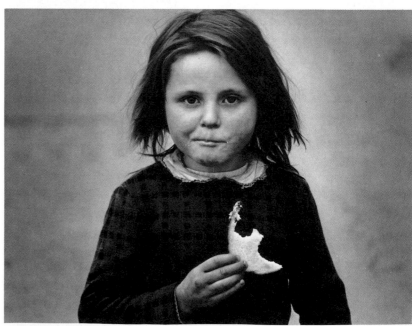

IRELAND Eva Rubinstein

I'yehe! my children—
My children,
We have rendered them desolate. American Indian

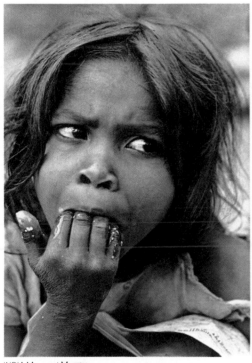

INDIA Margaret Murray

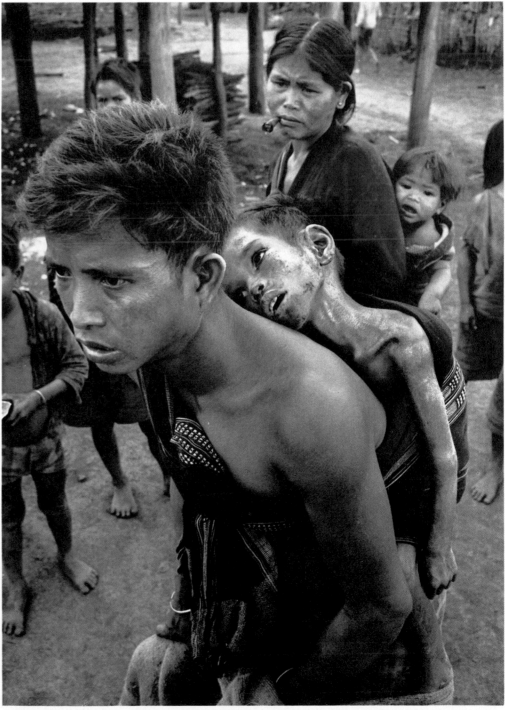

VIETNAM James H. Karales

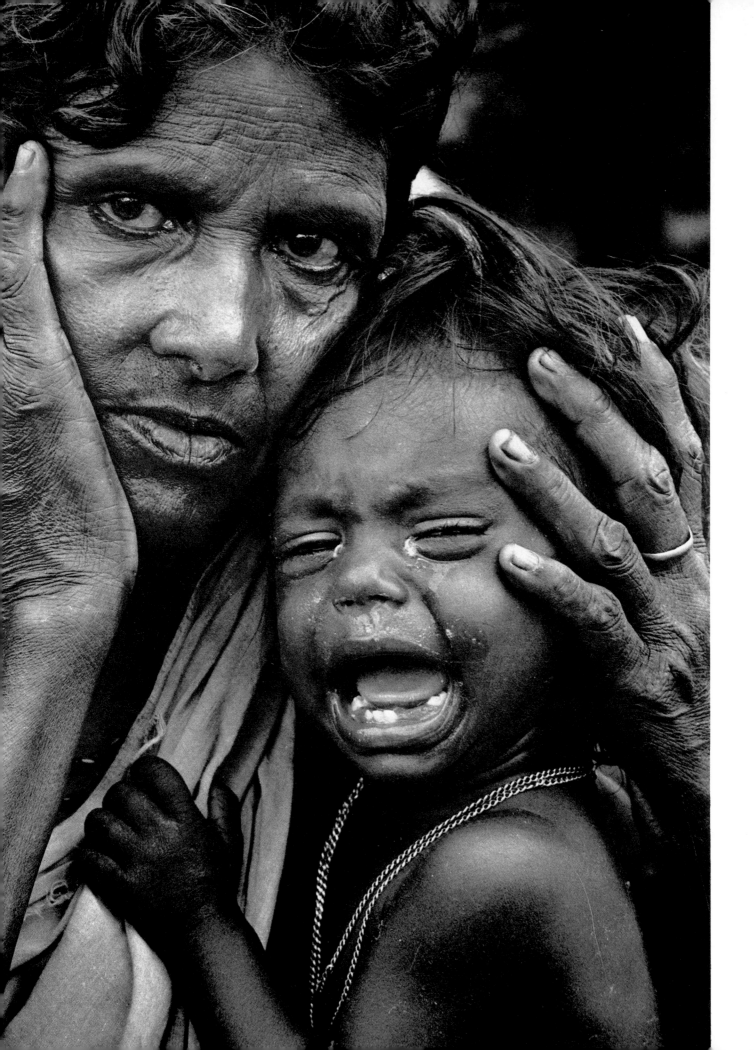

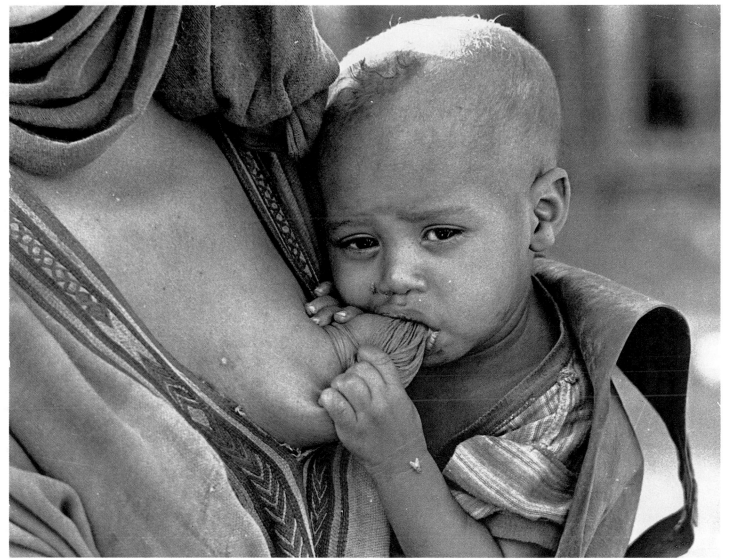

ETHIOPIA Bo-Erik Gyberg/Camera Press

Come away, O human child!
For the world's more full of weeping than you can
understand. William Butler Yeats

151

The shattered mirror will reflect no more;
The fallen flower will hardly rise to the branch. Zenrin

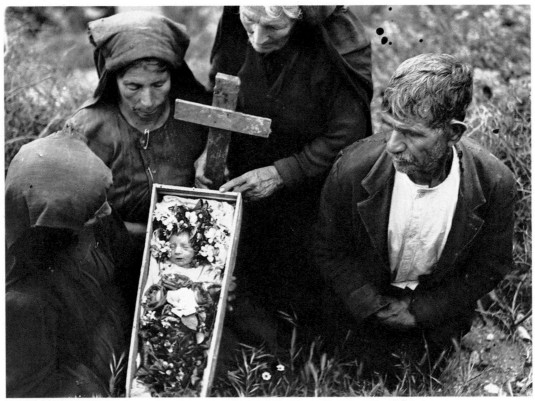

ITALY Federico Patellani

HONDURAS Arthur Leipzig

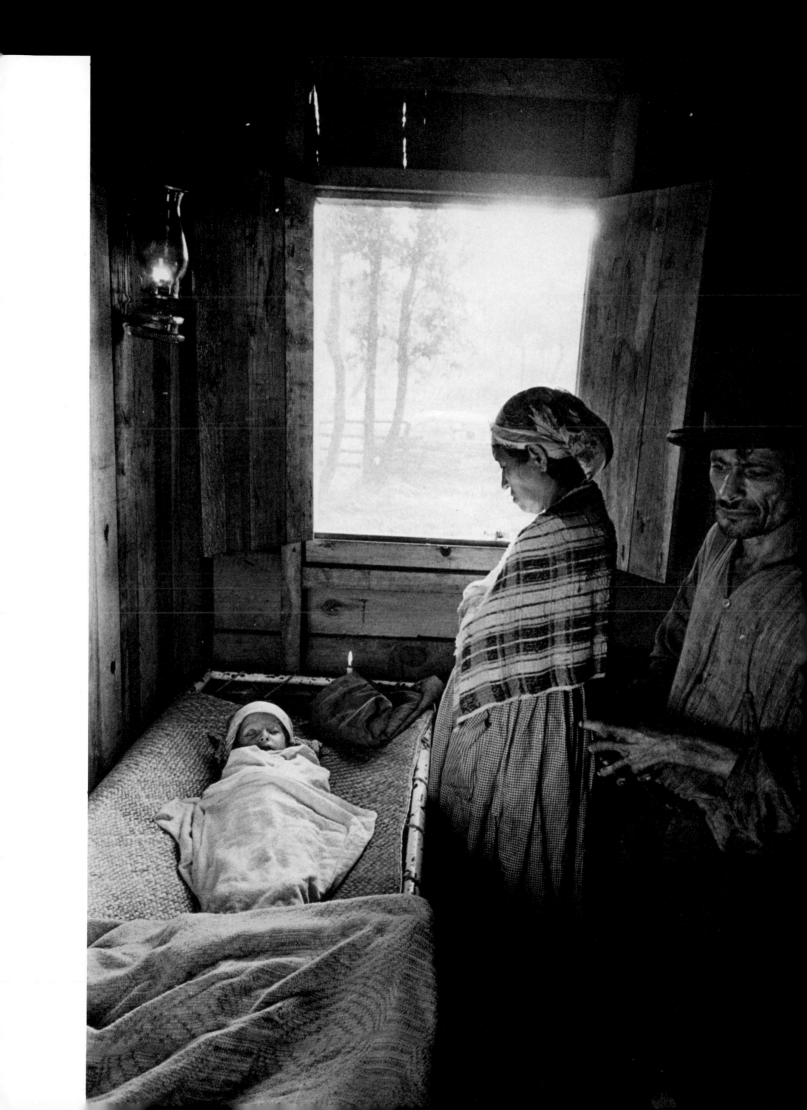

One generation passeth away, and another generation cometh:

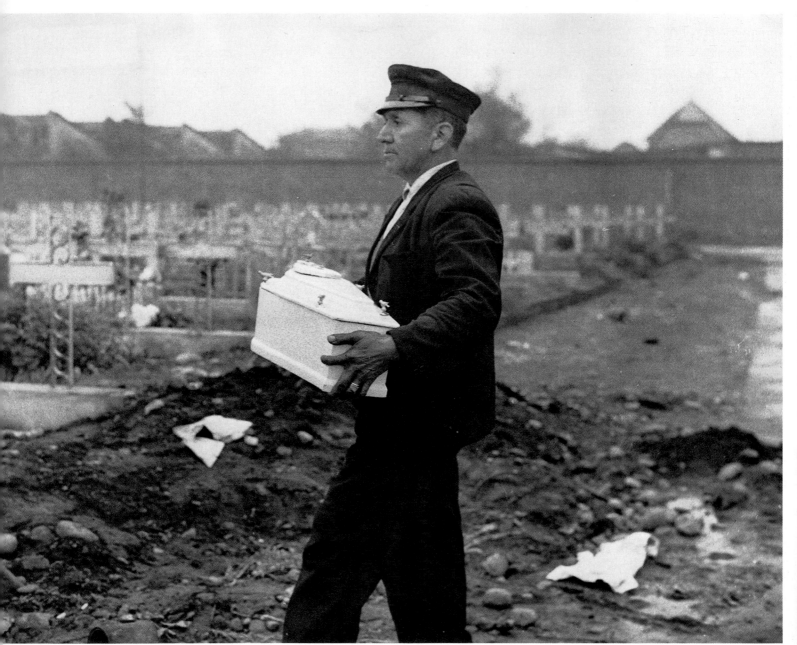

CHILE Paul Almasy/Camera Press

but the earth abideth for ever. Ecclesiastes 1:4

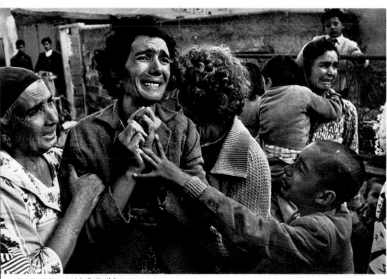

CYPRUS Donald McCullin/Magnum

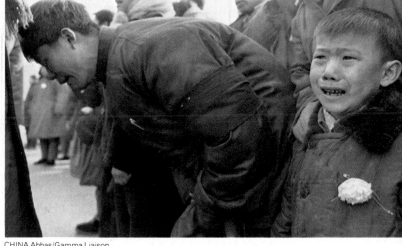

CHINA Abbas/Gamma Liaison

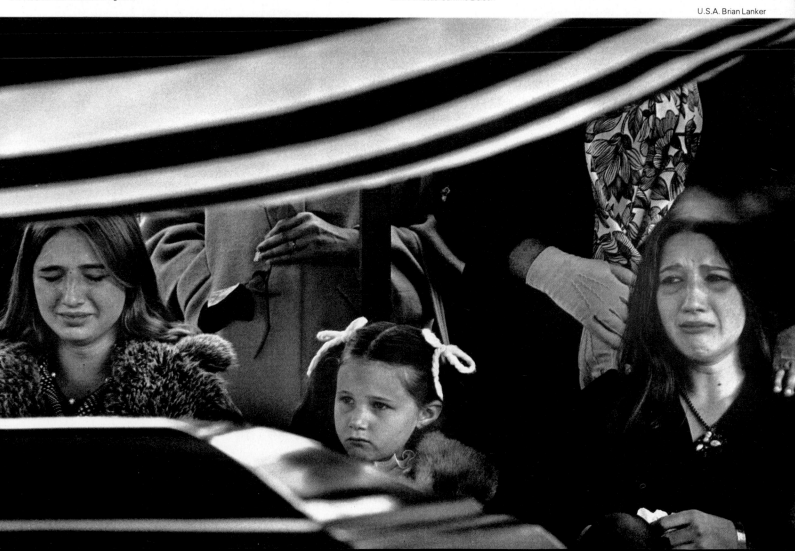

U.S.A. Brian Lanker

upgathered now like sleeping flowers William Wordsworth

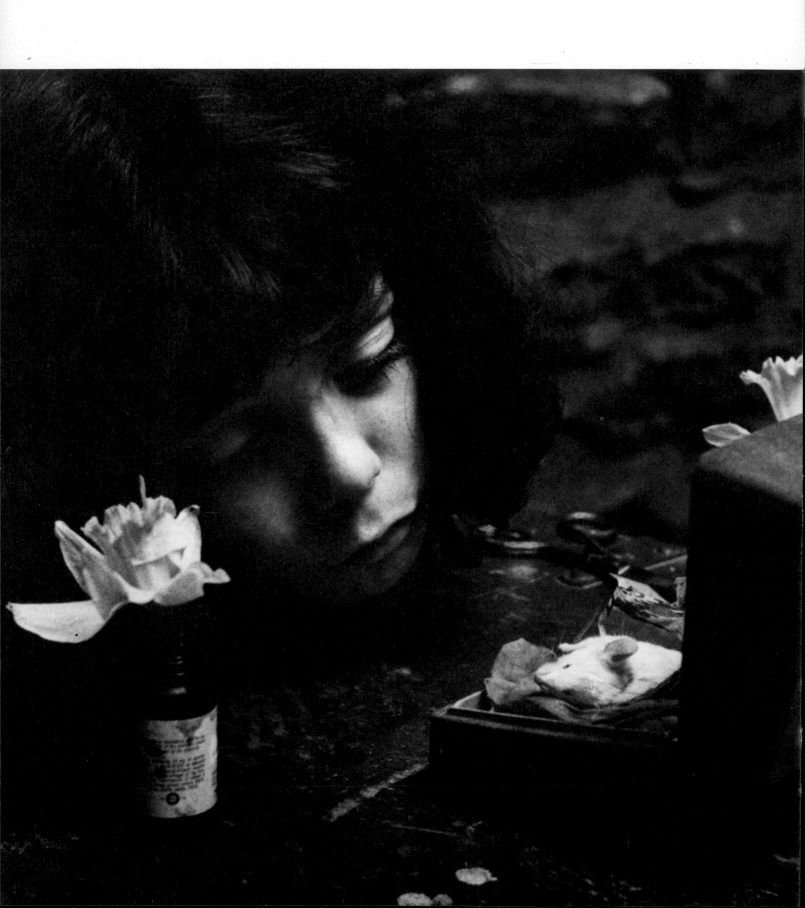

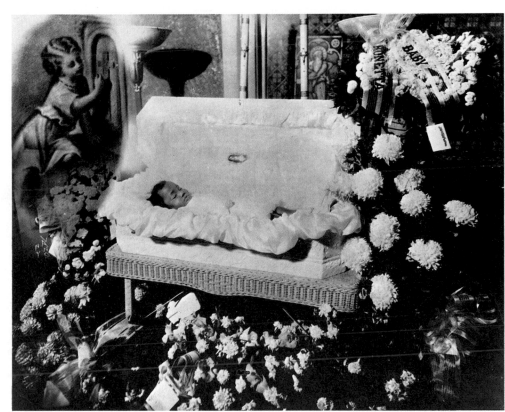

HARLEM James Van Der Zee

Their chant shall be a chant of paradise Wallace Stevens

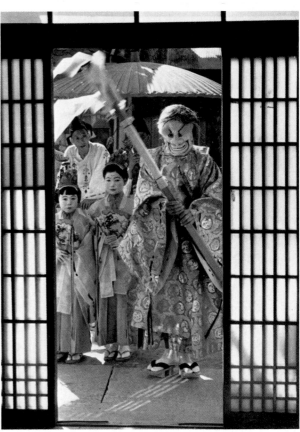

JAPAN Hideo Haga

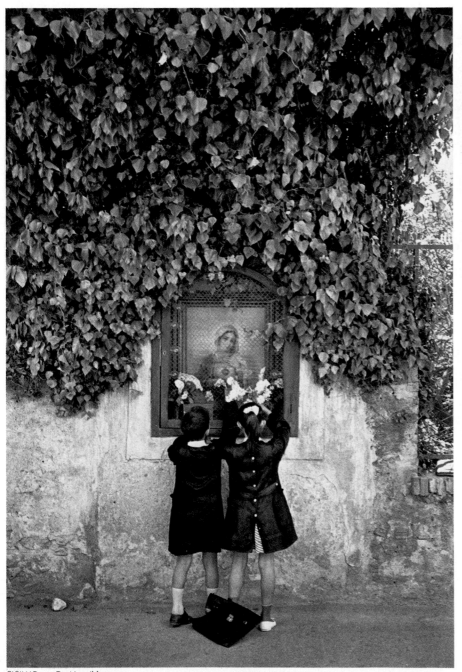

SICILY Bruce Davidson/Magnum

JERUSALEM Jill Freedman

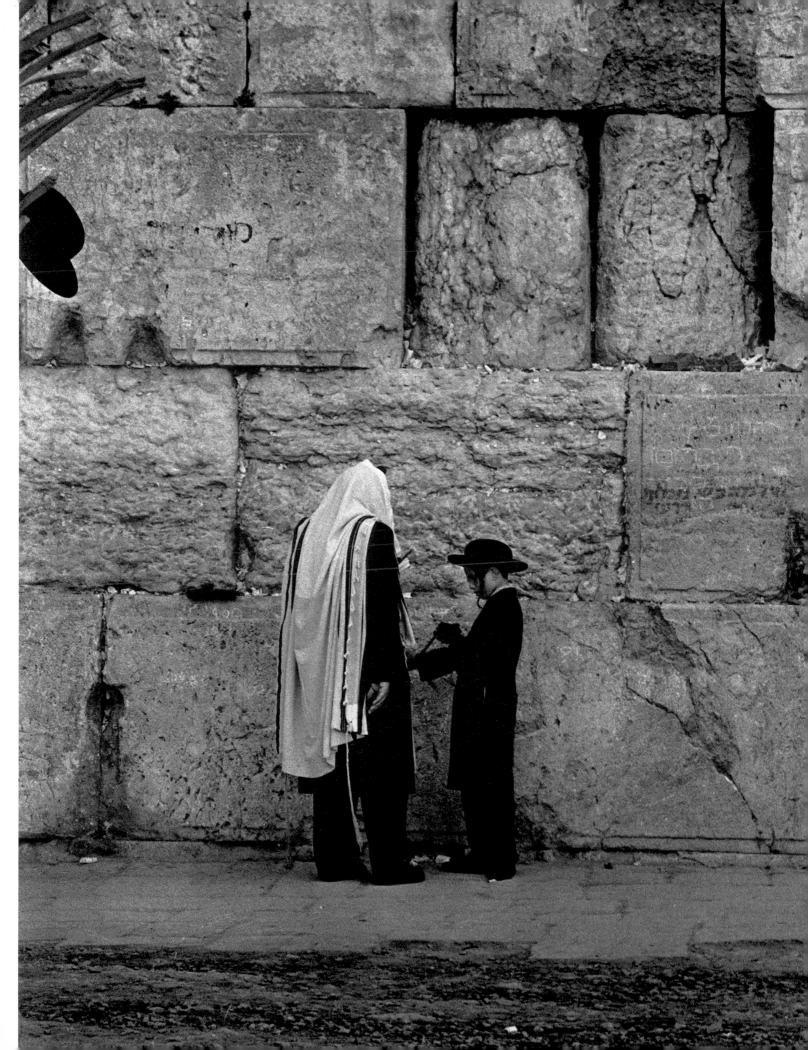

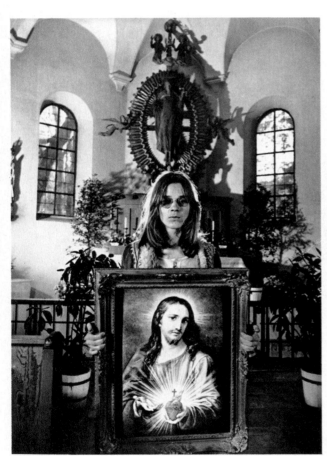

EAST GERMANY Thomas Höpker/Woodfin Camp

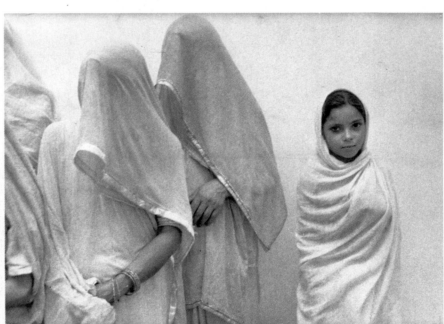

INDIA Bob Willoughby

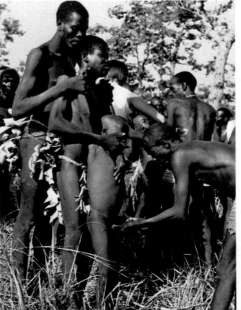

CAMEROON Jean-Claude Bouvier/Rapho

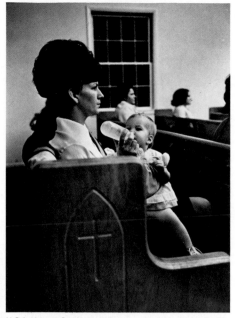

U.S.A. Norman Snyder

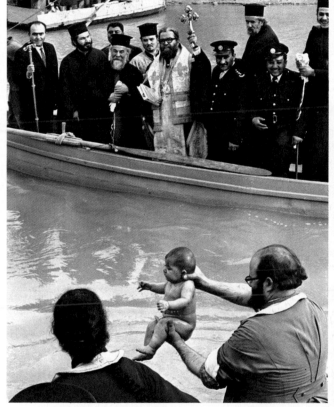

ISRAEL Fee Schlapper

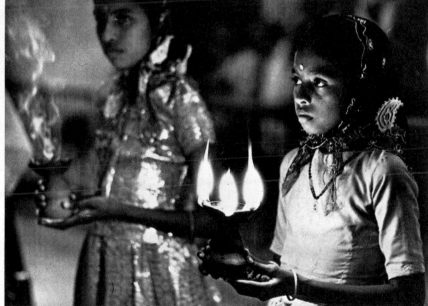

SRI LANKA Henning Christoph

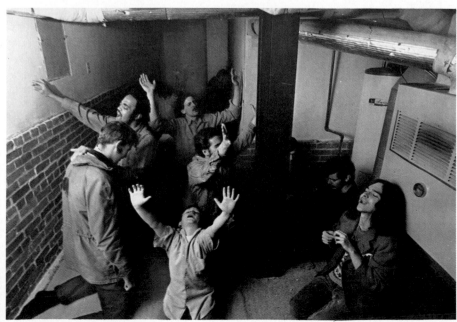

U.S.A. Thomas Höpker/Woodfin Camp

161

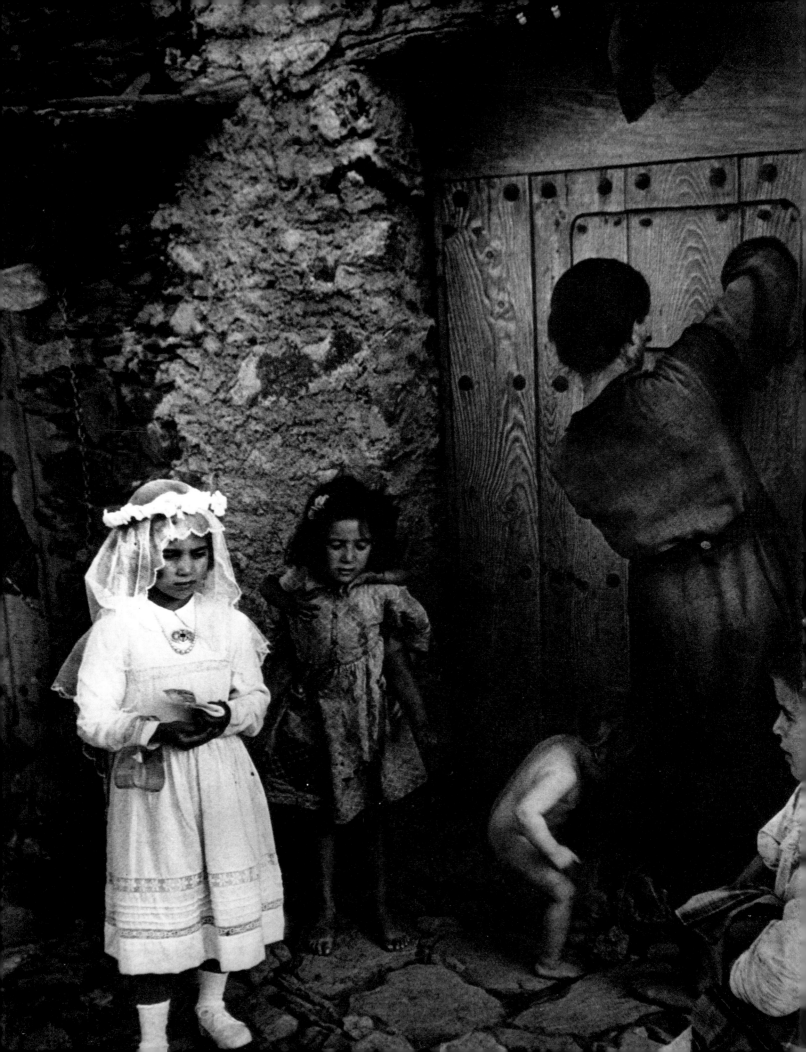

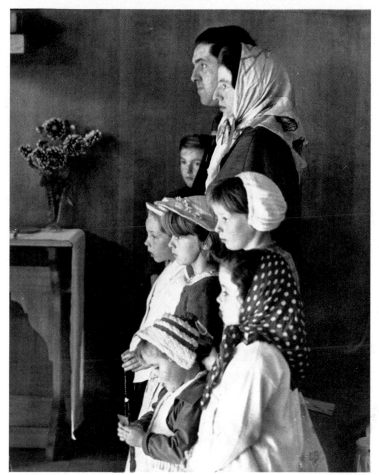

IRELAND Brian Seed/Black Star

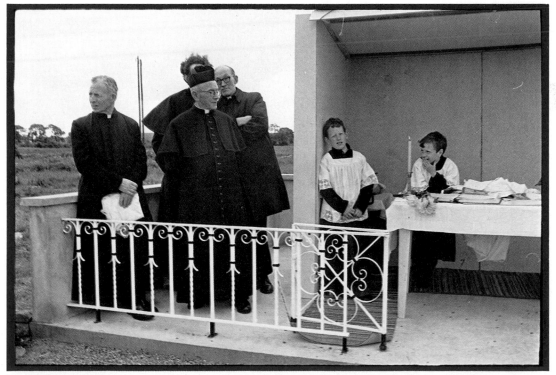

IRELAND Jill Freedman

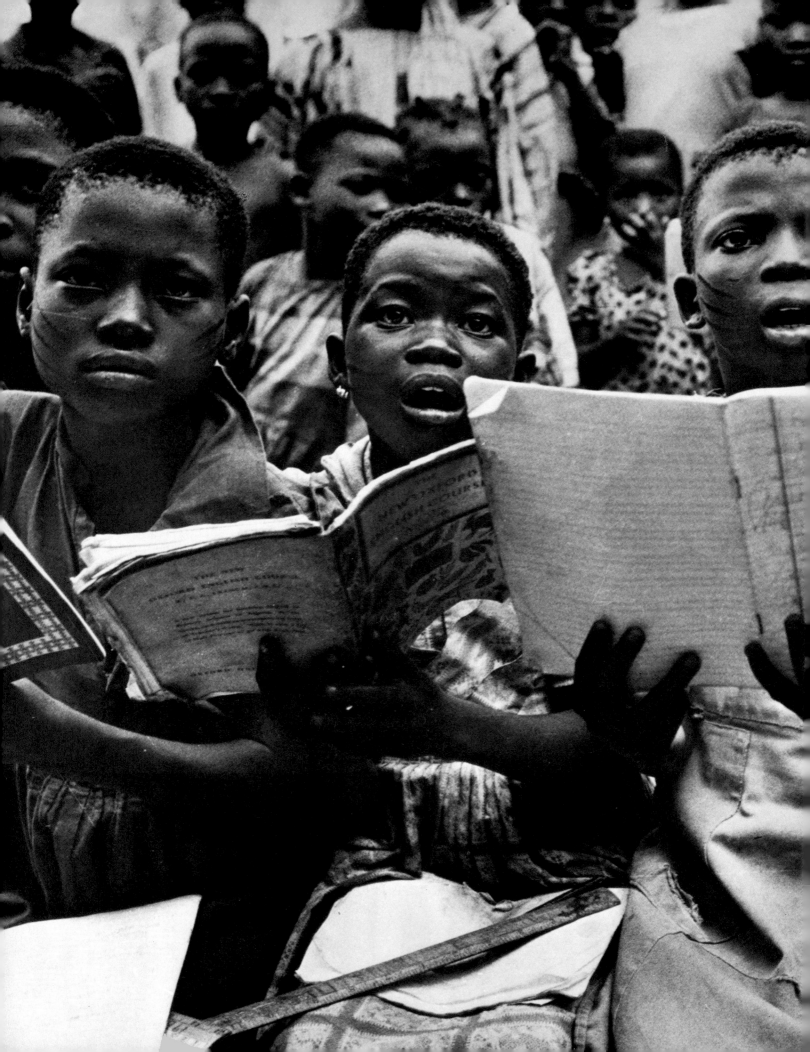

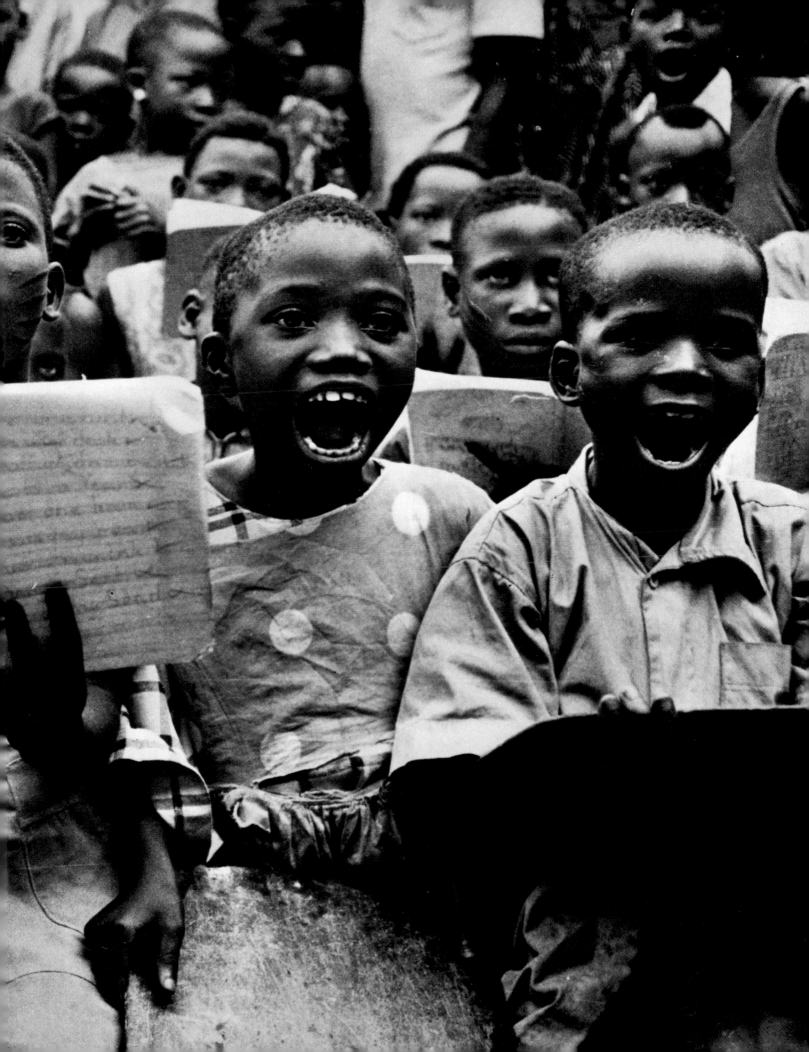

Preceding pages: NIGERIA Michael Friedel

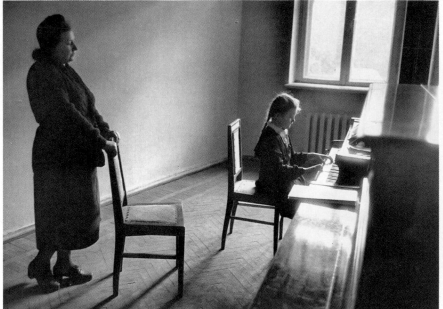

U.S.S.R. Elliott Erwitt/Magnum

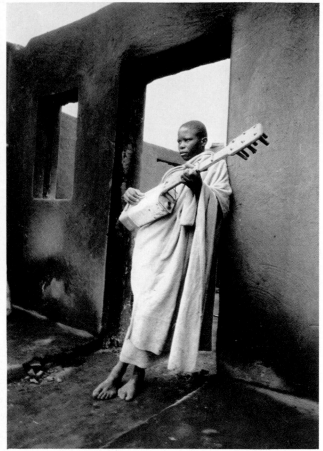

SOUTH AFRICA Ian Berry/Magnum

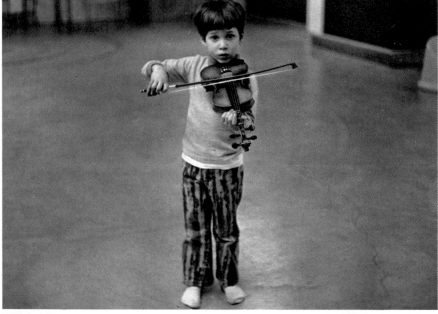

U.S.A. Ruth Silverman

Upon what Instrument are
we two spanned?
And what player has us
in his hand?
O sweet song. Rainer Maria Rilke

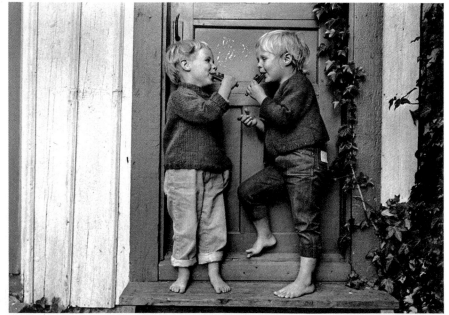

SWEDEN Ann-Sofi Bergman/Tio

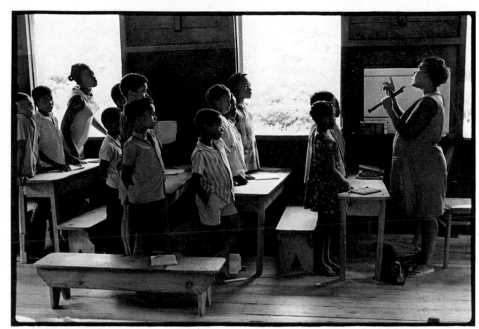

DOMINICA James R. Smith

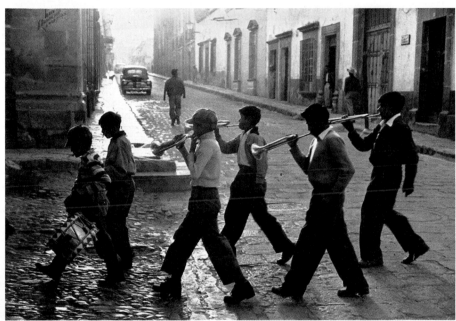

MEXICO Elliott Erwitt/Magnum

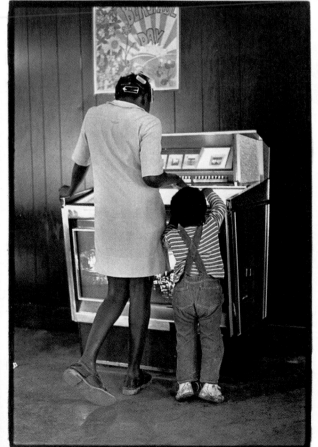

U.S.A. Valerie Wilmer

CHINA Richard & Sally Greenhill

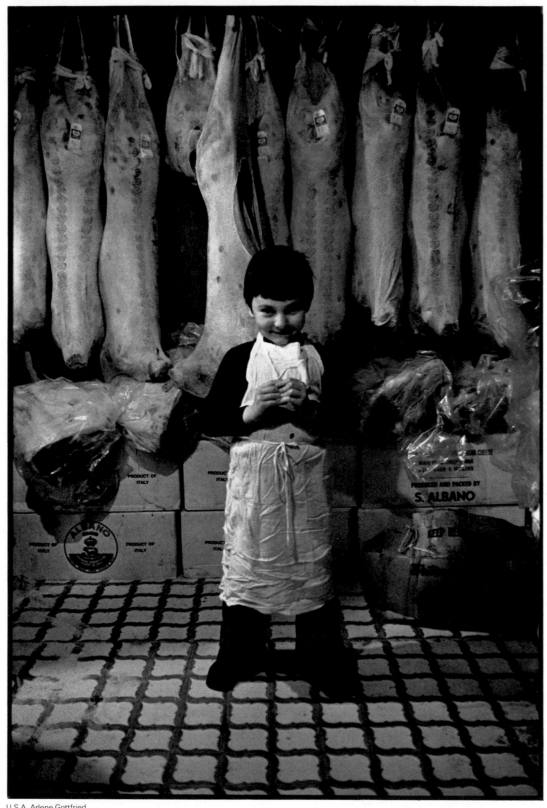

U.S.A. Arlene Gottfried

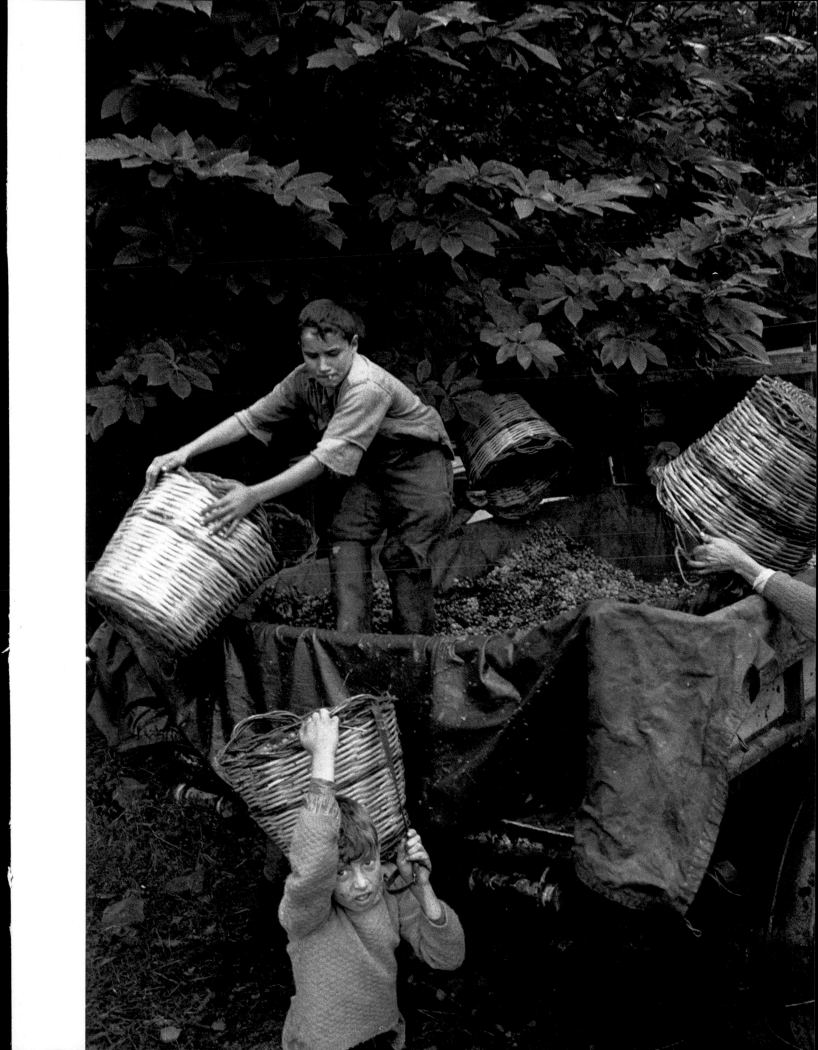

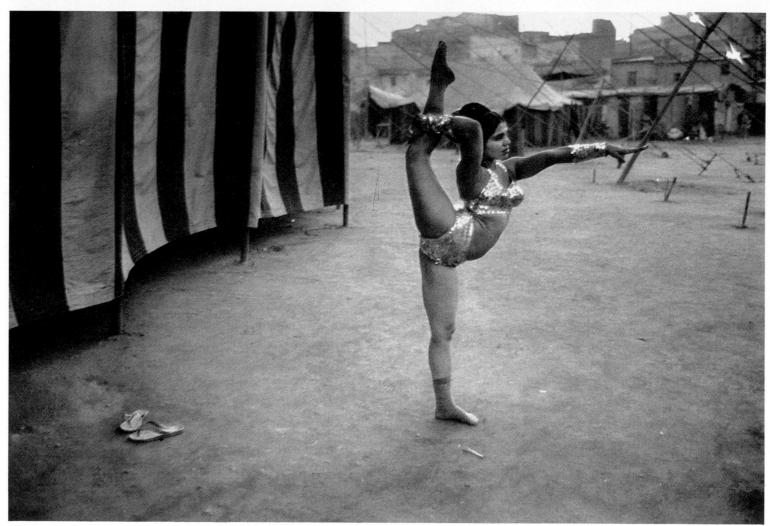

INDIA Mary Ellen Mark/Magnum

Remember the days of old,/consider the years of many generations:/ask thy father, and he will show thee;/ thy elders, and they will tell thee. Deuteronomy 32:7

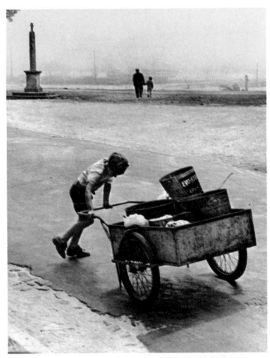
PORTUGAL V. Dukat/Magnum

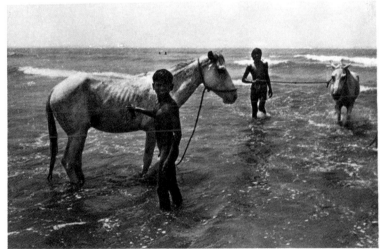
INDIA Jessie Ann Matthew

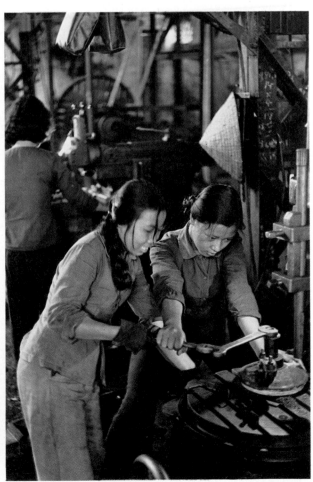

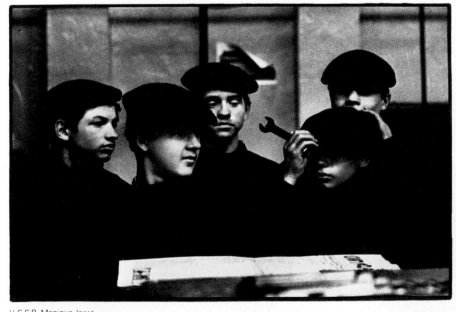
U.S.S.R. Monique Jacot

CHINA Marc Riboud/Magnum

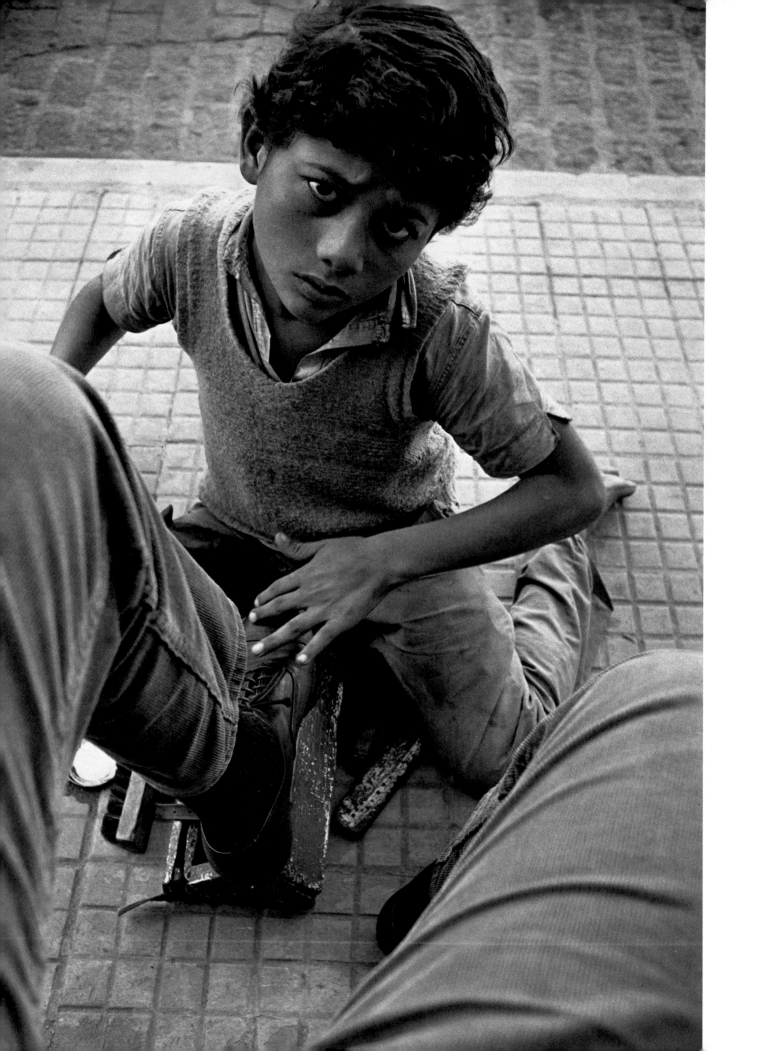

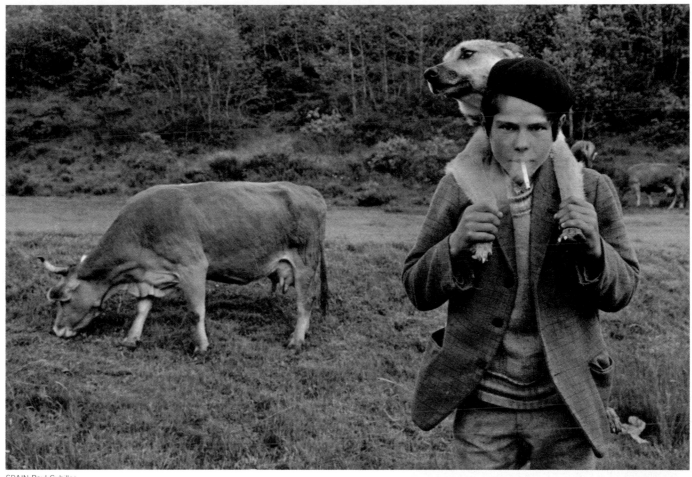

SPAIN Raul Cubillas

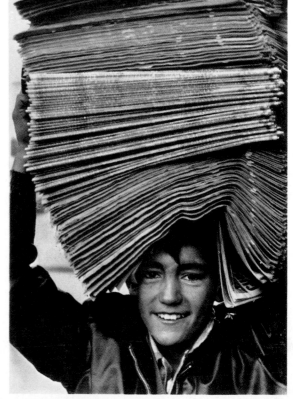

U.S.A. Joseph Sterling

HONDURAS David Mangurian

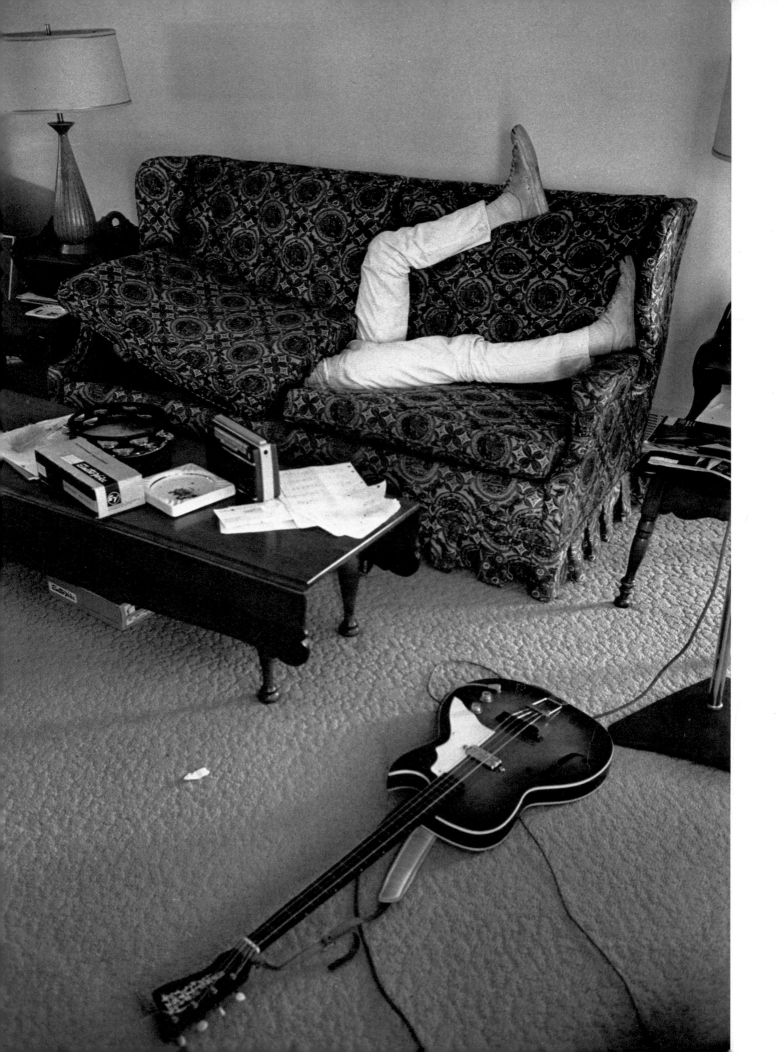

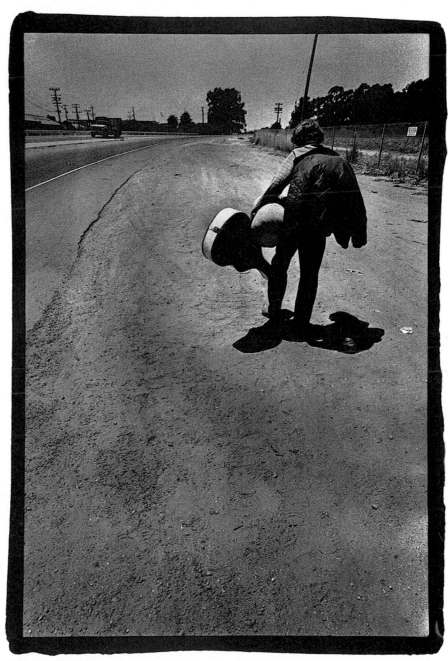

U.S.A. Robert Burroughs

Ah, there are no children nowadays. Molière

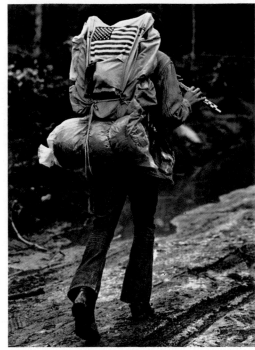

U.S.A. Dennis Stock/Magnum

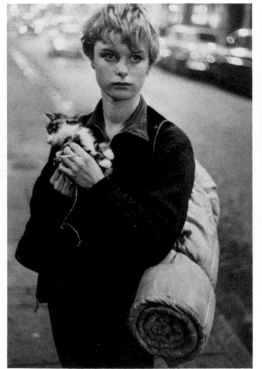

ENGLAND Bruce Davidson/Magnum

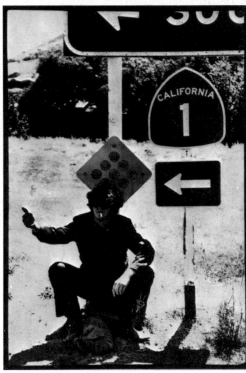

U.S.A. Dennis Stock/Magnum

U.S.A. Charles Harbutt/Magnum

I'm naked to the bone,
With nakedness my shield.
Myself is what I wear:
I keep the spirit spare. Theodore Roethke

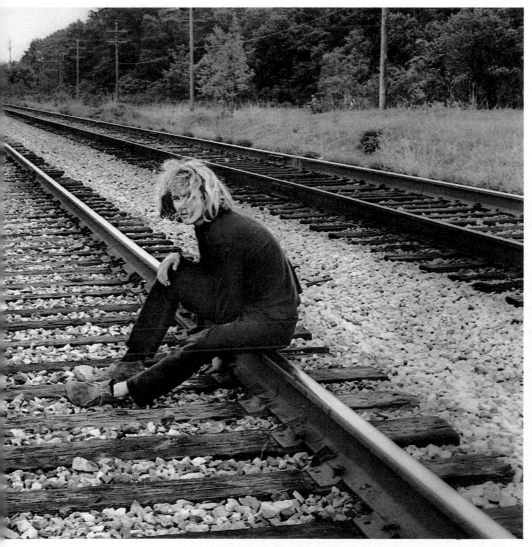

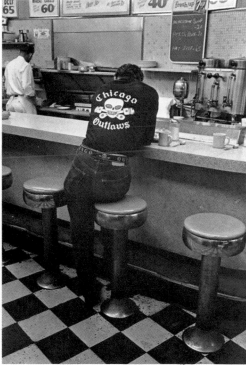

U.S.A. Danny Lyon/Magnum

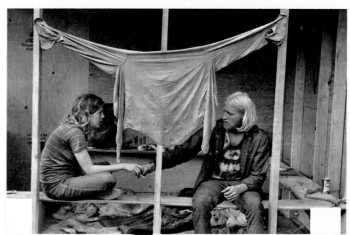

U.S.A. Leonard Freed/Magnum

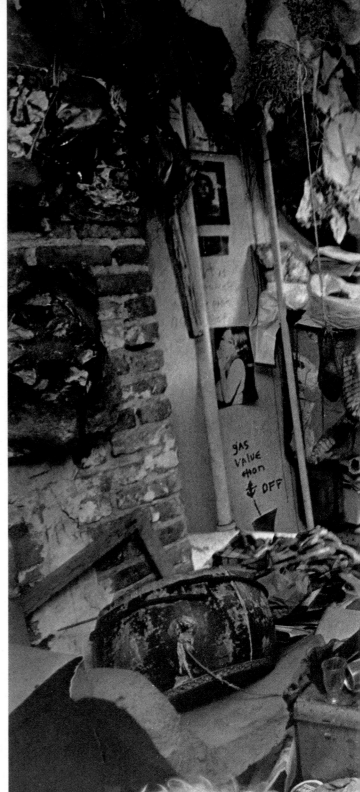

U.S.A. Charles Gatewood/Magnum

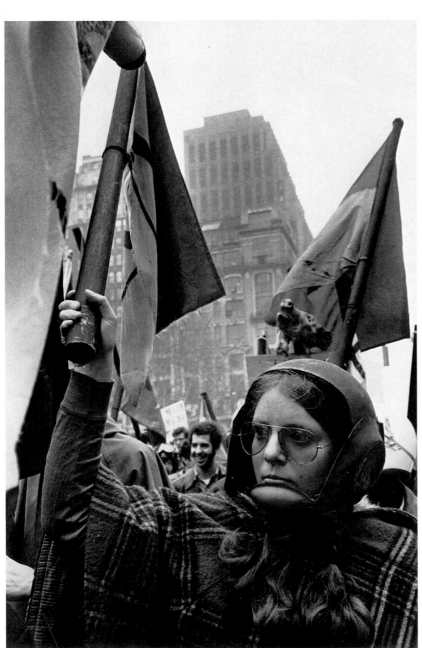

U.S.A. Charles Harbutt/Magnum

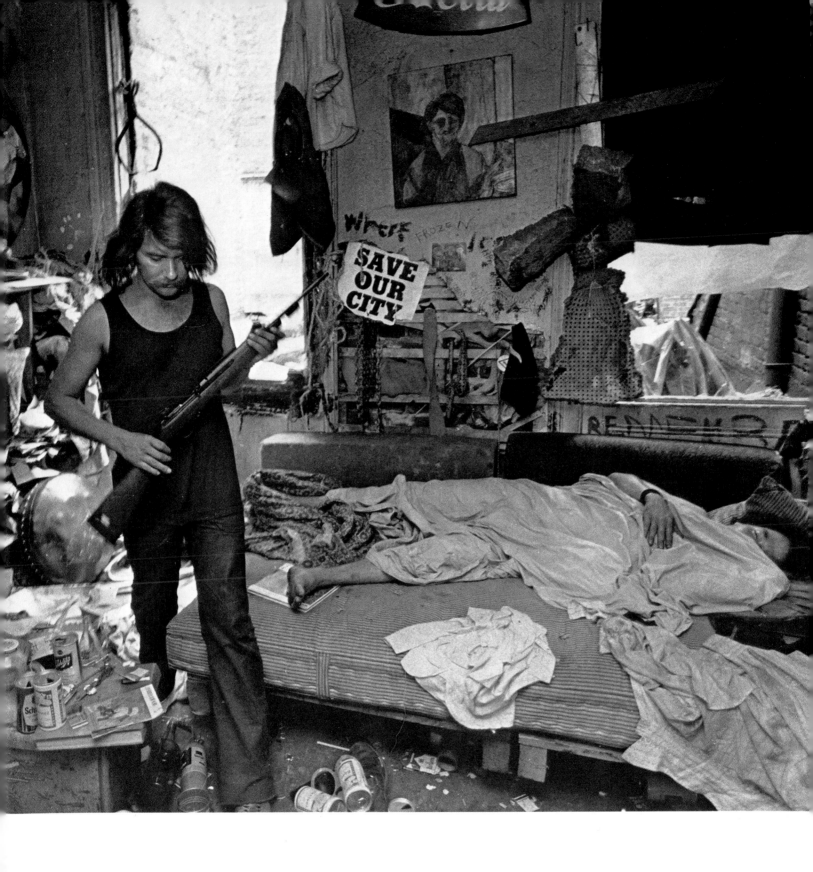

My youth is gone, and yet I am but young Chidiock Tichbourne

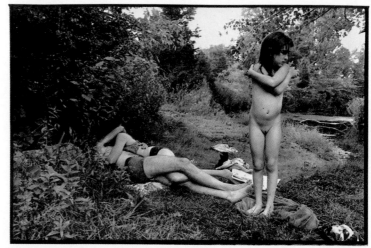

U.S.A. Joan Liftin/Woodfin Camp

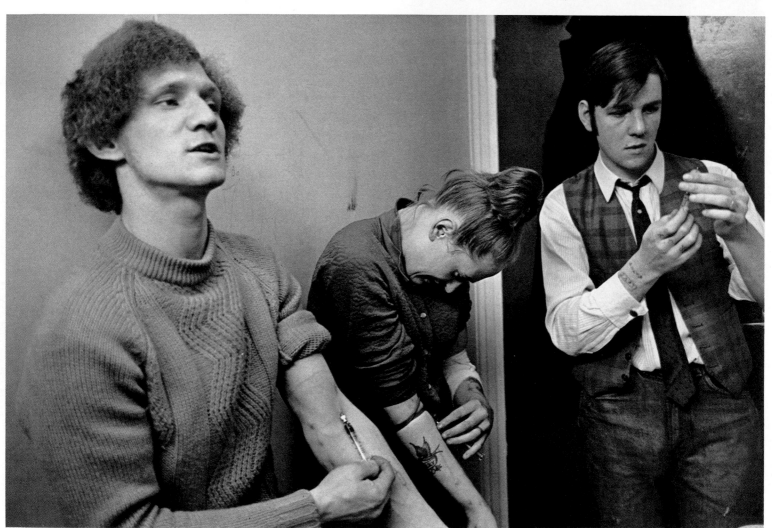

ENGLAND Mary Ellen Mark/Magnum

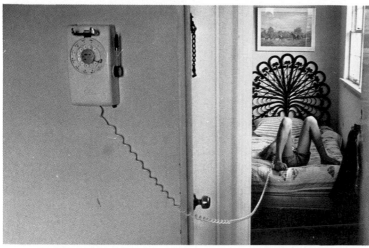

U.S.A. Bill Strode

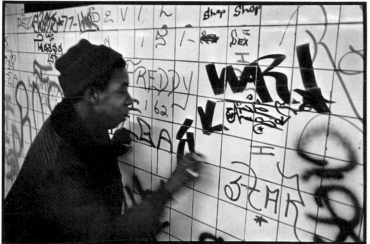

U.S.A. James R. Smith

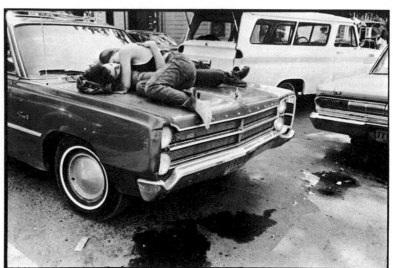

ENGLAND Bruce Davidson/Magnum

U.S.A. Abigail Heyman/Magnum

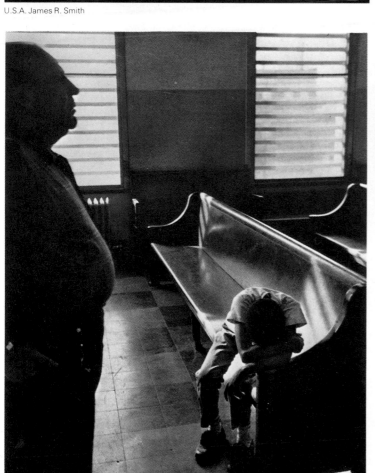

U.S.A. Charles Harbutt/Magnum

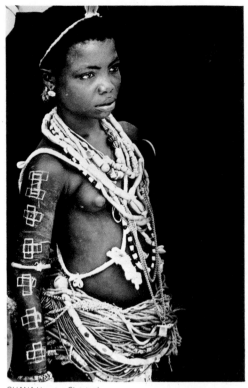

GHANA Henning Christoph

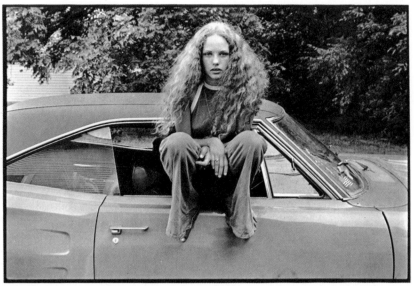

U.S.A. James R. Smith

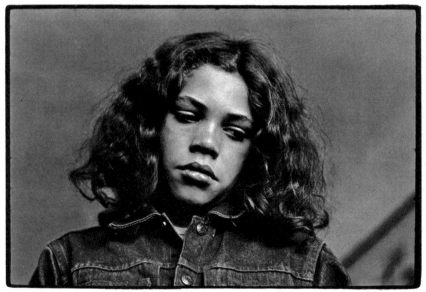

U.S.A. Mary Ellen Andrews

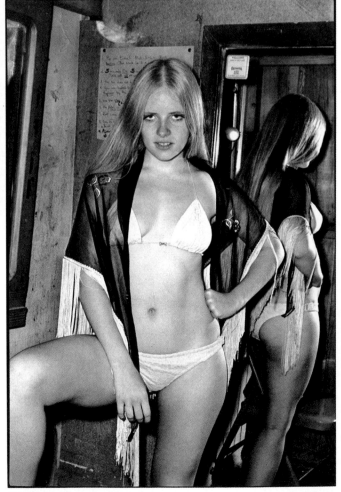

U.S.A. Eric Kroll

Practice your beauty, blue girls, before it fail. John Crowe Ransom

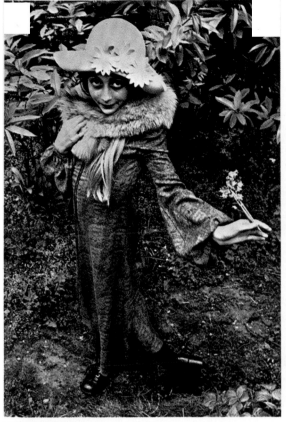

ENGLAND Suzie Maeder

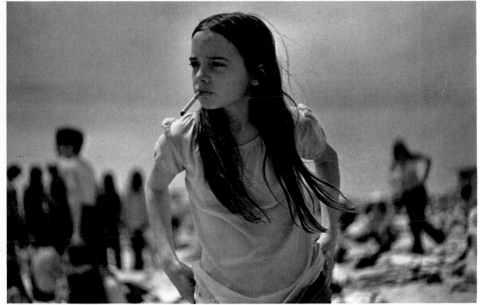

U.S.A. Joseph Szabo

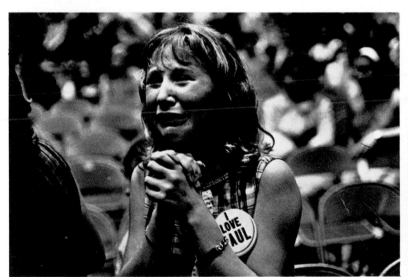

U.S.A. Josepn Sterling

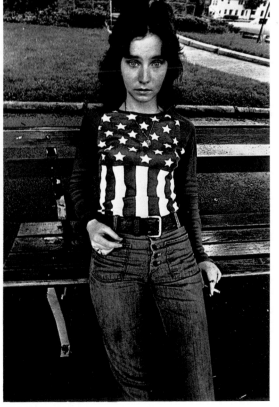

U.S.A. Harvey Stein

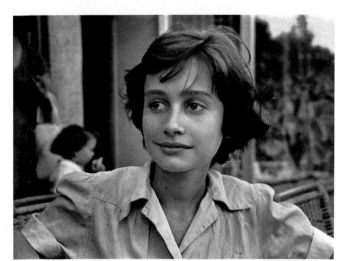

ISRAEL Ruth Orkin

183

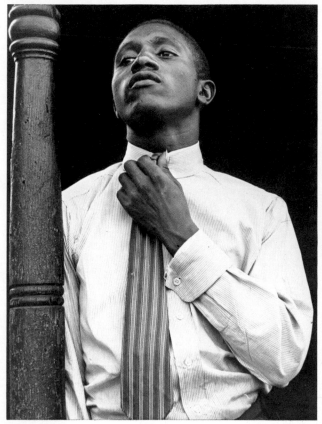

U.S.A. Arthur Rothstein

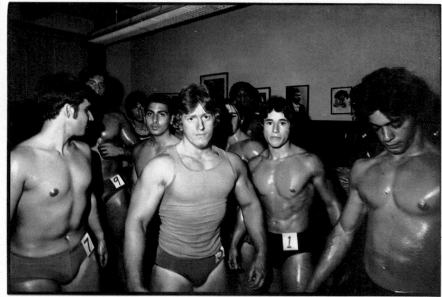

U.S.A. Eric Kroll

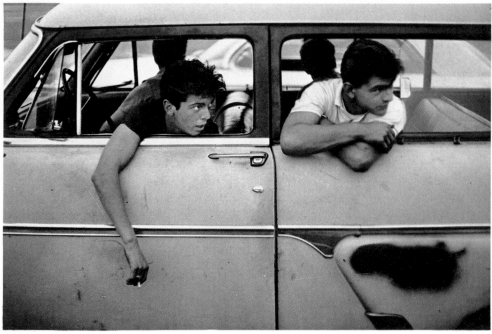

U.S.A. Joseph Sterling

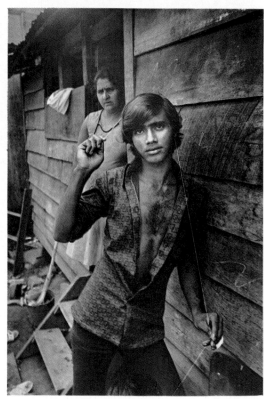

SURINAM Willem Diepraam/Woodfin Camp

Lookin' for fun and feelin' Groovy Paul Simon

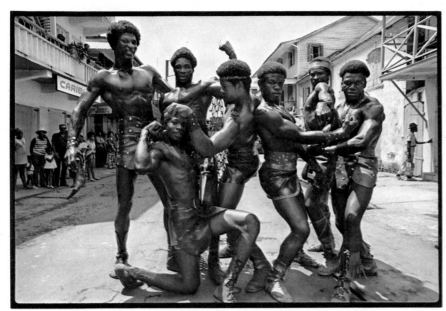

DOMINICA James R. Smith

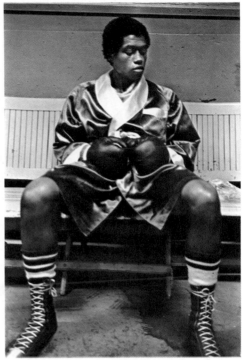

U.S.A. Allen Metnick

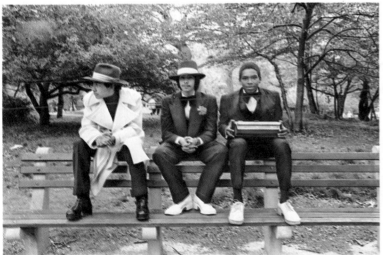

U.S.A. David Haas

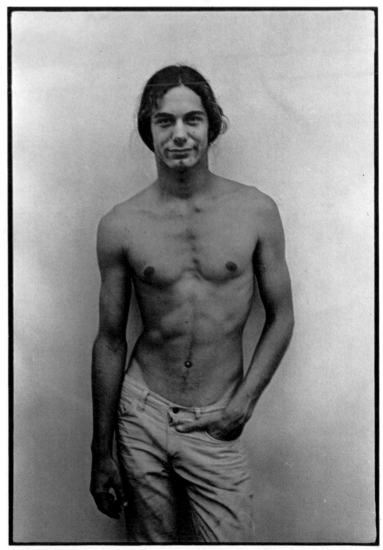

U.S.A. Lilo Raymond

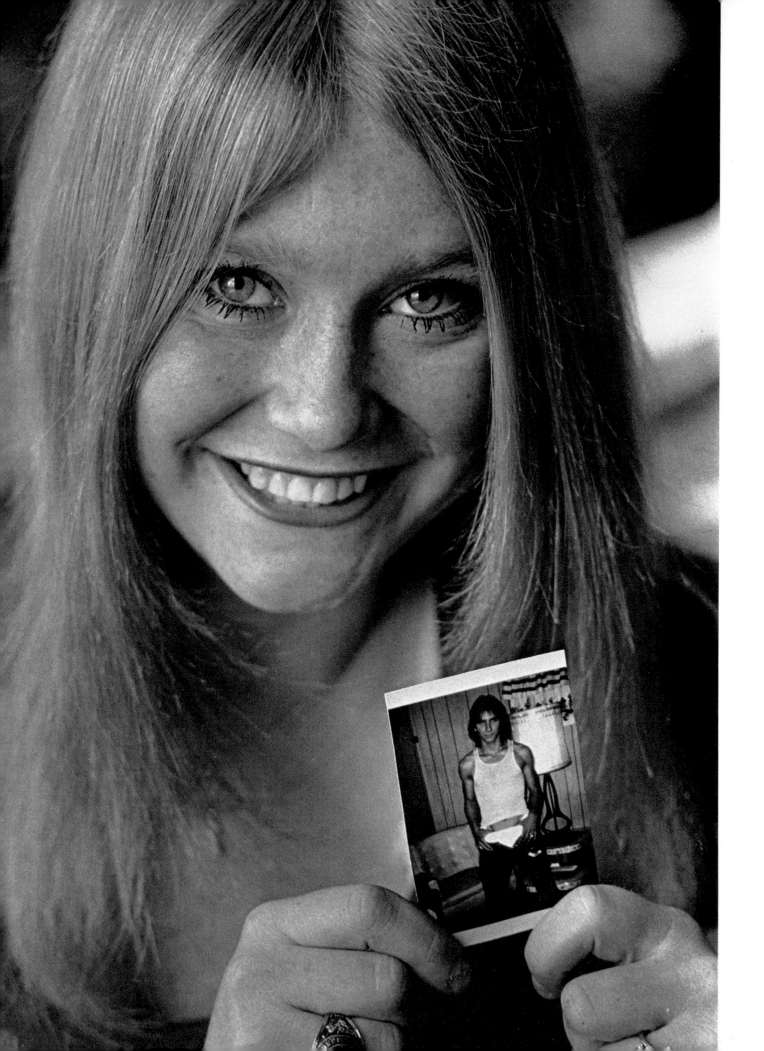

U.S.A. Joseph Szabo

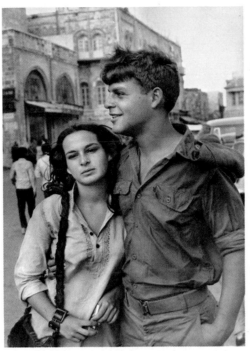

ISRAEL Aliza Auerbach

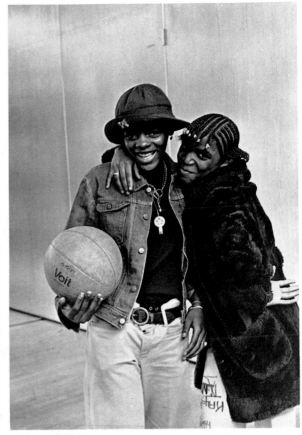

U.S.A. Beryl Goldberg

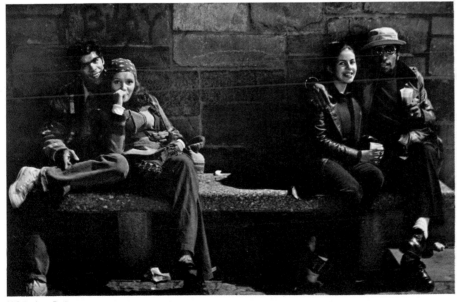

U.S.A. Joan Roth

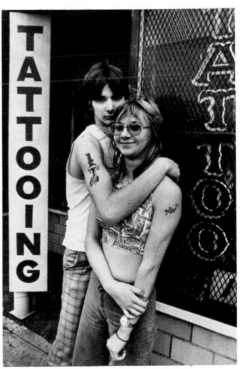

U.S.A. Dan J. Dry

Very fine is my valentine
Very fine and very mine.
Very mine is my valentine very mine and very fine
Very fine is my valentine and mine, very fine very
mine and mine is my valentine Gertrude Stein

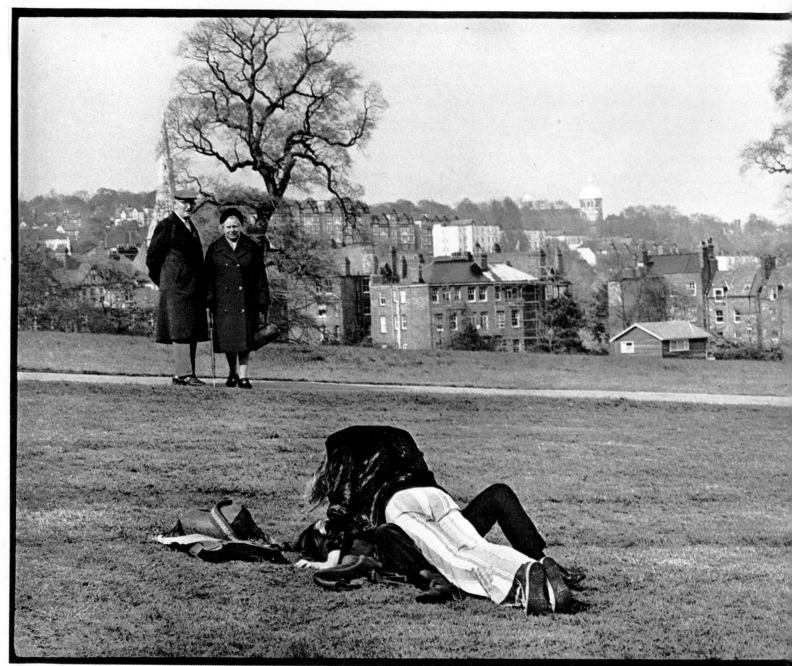

ENGLAND Peter Baistow

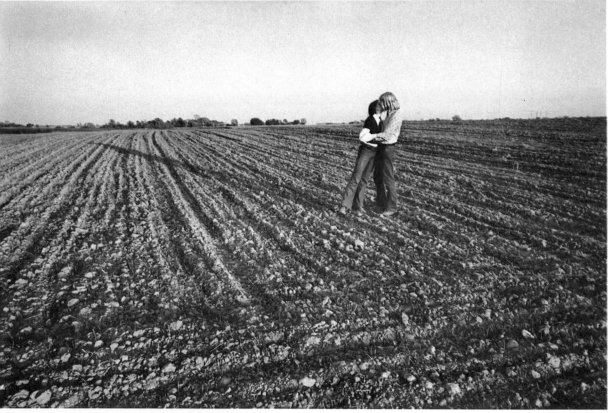

U.S.A. Ken Heyman

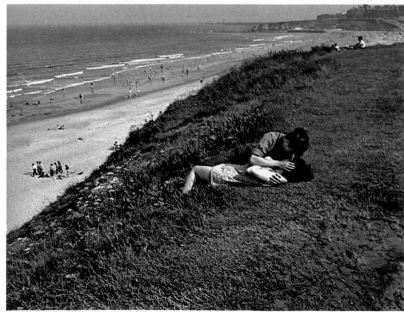

U.S.A. George Krause

189

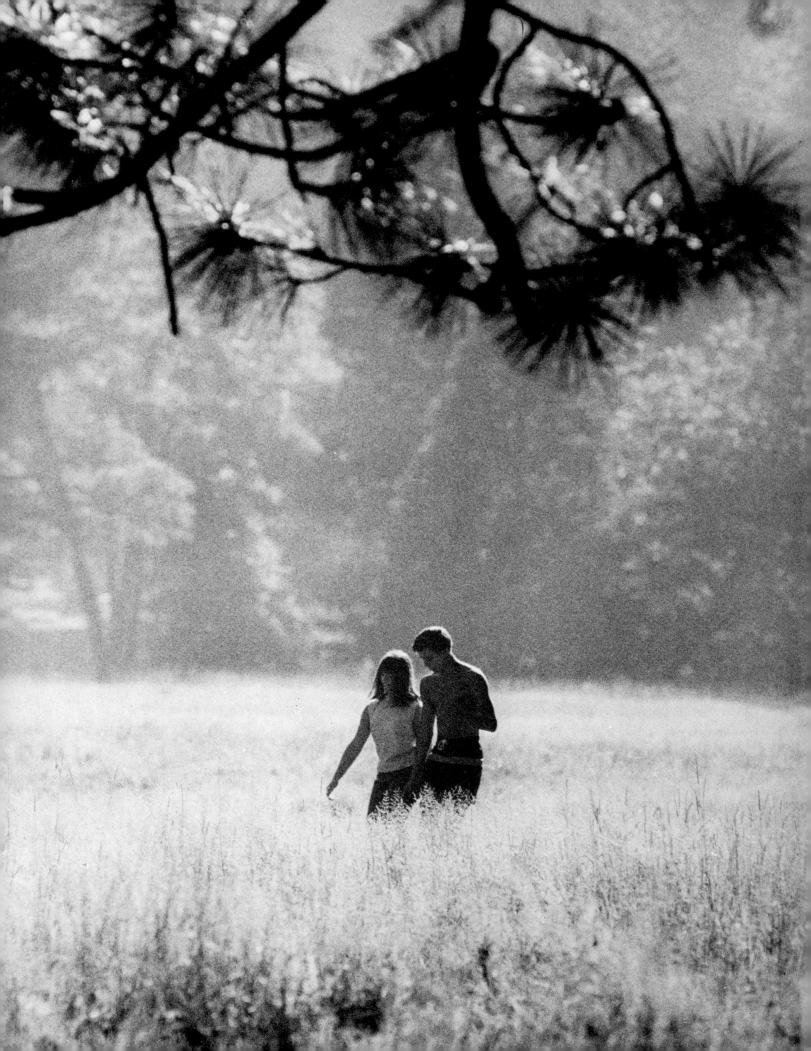

FRANCE Jürgen Vollmer/Rapho-Photo Researchers

Love to Love calleth,
Love unto Love replieth—
From the ends of the earth, drawn by invisible bands,
Over the dawning and darkening lands
Love cometh to Love. Robert Bridges

U.S.A. Ken Heyman